# Miami Ink

## Marked for Greatness

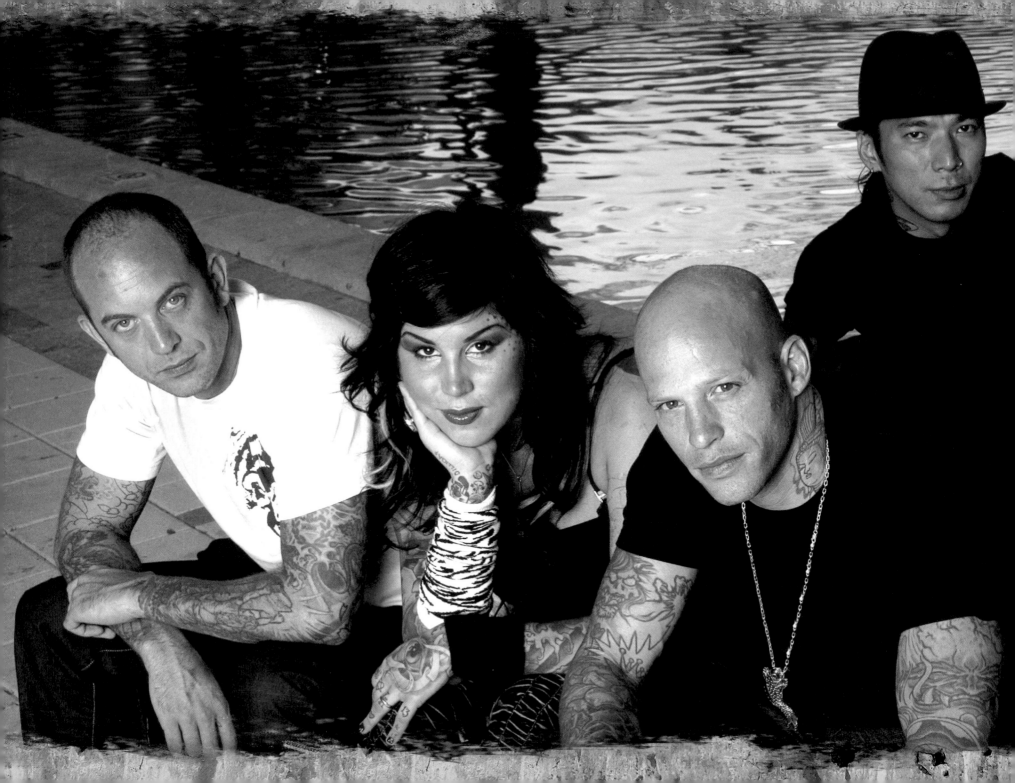

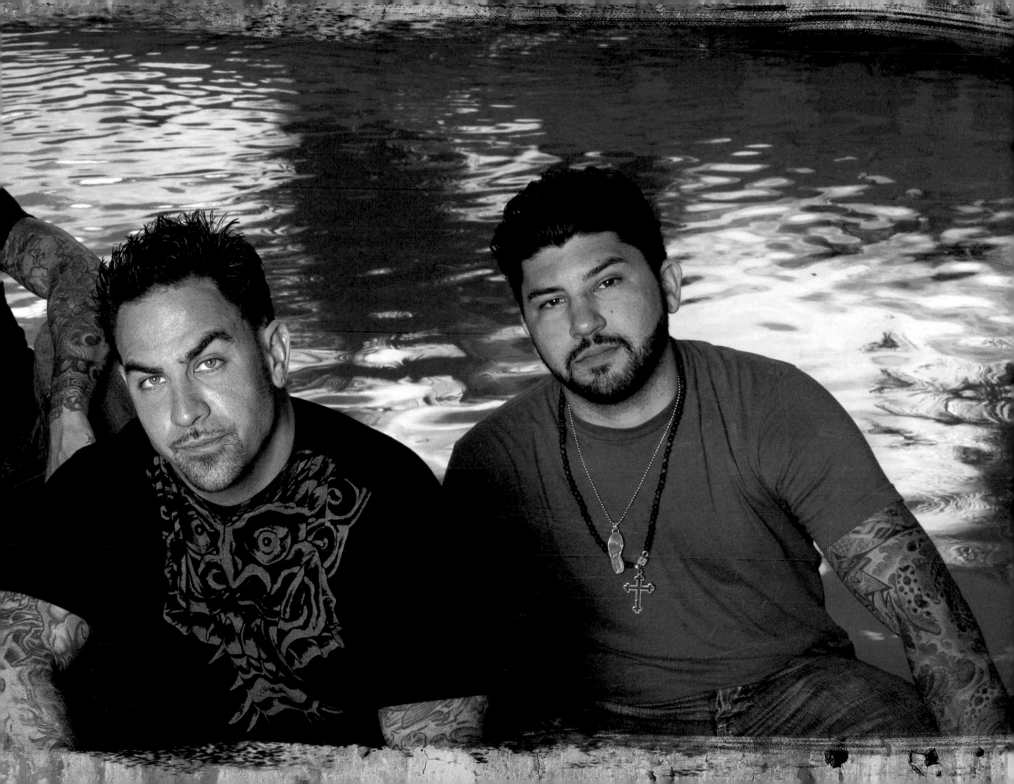

*Miami Ink: Marked for Greatness*

Writer: James Wagenvoord
Contributing Editor: Brian Kramer
Contributing Writer: Eliabeth Havey
Designer and Lead Photographer: Matthew Eberhart, Evil Eye Design
Contributing Designer: Diana Van Winkle
Contributing Photographers: Omar Cruz, Tom Grizzle, Klynt, Eric Larson,
    Patrick Penkwitt, and Andrew Southam
Copy Chief: Terri Fredrickson
Publishing Operations Manager: Karen Schirm
Senior Editor, Asset and Information Manager: Phillip Morgan
Edit and Design Production Coordinator: Mary Lee Gavin
Editorial Assistant: Kaye Chabot
Book Production Managers: Pam Kvitne, Marjorie J. Schenkelberg,
    Rick von Holdt, Mark Weaver
Contributing Copy Editor: Don Gulbrandsen
Contributing Proofreaders: Thomas Blackett, David Krause, Stan West

Meredith® Books
Executive Director, Editorial: Gregory H. Kayko
Executive Director, Design: Matt Strelecki
Managing Editor: Amy Tincher-Durik
Executive Editor/Group Manager: Larry Erickson
Marketing Product Manager: Steve Rogers

Publisher and Editor in Chief: James D. Blume
Editorial Director: Linda Raglan Cunningham
Executive Director, Marketing: Steve Malone
Executive Director, New Business Development: Todd M. Davis
Executive Director, Sales: Ken Zagor
Director, Operations: George A. Susral
Director, Production: Douglas M. Johnston
Director, Marketing: Amy Nichols
Business Director: Jim Leonard
Vice President and General Manager: Douglas J. Guendel

Meredith Publishing Group
President: Jack Griffin
Executive Vice President: Karla Jeffries

Meredith Corporation
Chairman: William T. Kerr
President and Chief Executive Officer: Stephen M. Lacy

In Memoriam: E.T. Meredith III (1933-2003)

**TLC**
live and learn™    *Miami Ink*

Discovery Book Development Team
David Abraham, General Manager, TLC
Matthew Gould, Executive Producer, TLC
Emily Jerez, Production Coordinator, TLC
Camilla Carpenter, Account Executive, TLC
Denise Williams, Production Manager, TLC
Carol LeBlanc, VP, Licensing
Elizabeth Bakacs, VP, Creative Services
Maren Herzog, Creative Manager
Caitlin Erb, Licensing Specialist

Special thanks to Steven Sloane Newburgh, Fowler White Burnett, P.A.

All of us at Meredith Books are dedicated to providing you with information and
ideas to enhance your life. We welcome your comments and suggestions. Write to
us at: Meredith Books, 1716 Locust St., Des Moines, IA 50309-3023.

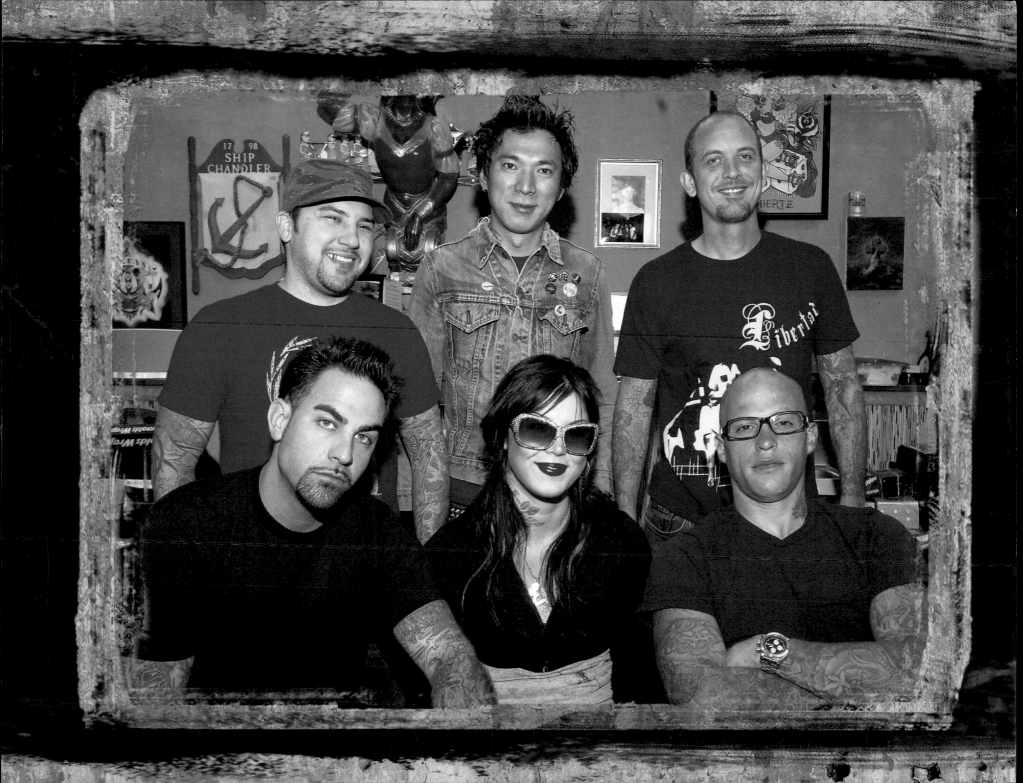

Ami

Garver

Nuñez

# Table of Contents

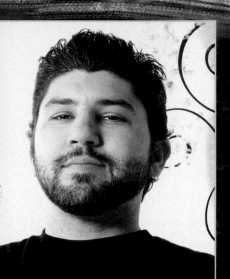

*Darren*

*Kat*

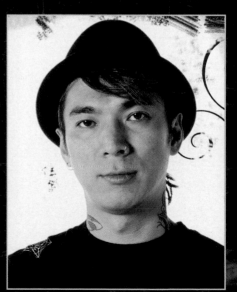

*Yoji*

# South Beach Style

It's the color. No, maybe it's the air. Either way, for an artist working on South Beach in real time in the real world, the vibe, the whole experience is pure creative inspiration.

The color palette, clear and bright during the day, is one-hundred-percent dedicated yellows, greens, reds, and blues. Each stripe of the rainbow boldly states its presence. And then during the long evening, the night brings on shimmering deep purple and black opalescence—cut by brilliant neon flashes that zigzag like a stock market chart. Overhead the stars just seem brighter. The air feels soft, carrying moisture nurtured by the Gulf Stream that flows a few hundred yards off Miami's plate of sandy beaches.

This is the setting in which an artist's sense of space and time, color, and energy is aroused, enhanced, and reinforced. This is the setting in which the artists of *Miami Ink* thrive.

South Beach—nicknamed SOBE by its inhabitants—has risen, fallen, and risen again since its beginnings as a relaxation destination nearly 100 years ago. It became an Art Deco treasure of design and architecture in the 1920s and 1930s, only to fall into disrepair and neglect. Then in the late 1980s and early 1990s, a cadre of beautiful people—Versace, Madonna, movie stars, and supermodels—rediscovered the area, reestablishing it as a leading edge of architecture, fashion, and style.

> *South Beach has been called the American Riviera, an Art Deco playground. In the last decade, the area has taken on new life as a big, ultra-chic, 24/7 street party.*

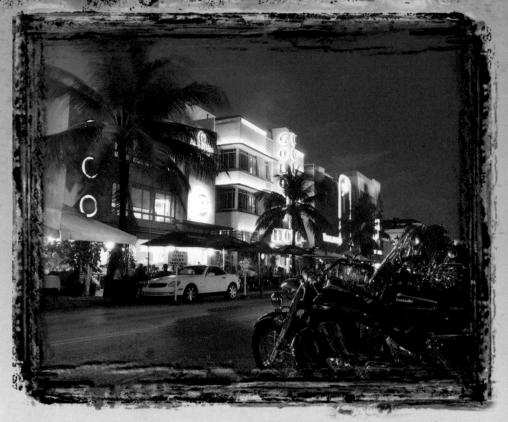

Every night of the week, tourists and locals alike cruise the brightly glowing strip of Washington Street, the main drag through South Beach, often hanging out at shops, restaurants, bars, and clubs until early in the morning.

A mile north of South Beach there is an assumed but unmarked boundary, where the glass-sheathed condos and resort hotels of Miami Beach suddenly crop up, setting the pace for the Gold Coast ocean communities that line the shore all the way up to Palm Beach. But in South Beach the look and feel is bold yet relaxed. The painted plaster, two- and three-story structures follow the rule of three—a hallmark of Art Deco architecture. For example, the windows on the original period buildings run in rows and columns of three. The look is strong and rectilinear, with capped construction that features stepped parapets where gargoyles might have perched in an earlier time. Most important, though, the buildings of South Beach have stood up—and

continue to stand up—to seasonal storms, driving rains, and hurricane-force winds that bounce off their facades every few years.

Early morning for a South Beach tattoo artist is noon. Their shops begin to open around lunchtime for another 14-hour day, which will end around 2 a.m. when night crawlers are still an hour or two away from thinking about rest. In the early afternoon, casually toned open-air cafes begin to fill with men and women who appear free of the facial stress lines taken for granted in most cities. Traffic-stopping young women meander along the sidewalks between the funky shops and casually chic restaurants that have become important elements in the South Beach coat of arms.

Fifteen years ago—the old days in this sybaritic village within a beach town within a sprawling metropolitan area—there were only four tattoo shops. Times have changed, and now there are many. Today scattered among the clothes shops, restaurants, bars, and the Royal Palm-accented sidewalks,

The orange and purple neon tattoo sign atop the unassuming facade of the *Miami Ink* shop flashes well past midnight, as the artists work in the shop creating new tattoos for visiting clients and night owl locals.

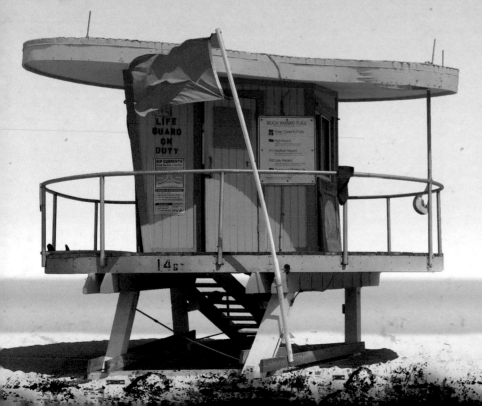

you can find a dozen shops devoted solely to the art of tattooing.

But in the spring of 2005, the history and heritage of South Beach tattooing was focused on a single shop. This was the day when neon tubes that spelled "TATTOO" first flickered over a formerly nondescript storefront on Washington Street. This was the day four artists, friends from their early days of training in the original South Beach tattoo style, came together again. This time as partners. This time as *Miami Ink*.

# Four Plus One

They felt the sting of tattoo needles and received their first tattoos as kids in different and distant towns—Pittsburgh; Tel Aviv; Waterbury, Connecticut; Miami Beach; and Tokyo. What were the odds that five young guys—Ami James, Chris Garver, Chris Nuñez, Darren Brass, and Yoji Harada—who were born within two years of each other, who had forded their individual paths through tough adolescences, would come together in South Beach, Florida, and emerge as a group of nationally celebrated artists who make tattoos?

But how did they get to *Miami Ink?* The answer is a little like that old saw about a tourist asking directions in New York City. ("How do I get to Carnegie Hall?" "Practice!") And they did practice. They worked in shops, they refined their drawing abilities, they learned how to handle the equipment, and they practiced the strokes. Yes, they were favored by mentors, but they practiced and drew more tattoos.

As these five young men began to know other artists and learn from them, their individual paths began to cross. They met at first almost by accident, but then with more frequency as they moved around the U.S. and the world in personalized orbits, developing their crafts and building their careers.

*Individually they were each leaders, but as a group, they were a lot more than five personalities. They were an unbeatable, unmistakable team.*

Navigating through the complex professional world of the tattoo arts, they began to connect with each other. Their friendship flowered and then in the late 1990s they found themselves all working at the same shop in South Beach for a year.

There were laughs—a lot of them—and action and music and a beverage or two. There was even some money earned. But then they moved on

once again, spreading out across the country. There was more work, long hours, new stresses, exciting projects, and the experience of watching, learning from, and hanging out with other artists.

When conversations first took place concerning the creation of a television show about a group of tattoo artists, Ami James was one of half a dozen people sitting at the table in a New York restaurant. He was the one who actually did tattoos in the group, and the inevitable question, "Any friends in the business?" quickly arose. Immediately Ami called the four other people he knew who could make the project happen. And had it been Darren Brass, or Chris Nuñez, or Chris Garver at that same

table that day instead of Ami, it still would have been the same foursome.

From the producer's point of view, they looked perfect for television. Ami was "tough but fair," Darren Brass was "the lovable one," Nuñez was "the ladies' man," and Chris Garver was "the intellectual." And then there was Yoji, "the loyal apprentice." They were a lot more than five personalities. They were an unbeatable, unmistakable team.

Eight months later, the group officially became *Miami Ink* and opened for business on bustling Washington Street. Their little shop is the location of the TLC television series. It's the place where they show off their distinct talents on a weekly basis. But from the beginning, this shop has been more than a set for a TV show. *Miami Ink* is a real needle-and-ink shop, open for business day after day, and put together by "four of the greatest artists, and five of the best friends" in the business.

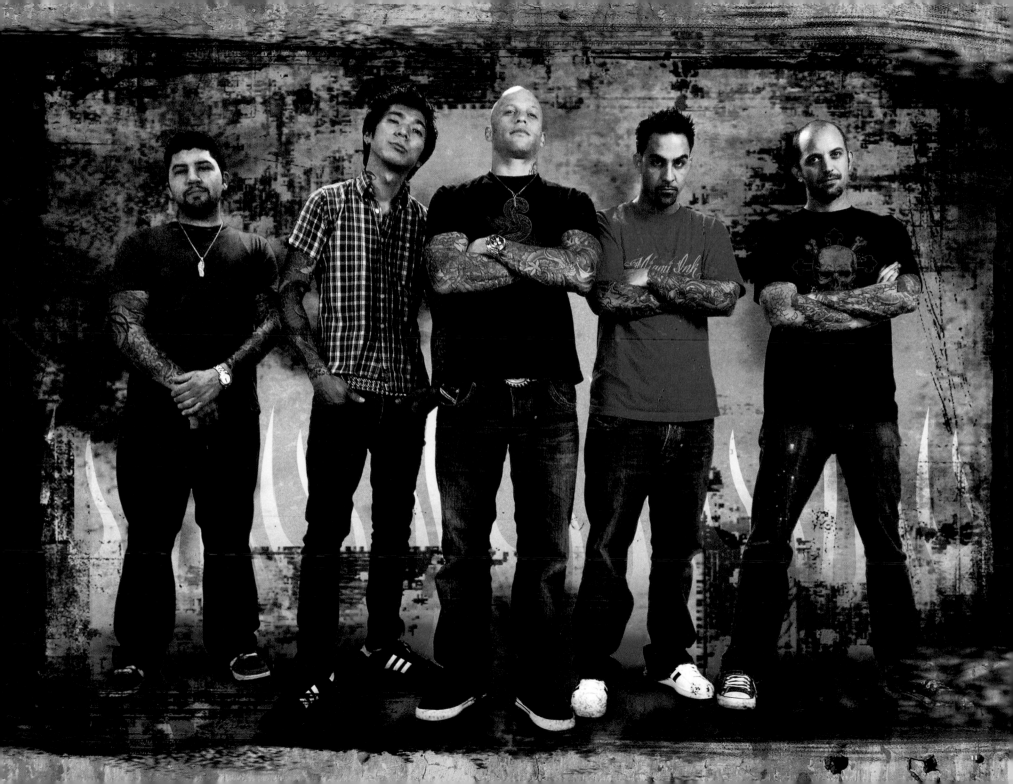

# Renovating the Shop: Making a Space a Place

**Y**ou could call it another glorious day on South Beach with the bright afternoon sun tempered by a soft, on shore breeze. But behind a door on Washington Street, the dust was rising and tempers were flaring.

Inside the small shop was a gathering of four of the best tattoo artists in America. Ami, Darren, Nuñez, and Garver had come together from New York, Boston, and Los Angeles to their emotional home office—South Beach, Florida—to get it done.

Their friendships were solid and long-lived. Over the years they had worked together, competed with each other, bumped into each other on the tattoo trail, and shared a lot of laughs. These guys (along with a music-loving apprentice who was still not certain that tattooing would be his life's work) had come together for a chance to be

partners in a true adventure—to work together and build their own business, *Miami Ink*.

This was, however, the first time they had worked together on a construction job. Time was getting short with only days before the opening. Not only did they need to transform a space into a working tattoo parlor to start serving clients, but TLC also wanted to film them for a new reality television series. A production unit with cameras and sound equipment would be on hand for the renovation and opening. Filming of the show's first season would follow immediately. They had to build their business from the ground up—literally, because they were starting with only the floor and the walls. This wasn't going to be easy.

On the noisy and dust-filled construction site, there was tension

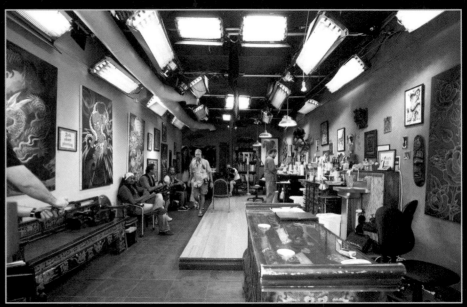

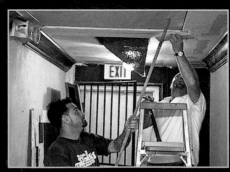

After stripping down the space to bare walls, the guys built a soundproof platform on which they can comfortably work on clients and film the show. Major ceiling and plumbing repairs were followed by hours of finish work—painting, laying tile, and outfitting the workstations. The final look is exotic, Bohemian, and hardworking.

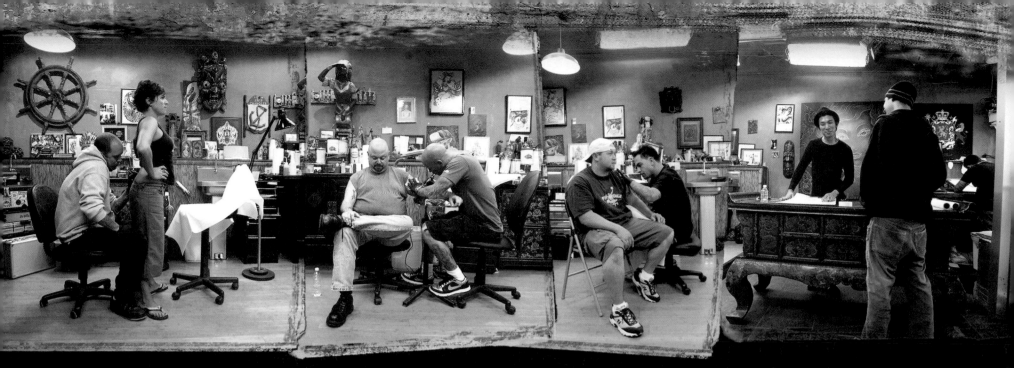

and jokes and things that probably shouldn't have been said. But more often than not, there were apologies as well. Somehow the guys made progress each day. Flooring was laid, floors were swept; drywall went up, floors were swept; new windows were installed, floors were swept; the back rooms (including a bathroom and small office) were completely reworked and painted and, oh yes, the floors were swept again. Final touches—painting display pictures and putting everyone's personal mementos in the right positions—were completed only minutes before the doors opened to friends, family, and potential clients.

Ami played the role of taskmaster among equals during the construction phase. Soon the guys made sure that the "space" became a "place."

*"We are the way we are, and we're always going to be that way—with the jokes and the tension and the upset style that we have with each other in a weird way. But it's tough love. It's exactly what I thought it would be."*

**—CHRIS NUÑEZ**

*We had some rough times, you know, just getting through everything ... The whole buildup of the shop was tough. We were working long days—just blood, sweat, and tears for a good month. It was rough, but you know it made it*

*that much better. Just being able to get through to, "Yo, here it is. This is for us. This is our shop. This is where we're going to do what we got to do." We put so much hard work into the shop—and I mean we busted our asses. We put in more hours of work than I've ever done on anything in my life. That shop should have taken us at least three or four months. We did it in about a month. With 14 to 16 hours of labor every day with just me, Yoji, Chris , and Darren. There's no way we're letting this go down the drain, not after putting this much effort into it.*

# Making the Show: Getting Real

Construction dust was still settling in the shop as designers, electricians, and lighting experts from TLC began setting up and turning on the power needed for television lighting. In a few days *Miami Ink,* thanks to the heavy lifting of the four artists and their apprentice, would be a very real day-in and day-out tattoo shop. And a lot more. The shop is also the primary set and the artists and apprentice the principal players in a weekly television show loosely labeled within the industry as reality TV.

A weekly television series about a group of tattoo artists? Absolutely. In some ways tattooing has become the NASCAR of the arts. Immensely popular with a dedicated public and long considered a little out of the mainstream, tattooing is, in fact, representative of the drive of the new century. A statistic tells the story: One

out of every seven adults in the U.S. sports a tattoo. And tattoos as art are becoming increasingly popular among celebrities, athletes, and "regular, everyday" people, who have a statement to make or a memory to preserve.

The television production unit assembled in South Beach to record the colorful, painful, intriguing world of the tattoo arts was charged to get the real story by allowing the artists to be artists. It's a weekly documentary, not a theatrical creation. *Miami Ink* as presented to a nationwide audience is the same *Miami Ink* that is open for business long after the television cameras shut down in the evening and at the end of a season.

And it takes talented people to accomplish this goal. While the shop was being readied for business, TLC set up production offices in several South Beach locations. The director's control

Making a *Miami Ink* episode requires dozens of skilled professionals (clockwise from top left): Floor producers prepare for shooting; sound technicians mix audio from numerous microphones; directors watch simultaneous video feeds; sound technicians attach personal microphones to clients; producers preinterview clients.

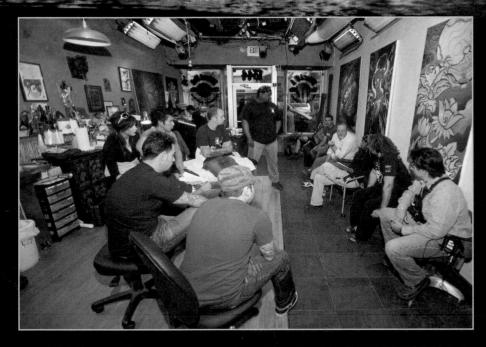

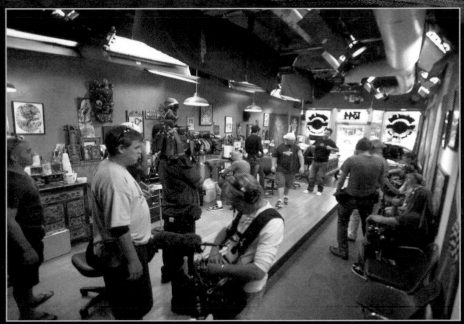

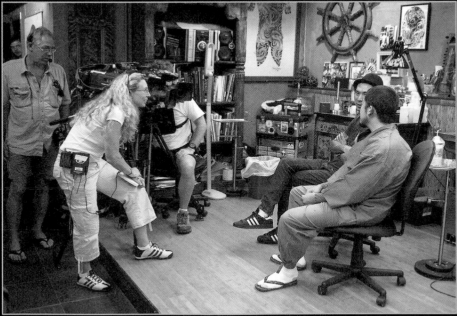

Top: During the early morning production meeting, the artists and crew discuss the day's list of clients to work on and segments to be filmed. Bottom: A director offers helpful questions and suggestions to Yoji and visiting tattoo artist Shinji Horizakura during the filming of a segment.

Top: The cast and multiple camera crews prepare to shoot several simultaneous tattoo sequences in the shop. Bottom: Darren and Garver chill outside the shop while Shinji and Yoji grab a quick lunch in between filming segments. Of course, a camera is still running to catch any interesting bits of dialogue or interaction.

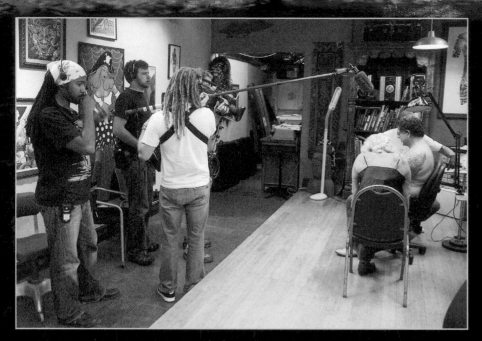

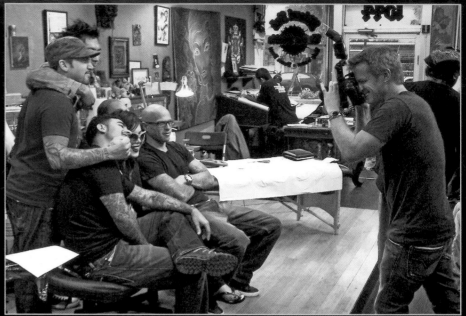

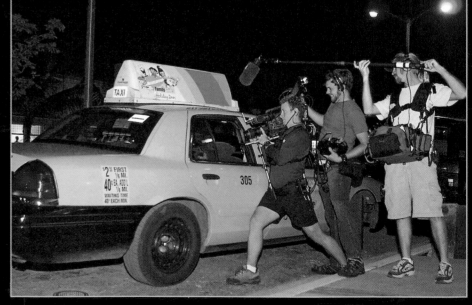

Top: Under the watchful eye of a floor producer, an audio and video team films the process of a client receiving a *Miami Ink* tattoo. Bottom: Cast wranglers shuttle the artists and clients between filming locations and do about anything necessary to keep the show running smoothly and seamlessly.

Top: During a break in filming, the cast poses for an impromptu group shot to promote the show. Bottom: To capture an action shot at the end of a long day of filming, an audio and video team focuses attention and their equipment on a cast member pulling away from the shop in a cab.

room was created in a room above the *Miami Ink* shop and linked to the main floor through ceiling-mounted cameras and microphones so the director can be privy to every move and sound while filming a segment. Throughout the filming of individual episodes, three crews, each with a cameraman, audio supervisor, and segment producer, document four or five individual tattoo creations each day.

When *Miami Ink* isn't under the watch of cameras, the artists' day begins around noon with breaks at the convenience and desire of the artists. The workday often goes until one or two the next morning. Of course, things happen and unscheduled changes take place. It's just the way it is. But during production, the artists' schedules become more rigid than anything they ever anticipated. Each morning there's a story meeting at 9 a.m., a production meeting at 10, and camera work begins at 11. The typical production day ends around 8 p.m.

Tight schedules are maintained for the artists for pre-tattoo and post-tattoo interviews. The same tight schedules hold for the clients, along with fairly rigid times for developing sketches and doing the actual tattooing. In the production offices, interview questions are framed, transcripts are typed, camera shots are cataloged, dates are set for clients for upcoming tattoos, client audio interviews take place, video tape is reviewed, and preliminary cuts are indicated by the directors and their teams of technical support people.

All of this effort goes into capturing a reality that is perhaps more real than most shows that call themselves reality television. For the artist, creating a tattoo is to capture time. Tattoo ink, etched into an image, is there to stay. It's not going to be erased or knocked down and drawn again. It's a keeper. And the pressure for the artists and the TLC crew and the clients is considerable. It is an art. It is real.

  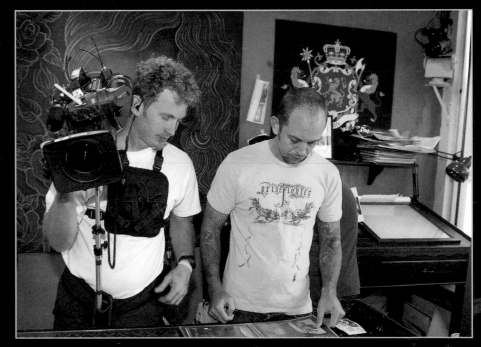

**Left:** Overhead cameras throughout the shop capture overall shots of on-set activities. **Right:** Lipstick cameras, which can be attached to workstations or even cast members, capture up-close detail shots.

**Above:** A camera operator and artist Chris Garver review source images for a tattoo project in preparation for filming b-roll (filler footage captured without audio) for one of the show's segments.

# Celebrate!

**T**he TV production crew was in place, the shop was almost ready, and items on the final to-do list for the opening-night party were slowly getting checked off one by one. Ami, Darren, Nuñez, and Garver were edgy and excited. In a few hours their shop would open to the world and officially become *Miami Ink*.

The final few days had gone blazingly fast—and there were still a few rough edges to smooth out. For one thing, the large graffiti- and tattoo-inspired acrylic paintings for the walls (created by the artists only a few days earlier) still needed finishing detail. But the big moment was almost here. Invitations and press announcements were in the right hands, and everything was coming together.

And then Yoji had a problem. At 2:30 in the afternoon, with the temperature hovering in the mid-80s, he hauled two "boats" of fresh sushi into the shop, looking for a place to keep the food until the party. Ami could barely contain himself.

*Sushi needs to be cold when it's served. And he was going to set it in this shop? And then there were cartons of little crispy dumplings all over the place. By the time the party started, they would have been soggy. And I just looked at him and said, "What*

## There wasn't a formal ribbon cutting. The guys just finished setting up the shop and threw open the door.

*are you thinking? What are you going to do with these big-ass sushi boats?" They don't fit in the fridge, so he runs over to the next-door restaurant where they had big coolers. They let us keep the sushi in there, thank God, because we would have had to throw it away. Nobody wants to eat raw, hot tuna.*

The sushi situation resolved, there were a few other things to do, including hanging up a *Miami Ink* sign in the window. A custom sign had been ordered from a local sign printer, but when it arrived a few minutes before visiting friends and guests, the results were underwhelming at best.

*Yeah, our great Miami Ink sign. We hired a guy and paid him a whole bunch of money to make a sign for a window. You figure he's going to make sure it's correct. That he'll make sure it's on line and that all the letters are the same size. It was a disaster—it's not even red, it's orange! The stars are crooked. It'll have to be replaced. But we have no Plan B, so we'll hang it in the window, at least for the party.*

There wasn't a formal ribbon cutting. The guys just finished setting up the shop and threw open the door.

Whether it's celebrating the opening of their shop, welcoming tattoo artist Kat Von D, or promoting their friends' new South Beach businesses, the men of *Miami Ink* know how to have a good time.

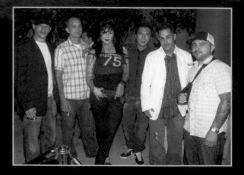

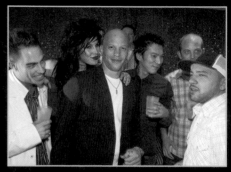

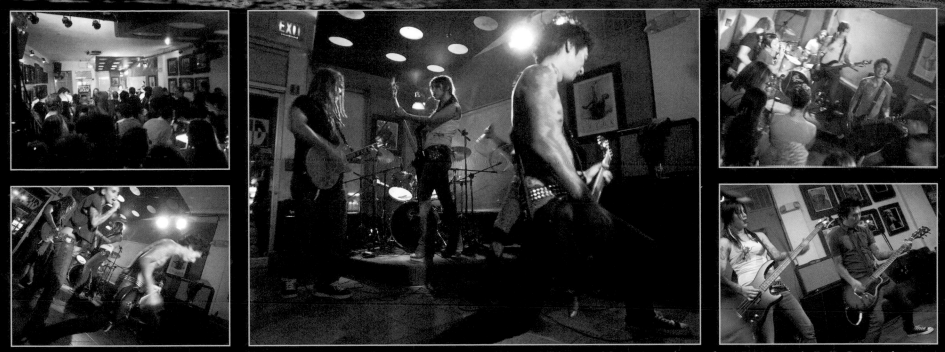

To celebrate the second half of the first season of *Miami Ink,* Yoji pulled together a group of guitarists, a singer, and a drummer; held a single, intense rehearsal; and hosted friends and clients at the club next door for a night of rockin' tunes that the guys and their guests aren't soon to forget. Even tattoo artist Kat Von D got into the act as part of the impromptu band, flexing her musical muscles and playing some wicked riffs.

Simple but effective because in moments the *Miami Ink* opening party was under way. The shop filled quickly with people and talk, laughter and music. And no one would have been surprised to hear, "Wine for my men, tomorrow we ride!" Now was the time to celebrate because the next day at noon the shop would be open for business. The party was a good time and a huge success—and Ami was pleased.

*It was a lot of fun. And, you know, I was happy that all of our friends were there. We could have made it bigger. But it was cool. I was happy. We were all pretty happy with it.*

The real party was only beginning because for good friends, the party doesn't necessarily have to end. In the weeks that followed, a number of one-day "pressure-relief outings" took place. There was a trek down to the Keys, marlin fishing, a day on the beach, and miniature car racing. And there were also the spontaneous tension breaks and celebratory nightcaps at Club Deuce, a dive bar around the corner where tattoo artists have hung out for more than 20 years.

After the shop had been open for six months, the guys decided it was time to host another party to celebrate their initial success and officially welcome tattoo artist Kat Von D. Because Yoji was a professional guitar player since his childhood in Tokyo, he hosted an evening of metal and punk music at the small nightclub next door. (Nuñez had tattooed the bartender.) Although still a tattoo apprentice, when Yoji picks up his electric guitar he is very much the lead. In one afternoon he put together a party band that included Kat on electric bass, a girl singer with a big voice and a high octave range, and one of Garver's clients on drums. A few days later (after a single rehearsal), music exploded from the club next door, Jazid, and people rocked in a small room under a low tin ceiling. The place was jammed, the night was warm, and everyone was in their rightful place in SOBE.

# Equipment and Accessories

One of the final things to do before opening day at *Miami Ink* was putting all the tattoo materials and sterile equipment in the appropriate places. An autoclave sterilizer was moved in, containers for toxic waste (known as "sharps") were set up, and individual worktables were placed in each artist's station. The most important goal in setting up a tattoo shop is to prevent cross-contamination. This takes real effort because tattooing, by its very nature with needles, wipes, inks, salves, and human blood, has all the elements to create a contaminated workplace. In fact, tattooing requires the same high level of sanitation as is present in a first-rate dentist's office.

At *Miami Ink,* everyone is involved in ensuring a safe and clean shop, especially Yoji. His job as apprentice is to scrub and set up the shop before opening each day, and then to break down and scrub the shop again at the end of each day; he also scrubs down stations between every client session. For their parts, the artists have their own silent checkpoints and standards. They pay attention to everything at every step, ensuring that all supplies are clean and safe. The stencils, marker pens, and ink must be safely discarded after each session. The same goes for gloves, wipes, salves, gauze, and bandages. Ink cups and needle sleeves are sterilized in an autoclave after use and stored in sterile plastic wrap or film. Needles (new from a sterile package for each use) are broken and discarded as well.

Tattoo artists lay down tattoos by injecting ink into a person's skin with an electrically powered machine that looks like—and hums like—a dentist's drill. The machine moves a solid needle (or a cluster of needles) up and down to puncture the skin at between 50 and 3,000 times per minute. The needle is punched about a millimeter into the skin, leaving a drop of ink with each strike. The machines are quite simple and haven't changed much since the late 19th century, when Samuel O'Reilly adapted a machine invented by Thomas Edison to engrave hard surfaces. In fact today's motor, tubes, and needles are still very similar to the ones first used by O'Reilly.

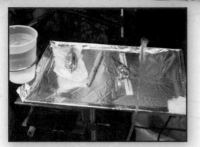

Foil and plastic-topped worktables hold sterilized equipment to be used during a tattoo session.

Latex or vinyl gloves are worn throughout the tattooing session by the artists. They are discarded immediately following use.

Petroleum jelly lubricates the skin and keeps it moist during tattooing.

Plastic razors lightly shave the skin area to be tattooed. They're disposed of after each session.

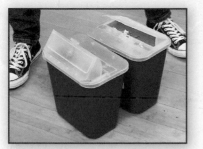

"Sharps" containers are biohazard disposal units with sealed lids that prevent the contents from being removed. A clamping system breaks needles prior to disposal.

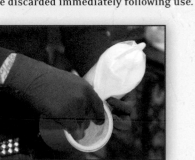

Spray bottles hold alcohol used during the prep stage as well as "green soap," a strong germicidal soap that cleans up excess ink and blood during sessions.

Washout cups hold clear water for rinsing ink from needle tubes during use. Rinse water is disposed of in a special container after each session.

Plastic cups hold the inks during a tattooing session; one color per cup. Leftover ink is discarded.

Each station is outfitted with a power supply box that links the handheld tattoo machine to a power source. The box regulates the flow of electrical current for smooth operation.

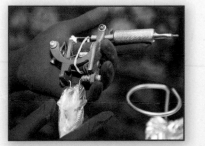

Tattoo machines drive the needles at controlled speeds to put ink pigments into the skin. Machines have several elements—an electric motor, a sewing machine-type foot pedal that controls the machine's power line, a tube system that draws ink through the machine, and a sterilized needle or cluster of needles.

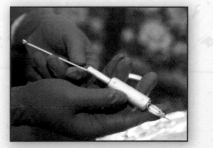

Needle tubes are small sleeves that fit onto the tattoo machine to guide the needles. These reusable tubes are autoclaved (and sterilized) after every use and then stored in sealed, sterilized packets.

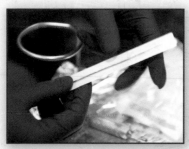

Various thin metal needles, soldered onto bars of different widths and lengths, are used, depending on the style and type of work. Every session begins with new pressure-packed needles. Needles are dipped into ink—much like a paintbrush being dipped into paint.

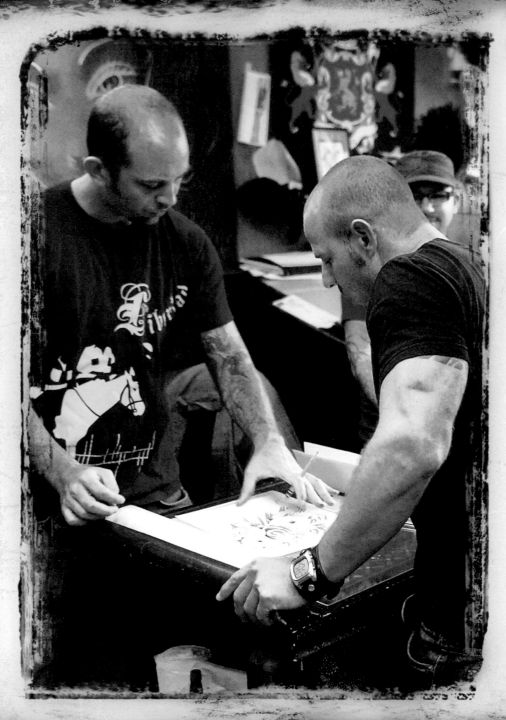

# Consultation, Sketching, and Closing the Deal

At *Miami Ink,* a new tattoo always begins with a conversation. When something is being made out of air, something that hasn't existed before—whether it's a picture, a song, a poem, or a dance step—there has to be a beginning. So it is with a tattoo.

If you hang around *Miami Ink* for an afternoon, you'll hear fragments of opening conversations. "What are you thinking about?" "Maybe if we do this to it … " "Smaller might be best." And, "No, it'll look like mush." The first order of business is making decisions: getting specific about the subject of a tattoo, its location on the body, and its size, colors, and style. This exchange between customer and tattoo artist serves several ends. It begins the connection between two people who are going to be intimately involved with each other, at least for a while. It gives both the artist and the client a chance to decide if they really want to work with each other. It brings in another experienced viewpoint to an idea or emotion that is to be permanently marked on another body. And most important, it creates an agreement, a mutual understanding about the work to be performed.

This understanding is critical because the work is going to be part of the client forever. This is no time for a "failure to communicate." For example, when Chino came into the shop wanting a tattoo to celebrate his wedding anniversary, Garver took a few minutes to discuss the project and convince his client that he needed to put a little more thought into the piece. Looking at it through Garver's eyes, Chino agreed to step back for a moment.

*I came in with an open mind. We've been married for 10 years, and the idea was for a tattoo about our life.*

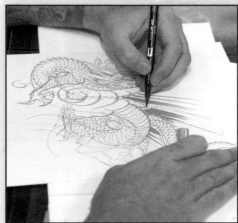

*But Chris said that I really need to concentrate on what I really want and put more thought into it. I wanted maybe a tribal sun symbolizing a new beginning in life and maybe a Japanese symbol for longevity to go with it. But I want it to make her happy. I have to put some more thought into it. I'll be back tomorrow.*

Sometimes a client's ideas quickly take shape during the consultation. For example, a music producer with an idea for interpreting the album art of his newest CD sat down with Ami, and in 10 minutes, they had a strong plan for a complex design in place.

*Actually, my consultation went well. [Ami] was really professional. He took a look at the album and really made some good suggestions. I'll see his sketch tomorrow. I have a good feeling about it.*

Candor counts. Because a tattoo is a permanent mark or collection of marks on one's skin, the honesty of the artist becomes very important. There are things that just don't or won't

Although custom tattoos often begin with freehand sketching, most tattoo designs also involve tracing paper, a photocopier, and a lightbox.

work. Where a tattoo should be placed, how it will look as the body moves, how coloration will change, and the permanence of the emotion (Will you really love her forever?) all contribute to the tattoo experience. Chris Nuñez has

*"Someone comes in with an idea, and then it's up to us to work with them, talk it over, take that idea, and put it onto paper and then onto their skin. That's our job. That's what we do."*

**–AMI JAMES**

clear views of his responsibility—and the responsibility of the client.

*It's my job to make sure the tattoo goes on clean and stays clean. It's her job to pick what she wants to do. And when there are things that I know are just not gonna work out, I tell my customer that it's not the way to go. Nine times out of 10 they listen, usually 10 times out of 10. But if it's*

*something they're really insistent on and I don't want to do it—I don't think it will work—I just refuse it.*

Turning a client's words into lines, shapes, and color—indeed, giving substance to imagination—requires skill and patience. And several checkpoints. First, client and artist must agree on the concept and the indicated treatment. Next the artist needs to draw the sketch. Then the artist (or apprentice) must turn the sketch into a transfer pattern so an inked design can be positioned and serve as a guideline on the body.

After a rough drawing is completed and agreed upon, the artist or apprentice either traces the design onto copying paper on a light table or turns it into a stencil. The tracing itself demands a tight focus and steady hand. Making a stencil by inserting the tattoo design into a thermal fax or copy machine and transferring a drawing onto special thermal paper is an easy alternative that saves hours of tracing. And when the tracing or the stencil is ready, it's time to transfer the working outline onto skin.

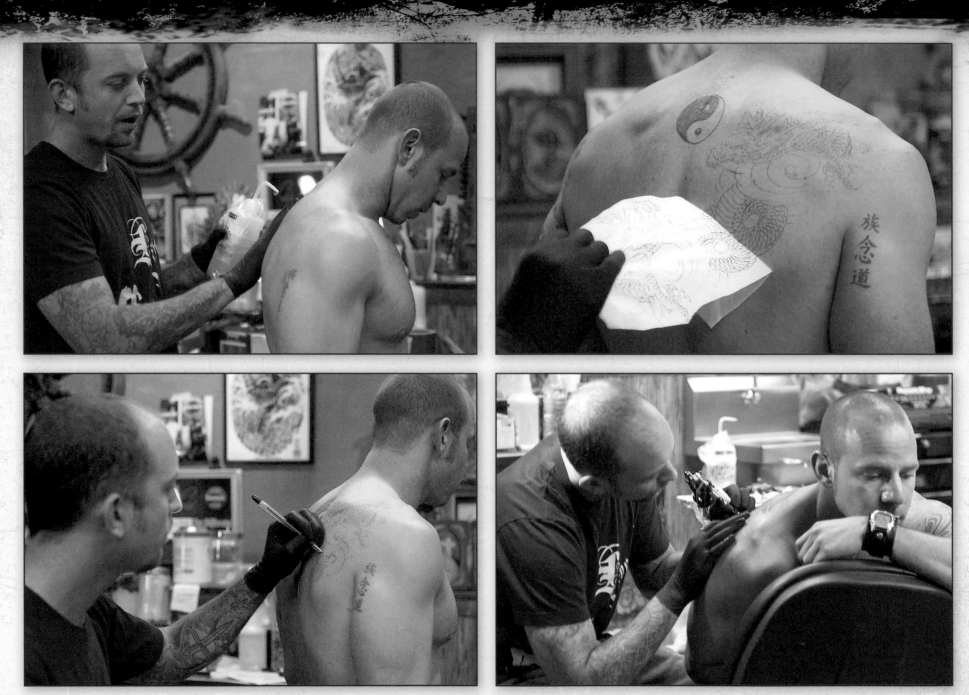

After a design is printed to transfer paper or made into a stencil, the artist cleans the destination site for the tattoo on the client and applies a thin coat of water. The artist then presses the paper (or in the case of a large design, several pieces of paper) onto the moist skin. The water temporarily adheres the paper to the client and transfers the ink to the skin. After removing the paper, the artist fills in fine details and any missing portions of the design with an ink pen or permanent marker. After everything is dry and the client is made comfortable on an adjustable chair or table, the canvas is ready for the artist to begin creating a new work of art.

# Transferring Images and Tracing Outlines

Transferring the temporary working outline onto a client's body is a major tattooing rite of passage. The tattoo is finally happening. For the first time, the client gets a sense of how the design will look and how it will work with the body. This is a fail-safe moment—from here on, it gets real.

First, however, a little more prep work is needed. The area to be tattooed is washed with soap and water, or treated with rubbing alcohol. The area is then shaved with a razor that is discarded immediately, and the skin is again wiped clean. Stick deodorant is liberally applied over the area to be tattooed in order to moisten the skin and firm up the outline. The paper or stencil of the tattoo is positioned, carefully rubbed to transfer the image, and then slowly pulled away from the skin, leaving the outline of the tattoo. A little more ointment is spread over the outline, which accomplishes two things: It protects the design from being accidentally rubbed off, and it prepares the skin to help the needle slide smoothly along the outline.

The tattoo machine is made ready, needles are put into place, ink is poured into small sterilized cups, and the artist

> *"I think the most important thing is to keep tattooing safe—to protect yourself and your customer."*
> **—CHRIS GARVER**

slips on a fresh pair of gloves. And as Chris Nuñez says, it is finally "make-your-magic time."

The first stage of the actual tattooing, the creation of the outline and any detailed linework, does hurt—at least a little until the endorphins kick in. In fact, the needle barely enters the skin, slightly less than 1/16th of an inch, reaching just beneath the thin epidermal layer. Clients typically get into a zone early on in the process, and outlining proceeds smoothly.

While the tattooing proceeds, the artist constantly wipes the skin of any traces of ink or blood. As the artists point out on the show, every part of the tattoo process is done with an eye toward maintaining a sterile working environment and preventing cross-contamination. Tubes are sterilized, bagged, numbered, and dated. Machines are rubbed down with disinfectant after each session and again at the end of each day. Pens and permanent markers that have been used to draw on skin are discarded, as are gloves, towels, and inks. And anything that's not disposable is sterilized in an autoclave and covered with thin transparent wrap.

## Making a Transfer
**Because the process is largely mechanical, design transfers are often executed by an apprentice. A thermal fax machine uses heat to transfer ink to a piece of paper, which can then be applied directly to a client's skin.**

# Brushwork, Coloring, and Aftercare

One of the unusual things about the art of tattooing is that the brushwork is done not with softly textured brush tips, but with a high-powered, handheld machine. Brushwork demands finely tuned eye-hand coordination to control the machine and lay down the shadings, tones, colors, and highlights that turn a tattoo into art.

And there are, of course, limits to the length of a session. A painter can work brushes over paper or canvas for days without hearing any complaints from the surface. A tattoo-receiving client responds directly to the needles.

This sensitivity dictates the length of a particular session. At *Miami Ink,* some sessions range from 30 minutes (for Kanji or a single word such as mom) to as long as 10 hours for intricate major pieces, such as a back piece or a Japanese-style sleeve. Important pieces are usually created during several visits spread out over a period of weeks. (Applied work takes a week to 10 days to heal before any follow-up work can be done.) Work on major projects is often spread out over years. Ami James has been working on a customer, adding constantly to the work, for nearly three years.

Chris Garver feels improvements in the equipment and materials in recent years have made the length and intensity of sessions much easier on both clients and artists.

*Today we have a great selection of different types of needles. This means you can do a superthin line, or you can do really bold lines. Shadings and tones can be more complex. There are more needle sets, called magnums, designed for shading and toning and*

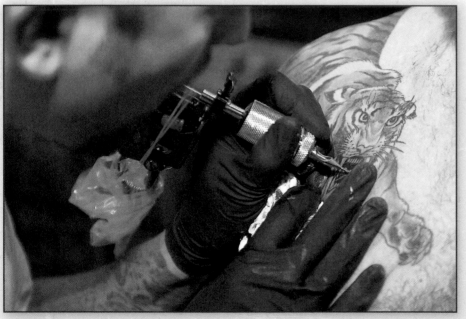

After the outline is complete, the artist switches needles and begins filling in various spaces with colored ink, often starting with the darkest color and working toward lighter colors. Excess ink is constantly wiped off.

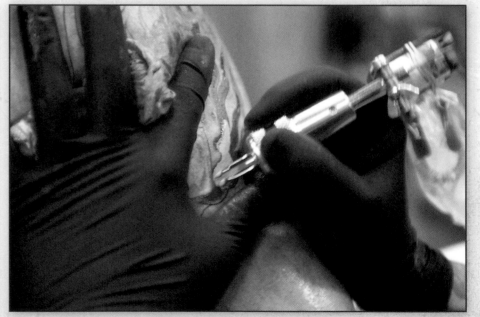

Using an application technique similar to painting with a brush, the artist can apply thick or thin layers of color, blend two colors, or work black or white ink into colored areas to create the illusion of shadows and highlights.

laying in color. And the colors are a lot better than they used to be. Tattooing is more versatile than ever before.

At the completion of a session, whether it's a partial piece with more to come or a finished tattoo, the work is wiped carefully and coated with a barely visible layer of petroleum jelly.

Several times a day, as sessions wind up, the call goes out for Darren Brass to give the message on aftercare. Darren has become the voice of *Miami Ink* on this topic. When Darren clears his throat, the room goes silent.

What you do is you leave your bandage on for an hour and a half to two hours; you take the bandage off and hop right into a nice hot shower. A hot shower is the best thing you can do for a tattoo. Couple hot showers a day, best thing you can do.

Once you're in the shower, you want to wash your tattoo well with soap and water. Just soap up your hands really well. Pretty much you can wash with any soap. A mild soap is of course better. It won't irritate it as much. But generally I recommend you use

whatever soap you're used to as long as it's not a heavily perfumed soap. A good antibacterial regular soap is fine. You don't want to use any sort of washcloth, you don't want to use a loofah sponge, anything like that. Just soap up your hands and wash your tattoo. Spend a couple extra minutes in the shower; let the hot water really hit the tattoo. That's great for it.

Once you're out of the shower, pat your tattoo dry with a towel. Pat it dry, don't ever wipe it. Once you do start to scab, you don't want to pull any of the

scabs, so just pat it dry. Then for the first two days, about two or three times a day for the first two days, you want to put on a very thin coat of Vitamin A and D ointment.

After the second day of using that, you're gonna stop, and for the duration of the healing of your tattoo, you're gonna put a fragrance-free hand lotion on three or four times a day.

And with the lotion, as well as the ointment, put on a very, very light coat. If you can see it on there, you've got way too much.

*"People need to relax and that's the thing. When you're being tattooed, you don't want to stress yourself out. You don't want to anticipate feeling the needles. You just want to go in nice and relaxed and you're gonna have that much easier of a sitting."*

—DARREN BRASS

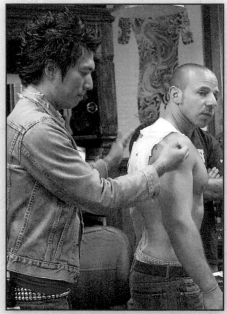

New tattoos are lubricated with petroleum jelly and covered with a waterproof bandage or sheet of plastic for several hours to allow the skin to heal initially and retain as much color and detail as possible.

# Sources & Influences

You need to know only one really important historical tattoo fact: As long as there have been people, there have been tattoos. That's pretty much Tattoo History 101. As for the different styles of tattoos, the ones you see today represent varying cultural sources, not chronological or historical differences. The kinds of tattoo art being created at *Miami Ink,* for example, have been inspired and influenced by attitudes and actions in eastern Asia (specifically Japan and China), the islands of the South Pacific, South and Central America (notably Brazil and Mexico), North America (Native Americans), India, much of Europe, and central Asia.

Human beings, from the beginning of time, seem to have had an innate need to decorate their bodies. In many cultures, tattoos have served as marks of identity. In the South Pacific tattoos were (and often still are) marks of power or domination. Ink was used to

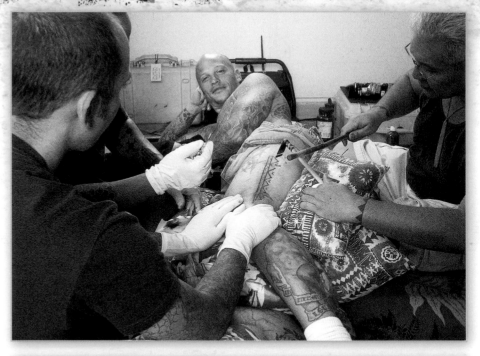

brand outcasts and criminals in Japan and throughout Europe. And in India small, simple marks were indicators of class for centuries. While the acceptance and popularity of tattooing as an art form, or as an administrative notation within various cultures, has waxed and waned over time, it has never disappeared entirely.

Shortly after opening *Miami Ink,* Ami James and Chris Garver flew to the island of Oahu to fulfill guest artist commitments at a Honolulu tattoo shop. While there, they learned about tattoo history and received traditional Polynesian-style tattoos from artist Keoni Nunes. Tapping into their skin with traditional hippopotamus tusk sticks, Nunes created personalized designs for Ami and Garver.

**Keoni's tattoos for Ami include the Niho Niho for protection, a Pawehe design for Ami's ability to bring many things together; and small Kapua'i, which represent the footsteps of his ancestors. Garver's designs from Keoni include the Niho Niho for protection; a Pawehe design that represents his ability to bring many things together; a Kaona design, which symbolizes knowledge acquisition; and a Koa'e Ula design, a seabird, for safe return after traveling.**

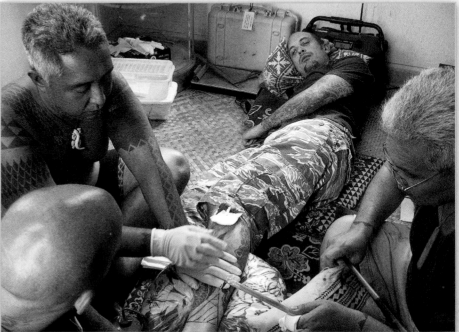

# Polynesian Tribal Art

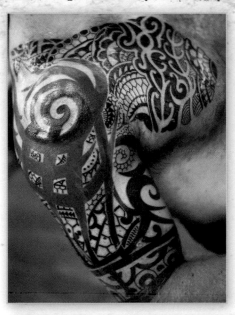 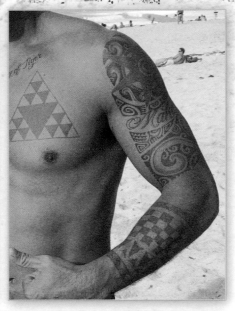

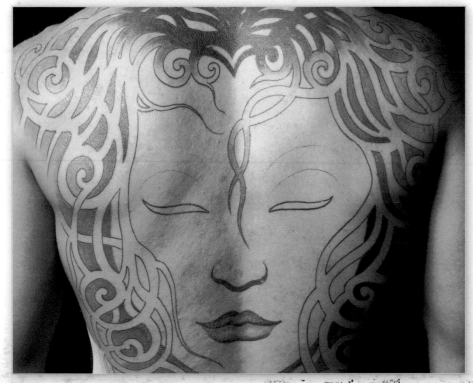

**M**illions of years ago, as people settled the individual islands of the South Pacific, the tattoo arts took on localized cultural meanings and looks. Among the Maori people of New Zealand, for example, tattooing was a sacred art. Tattoos were considered signatures, representing lineage and commitment to the tribe or group. Although Polynesian techniques, styles, and symbolism differ from island to island, the practice of tattooing usually celebrated important events throughout life. In fact people without tattoos were considered to be without any status.

In the middle of the 18th century, European ships began arriving and discovering the islands of the Pacific. Missionaries and merchants eventually infiltrated and exploited the islands. Missionaries were not good for the art of the tattoo, often demanding that natives not mark themselves and ordering islanders to cover their bodies. On the other hand, Western merchants were able to share the wonders of body decor with Europe. Captain James Cook, for example, brought a fully tattooed native to London following his South Sea adventures; many sailors also returned to their Western homes wearing tattoos.

Even today on Samoa or Hawaii or the Marquesas Islands, tribal-style tattoos, executed with traditional needles and ink, are still impressive for their design intricacy and visual impact. Most designs feature strong and distinct flowing lines. The tattoo patterns and symbols are complex and abstract, consisting of interwoven shapes and patterns that wrap well on the body.

Traditional Polynesian tattoos, as well as art inspired by tribal designs, have appeared numerous times in the *Miami Ink* shop. Clockwise from upper left: Ami added new Maori-style embellishments to wheelchair athlete Mark Zupan's body art. Ami and Garver encountered dozens of examples of outstanding Polynesian tattoos while in Hawaii. The stylized hair on a large back-piece created by Ami owes much of its intricacy and beauty to the artist's interest in tribal art.

# Far Eastern Art

The Far Eastern look has developed over the years to become one of the most popular and easily recognizable forms of modern tattooing. In fact, throughout America, contemporary Japanese tattooing has blended with Chinese techniques and images for a modern yet classic style.

The social significance of tattoos in the Far East has ebbed and flowed. In Japan, prior to the 19th century, tattoos were used mainly as marks of punishment; the tattoo symbols usually identified the wearer as a criminal of a specific class of crime. And from the earliest days in China, tattoos were considered barbaric, a mark of disgrace because many considered the body a sacred gift from one's ancestors that should not be altered except by nature.

> *"Japanese is one of the best ways to go. It's going to look good from a distance and up close. It's classic—never goes out of style."*
> —CHRIS GARVER

In the years leading up to the opening of Japan and China to Western traders and adventurers, criminals began altering their penal tattoos and turning them into highly decorative works. The development of woodblock printing made high-quality illustrations available to a wide audience and set the stage for the full-body tattoo designs seen today. As the best Japanese tattoo artists became increasingly famous, tattooing was no longer identified only with outlaws, Yakuza (organized gangs), and people on society's fringe.

When Japan opened to Western trade in the 18th century, tattooing was outlawed again with one exception—Japanese artists were allowed to tattoo foreign nationals. Soon major government

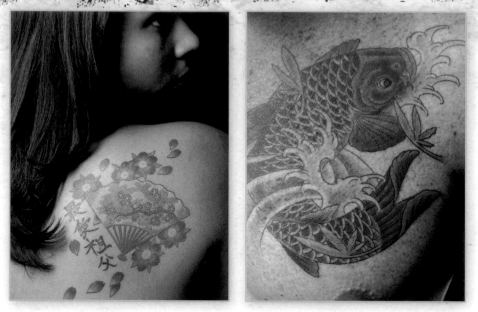

Chinese art and symbol tattoos have also become increasingly popular throughout the Western world. For example, Chinese dragons are drawn as benevolent protectors, not angry avengers. The yin and yang symbol of balance and harmony is as familiar as the Coca-Cola logo. Chinese characters can depict a wide range of thoughts and emotions as tattoos, often morphing into stylized calligraphy on lower backs, hips, and forearms. These tattoos, known as hanzi in China and kanji in Japan, are made up of as many as 30 strokes.

visitors, including England's King George V and Russia's Czar Nicholas, carried back to their homelands the work of Japanese tattoo masters on their bodies.

Artists Ami James and Chris Garver have both been tattooed in Japan and studied with the Horitoshi family of Tokyo, one of the leading Japanese tattoo organizations.

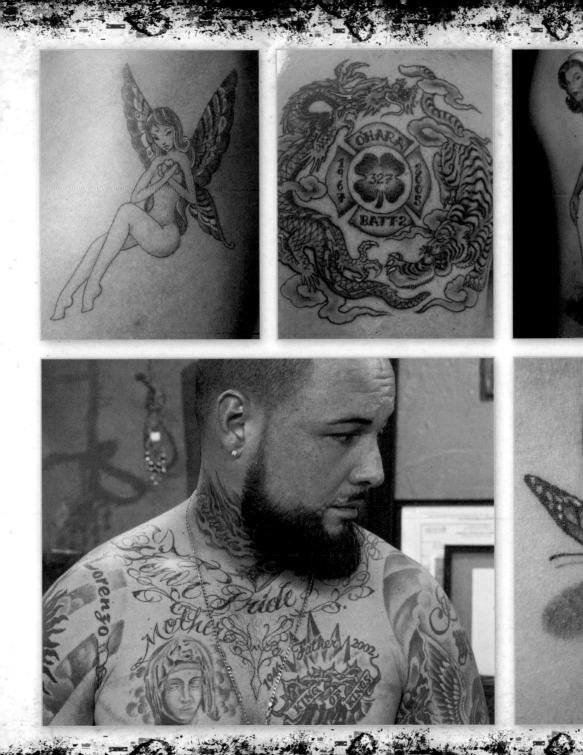

# Made in America

**A**merican tattoo style includes just about everything. Whether a client wants a family portrait, script, a family crest, a pop art-influenced graphic, a skull, a Mayan sunburst, bold geometric Mexican patterns, or a host of other images—the designs can all proudly be marked "Made in America" and held up as elements of a national look. Today the tattoo artist or client can dip into all that makes up the United States' culture, combining inspirations, creating original styles, and constantly evolving the art form.

Consider what's come to be called cholo—a West Coast Hispanic street look that's expanded to include line drawings of loved ones, harsh scripted words and phrases, and prison-style black-and-white line images. Cholo style serves as the underpinning of the dramatic faces and portraits created by Kat Von D and Chris Garver.

# Miami Ink Artist
# Ami James

# The tattoo shop in Tel Aviv

WAS CRAMPED, JUST ROOM ENOUGH FOR AN ARTIST

AND A CUSTOMER TO CREATE CUSTOM SKIN ART.

ISRAELI ARMY SPECIAL FORCES INFANTRYMAN AMI JAMES,

ON WEEKEND PASS FROM HIS DAY JOB, WAS FEELING

A LITTLE HUNGOVER, A LITTLE EXCITED. BUT MORE THAN

A MERE CELEBRATORY TATTOO WHILE TAKING A BREAK FROM

SOLDIERLY DUTIES, AMI WAS ABOUT TO GET

THE SURPRISE OF HIS LIFE.

**B**riefly left alone in the tiny shop, Ami gripped the artist's electric tattoo machine in his hand for the first time and experienced instant insight into his future.

*The guy walked outside to take a break and I grabbed the machine and started filling in the tattoo he was doing on me. That was the first time that I felt I could be a tattoo artist. I thought, "I can do this." I knew I was going to be tattooing.*

And yet from an early age, Ami's artistic instincts had always been present, continually been nurtured. Growing up in Israel, his father was a painter who frequently shared his passion with his son.

*He would grab a brush and give me some acrylic paints. I used to sit next to him and paint.*

Ami eventually began laying down his first tattoos at the ripe age of 14—as a junior high truant. With only a pin and thread, he inked a couple of guys in the South Miami neighborhood that he, his mother, and his brother moved to from Israel when he was 12. Ami's

teenage years were, in a word, rough—rough neighborhood, rough school, rough everything—but there were also quiet, artistic moments.

*By the time I was 16, I was really hanging out with whoever was crazy and getting in trouble. All this time I was drawing. I could beat up anybody and I could draw. That's what I was good at. My instinct was to fight or just sit there and draw something. I began drawing, making stickers and T-shirts for punk rock bands in Miami—doing what I could to make a dollar.*

For Ami the decision to be an artist who made tattoos was surprisingly easy. Becoming one, however, turned out to be more difficult. Writing in *The New Yorker* some 50 years ago, journalist S. J. Perlman noted, "The arts is a lousy buck." If Perlman had known anything about tattoo artists in the waning years of the 20th century he might have qualified the statement to read, "Learning the arts is really a lousy buck." For Ami, as it is for most accomplished artists, learning his art meant putting in the time and working as an apprentice.

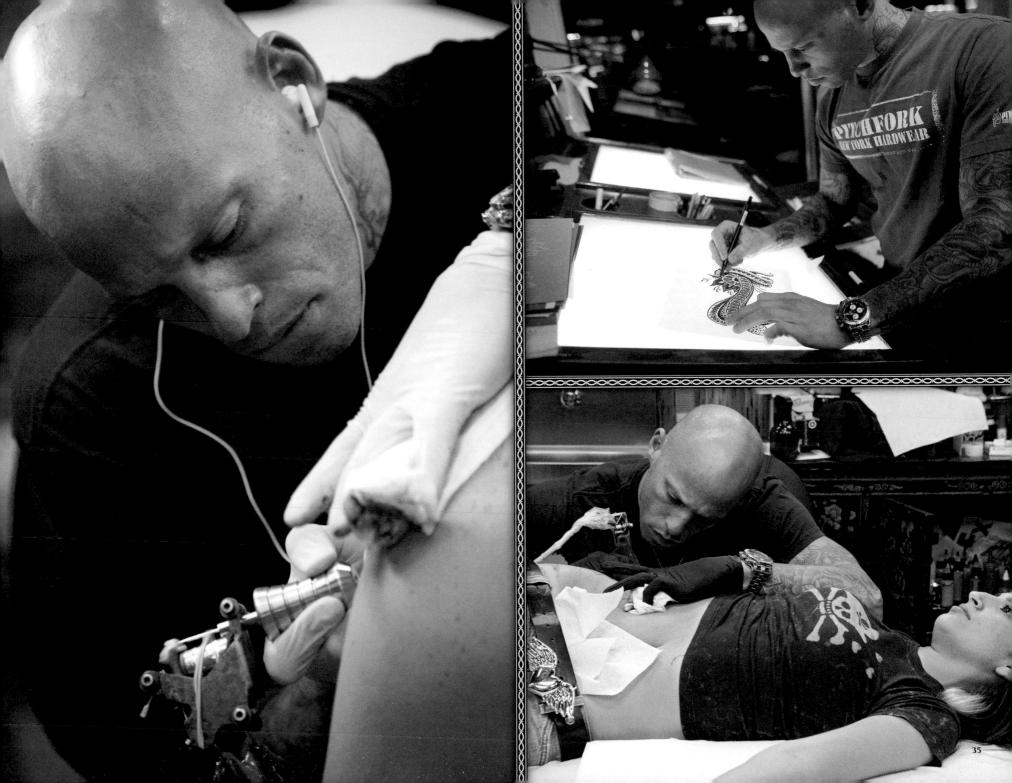

IT SEEMS TO ME THAT THE MOST MEANINGFUL
TATTOO DOESN'T HAVE TO BE THE PRETTIEST
OR THE MOST INTRICATE TATTOO. I THINK IT
JUST HAS TO BE SOMETHING THAT MEANS A LOT
TO THE PERSON—THE STORY BEHIND IT IS
WHAT CARRIES THE TATTOO.

Ami James

Although he often pores over source images for inspiration and then refines a design on paper, Ami is just as likely to grab a marker and begin sketching a large, original piece on a client's skin.

When Ami returned to South Beach following a tour of service in the Israeli Army, he knew he wanted to spend less time fighting and more time refining his art. He spent two years dabbling with a tattoo machine in his own home, inking himself and friends. But the work was lonely, and he didn't feel as though he was learning anything. Eventually Ami connected with Lou Sciberras, the internationally respected owner of Tattoos by Lou.

*In those days, I'd go by Lou's shop, stand by the window, watch the better artists work, and try to figure out their tricks. And I would get tattooed just so I could pick their brains and see how they were working. After a good eight months of hanging around outside and inside the shop, Lou offered me an apprenticeship. I shouted, "I'll be here tomorrow morning!" As soon as he made the offer, I knew that this was my big break and that the door was finally opening for me to belong to a family of artists.*

Apprenticing as a tattoo artist means long hours, little (if any) pay, and the seemingly unending responsibility to serve the rest of the talent in the shop in any way possible.

*Lou had four shops, and I would scrub four shops in the morning and then go and scrub four shops every night. And prep all the equipment, clean the tubes, lay out the needles, check to keep everything ready. Run and get him food, watch him work, and draw and draw, just basically be his "do boy." I was proud to be hooked up, to be identified with Lou; he was a star recognized all over the country. But at times it was pretty degrading. He didn't keep many emotions to himself and as the apprentice I got my share of swats in the back of the head.*

For Ami the emotional and financial price of his apprenticeship was a sound investment. For the first time he had a ticket, a calling card of sorts because of his training under Lou.

*I was able to finish my apprenticeship in a little under a year. For the rest of my life, whenever people ask me, "Where did you apprentice?" I will always say I tattooed under Lou Sciberras ... That's who taught me. He really got me started. A remarkable*

artist, an old-school guy who paid his dues for the 35 years that he was tattooing.

Doors began to open for Ami—in South Beach and all along the Tattoo Trail. You won't find the Tattoo Trail on MapQuest. Rather it's a self-designed journey in which artists travel the United States (and beyond), working shifts at shops, visiting with other artists, and—with luck—getting a featured guest shot at a leading shop for a few weeks or months.

Convention appearances are critical to success along the Trail. At these two- or three-day events, dozens of artists come together, set up temporary shops, and generally make themselves available to clients desiring one-of-a-kind tattoos. In the United States, popular conventions are held in New York, Philadelphia, Miami, Phoenix, Los Angeles, and other metro areas, while international conventions occur regularly in Madrid, Paris, London, Sao Paulo, Rio, Tokyo, and Melbourne.

Tattoo conventions are not as visible or as organized as the NASCAR circuit or the PGA Tour, but they are an important part of being a well-rounded tattoo artist. Here artists earn their reputations, develop friendships among their peers, make contacts with lifetime customers, and potentially make a lot of money.

Now that Ami is recognized as a major artist, conventions serve as a welcome break from the routine of working in and managing a shop.

*It's pretty simple. I set up my booth, put my portfolio out on the table,*

> "I have a tattoo in memory of Lou Sciberras from Tattoos by Lou. I'm happy that I got that tattoo because there's not a day that goes by that I don't remember what he did for me."

# The Words of Ami James

People don't care at 17,
they just want to go back to school
the next day and show everybody
their tattoo instead of looking
around at the best tattoo shops,
the better artists, the sterility, and
everything else that should be up
to code. When you see a father coming
in and making sure that his kid is okay,
it's a great thing, a great feeling
for the tattoo shop and all
the artists doing it.

A tattoo is not a pair of jeans
or a pair of shoes. It's on for life.
You'd better think about what
you're doing. You can't change it.

*people come by and take a look, and if they like what I've done, they take a seat or make an appointment. You meet a lot of new people.*

In the 10 years following his apprenticeship, Ami worked his way along the Trail, making stops in Chicago, New York, and Houston as well as in Europe and Asia. But as his world grew, he always returned, every six months or so, to work a while on South Beach with his old boss.

As in many circles, relationships in the art world are often a tightly interwoven, six degrees of separation sort of thing. If you don't know a particular artist, chances are a friend does. This kind of networking has enabled Ami to travel the world.

*Between my 10 friends I have a connection to anywhere in the world to go tattoo. We're really connected to almost every good tattoo artist. If I decide I want to spend some time traveling, I just have to get on the phone or ask a friend, "Do you know anybody in Paris or London or Munich or Tokyo or Sao Paulo?" These days it's pretty easy to put a trip together.*

Ami was working in New York when a friend asked him to stop by an East Village bar to meet some people who were interested in putting together a television series about a tattoo shop. Ami showed up late, hoping the TV producers would be gone, but within an hour he was taking his first steps toward the creation of *Miami Ink.*

And the second question (after answering "Yes" to "Are you interested?") was "Do you know anybody who could work with us?" That answer was easier. In the mid-1990s, Ami was not the only young artist working at Tattoos by Lou. Chris Nuñez, Chris Garver, and Darren Brass

all worked side by side for a year and a half, becoming close friends in the process. In the years that followed, each had earned wide respect and developed into an outstanding artist. So Ami reached for a telephone.

*These guys are my family. We've been there for each other through brawls, through bad times, through*

*"We obviously all help each other to make the shop better. That's what it's all about—actually pumping good tattoos out of here."*

*great times. We could go through a time period when we don't see each other and lift up the phone and say, "Listen, I need $1,000 right now." And the other guy will say, "Go to Western Union. It's there." Sometimes we didn't speak for a year and half because I was in Europe, Chris Garver was in Japan, and Chris*

*Nuñez was traveling in Thailand. And Darren—he was in Connecticut, where he opened a shop, got married, and bought a house. But with one phone call, everybody was back to make it happen. Everybody's just the same. It's like we're brothers. Nothing could happen between us to break this up anymore. We're Miami Ink.*

Exactly 17 years after doing those first primitive needle-and-thread tattoos in South Miami, Ami stood in front of video cameras—a star in the making—and taped the introduction to a story of five friends and their art for an international television audience.

*My name is Ami James, and I'm a tattoo artist. You can see most of my work in South Beach. When it came down to opening my own shop, I called three of the greatest artists and four of the greatest friends a guy could ever have: Chris Nuñez, Darren Brass, Chris Garver, and my loyal apprentice, Yoji Harada. We poured our hearts and souls into the shop. We worked our asses off. And opening our tattoo shop was a big challenge for all of us. But this was our shot and we took it.*

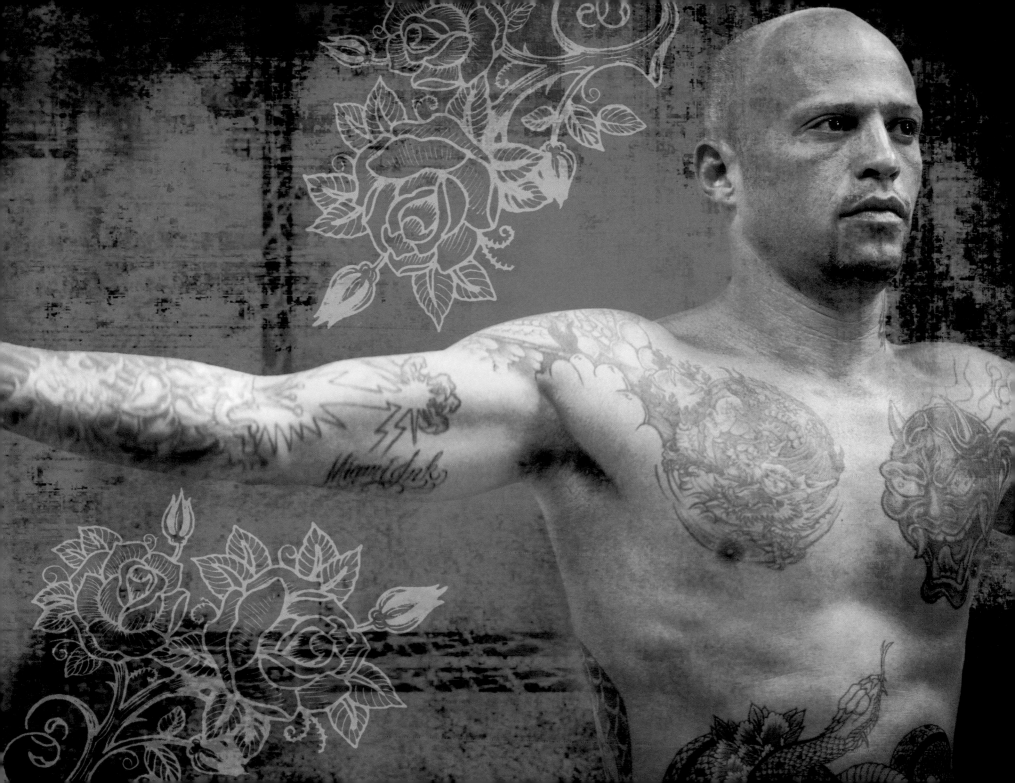

THE ARTWORK OF

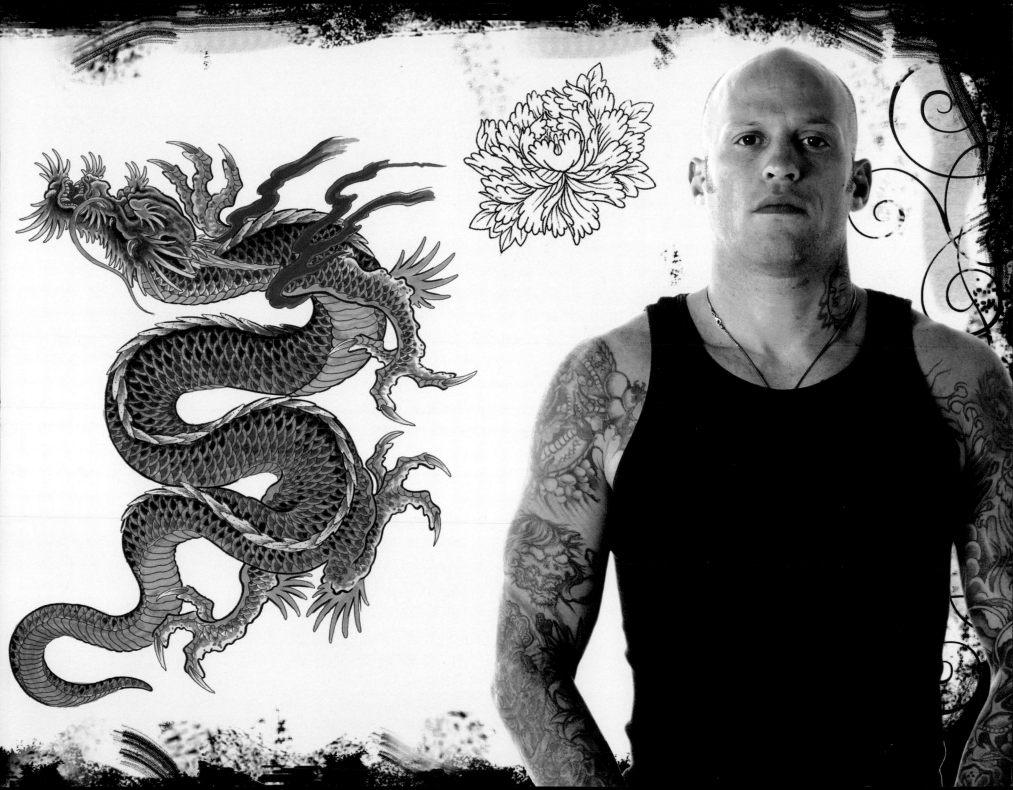

# Murderball

Mark Zupan rode into *Miami Ink* in his titanium wheelchair. Chris, his best friend and former roommate, came with him that morning. (And that's a whole other story. Mark was injured in a truck accident when he was just 18. Chris was the person behind the wheel that night, and Mark was thrown out of the truck and into a ditch. As a result of his injuries, Mark was permanently paralyzed from the waist down.)

With some other guys in a similar situation, there might be no words between them ever again—just hate. But these two are still tight. Mark even sees positives arising from the seemingly horrible event.

*It was both our faults. And getting past it was harder for Chris than me. I forgave him right away. Chris couldn't forgive himself. Your best friend is in a chair. Every time he saw me, it's like, "Oh great, I ruined your life." But he actually made my life better.*

Mark was referring to the fact that he is now a terrific athlete and

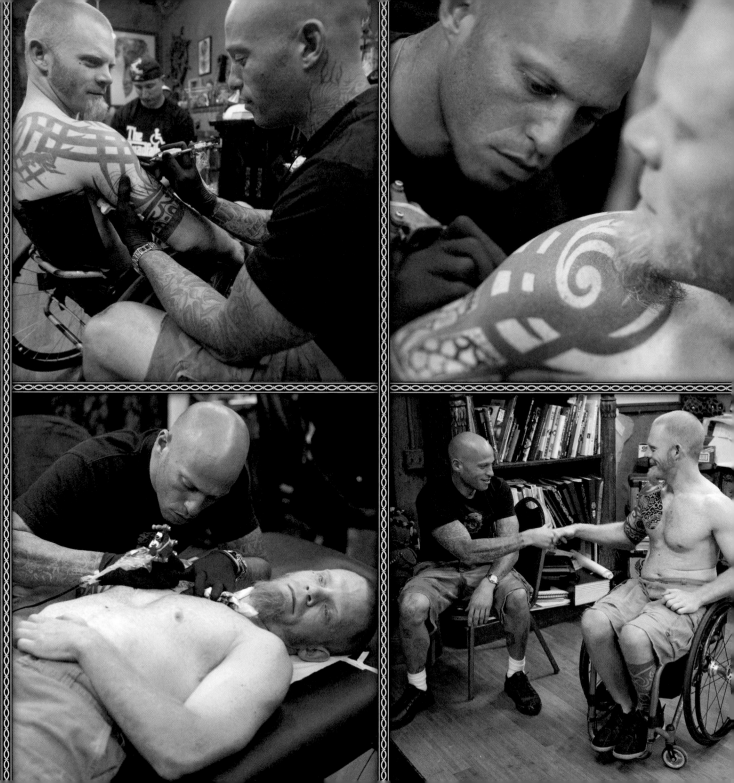

a member of the U.S. Paralympic Wheelchair Rugby team. His upper body is a mass of muscle. He can careen his chair into other guys with the best of them and win, win, win. He's traveled the world with the U.S. team and was even a member of the gold medal-winning team at the Athens Paralympics in 2004. And a documentary about him, *Murderball,* was nominated for an Academy Award.

*You pretty much come to terms with your accident. You figure out that walking isn't the most important thing to do in life. Being in a wheelchair opened so many doors for me, I wouldn't change it for the world. You take whatever it is and run with it.*

When Ami James met Mark, the rugby hero already had Maori-style tattoos on his right arm and shoulder, but he wanted Ami to do more work on them. Without a stencil to guide him, Ami worked on the massive piece freehand. Meanwhile Mark talked about being part of a team.

*In my line, it's full contact. You can hit somebody as hard as you possibly want to in a chair and they call it Murderball. But it's also a team, just like in any sport. And sometimes we're going to win; sometimes we're going to lose. If we lose, then we lean on each other and say, "OK, let's get our stuff together and come back and play the next game." It's just like life. Friends help each other get stronger and get better.*

Listening intently to Mark's insights while he tattooed, Ami said he was honored to tattoo Mark.

*Mark's story made me realize how much we rely on each other. Mark credits his participation in rugby and the support of his friends and family as a big part of his emotional recovery after the accident. His visit to the shop has really opened my eyes to what we have here at Miami Ink and what friends and family can do for each other. To see somebody take something so tragic in life, pull it out, and just make it so good—that's inspiring.*

> *"Mark's story made me realize how much we rely on each other."*

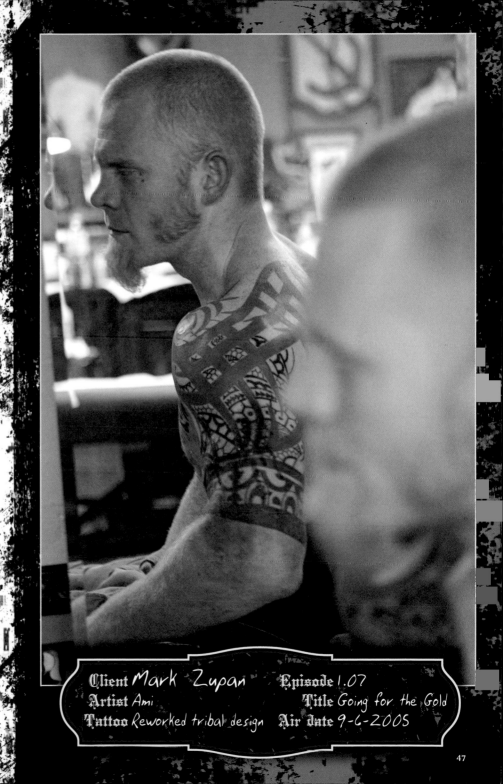

Client **Mark Zupan**
Artist *Ami*
Tattoo *Reworked tribal design*
Episode 1.07
Title *Going for the Gold*
Air date *9-6-2005*

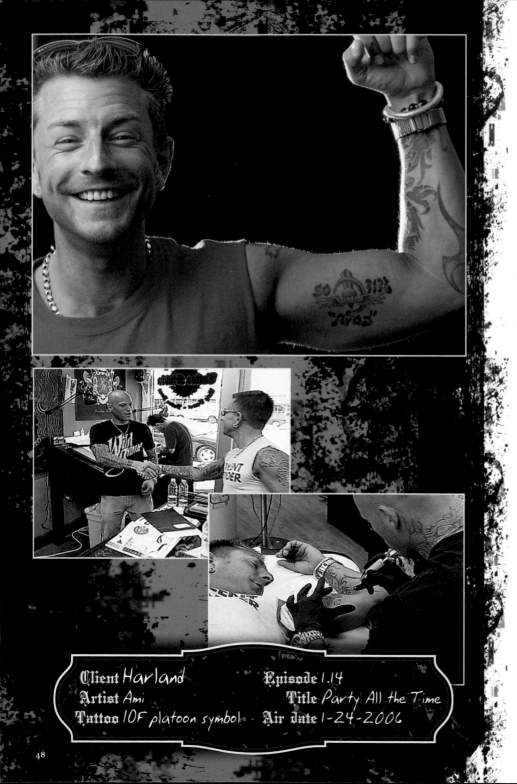

Client Harland
Artist Ami
Tattoo IOF platoon symbol

Episode 1.14
Title Party All the Time
Air Date 1-24-2006

# Brother in Arms

Harland had served in the Israel Defense Forces, or IDF, and came into *Miami Ink* for a tattoo of his former unit's insignia. Ami also served in the IDF and he liked the idea of working with Harland on this project.

*It's cool—I was in the Israeli Army for nearly three years. You went to Israel to join up—we must have been just about the same age. It's really unusual to meet anyone who went over and volunteered like I did.*

Harland, who had been in the Airborne Division for three years in the 1990s, handed Ami a drawing of the insignia. He was eager for Ami to work up a design. The unit insignia featured a sword with a sickle and a parachute in the center. Harland also wanted the Hebrew letters "Lamed, Samech" incorporated into the design.

They chatted in Hebrew as Ami worked up the design. When Ami finished, he applied the stencil to the inside of Harland's arm and began outlining. Memories of Ami's own days in the service came drifting back.

*My insignia was a tree—the root of Israel—and it was the first unit ever established. I love to hear about other insane people who actually did this besides me.*

He asked Harland about his experience and if being there had changed him.

*There were a couple of close calls, and I'm glad I made it out. I was discharged 10 years ago. And this is my 10th tattoo, so it all goes together. I used to be a straightedge, hard-core kind of guy. I never did much until I got over to Israel. This tattoo is just a good way of remembering some of the friends I lost, and all the good times, and the bad. It represents who I was then and what I am now, and what I'm still becoming.*

Pleased with the finished results, Harland complimented and thanked Ami in Hebrew. Ami said that the whole experience made him want to get the insignia from his own platoon.

*I think we both want to remember what that experience was like—forever.*

# Winged Warrior

Stacey, a professional boxer in a group called the Fighting Angels, came into the shop for a commemorative tattoo. She had recently returned from a match in Japan where she knocked out a high-ranking female boxer. According to Stacey, a pair of wings on her hips would remind her forever of the important victory.

*I took her "wings" in the match and now I'm going to get my own angel wings.*

Ami drew a couple of sketches and Stacy made her choice. Using the copy machine, Ami reduced the sketches to the exact size and then prepped the stencil. His biggest task was to place the wings symmetrically.

*It was a little hard to match them on each side, but I figured out a way to do it. I just pointed at the same spot and it worked.*

As he tattooed, Ami talked about his own love of boxing.

*I like to train, but I just don't have time any more. And I can't get hurt. I didn't use to care if my hands got messed up. These days I do. I worry about my hands now. They are my livelihood.*

When Ami was finished and Stacey finally stood in front of the shop mirror and admired her tattoos, she was absolutely elated. And the shade of blue that Ami had selected for the wings matched her boxing gloves.

It was exactly what Stacey wanted.

*It's symbolic of my trip to Tokyo. It's that moment—the single greatest moment of my life. And now I'll never forget it. I can move forward and know that I'm going to win even more fights—because now I have my wings.*

> *"It's symbolic of my trip to Tokyo. It's that moment, the single greatest moment of my life. And now I'll never forget it."*

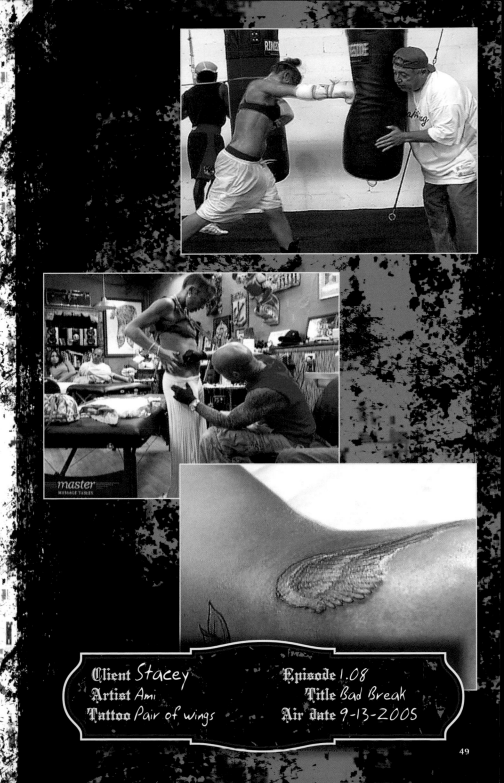

Client *Stacey*
Artist *Ami*
Tattoo *Pair of wings*

Episode *1.08*
Title *Bad Break*
Air date *9-13-2005*

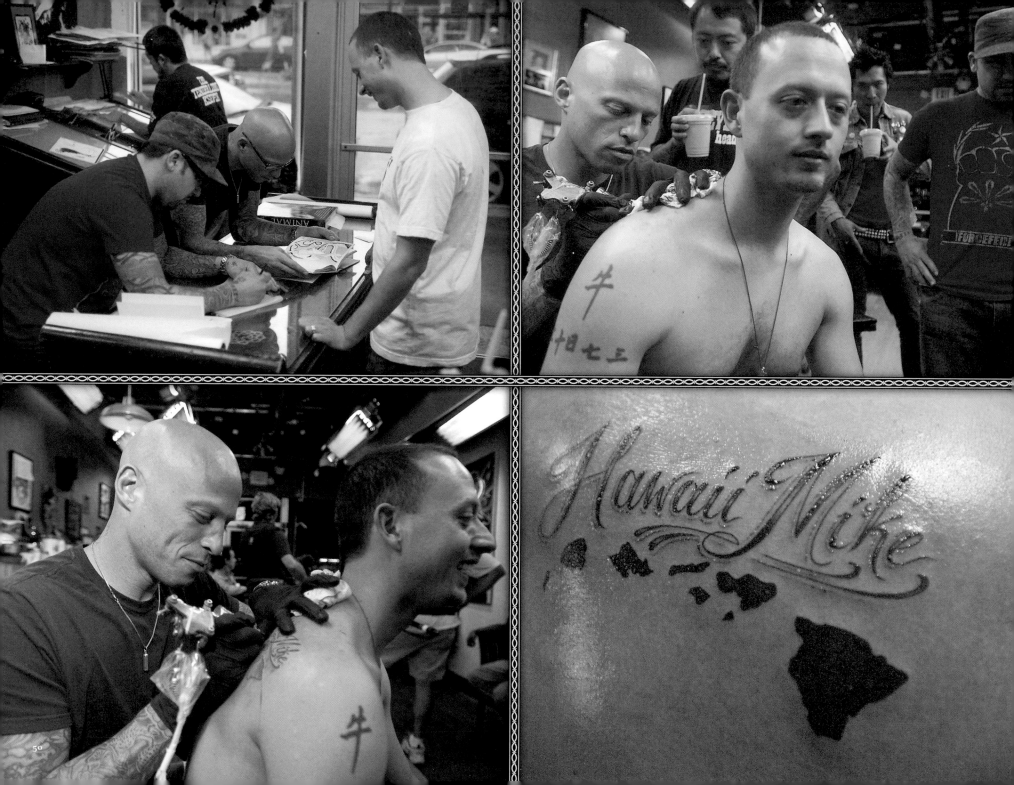

# Island Ink

Born in San Francisco, Mike lived in Hawaii as a kid and later moved to New York. His friends called him "Hawaii" Mike because he always wanted to surf and remember life in the islands. "Hawaii" Mike knew to come to *Miami Ink* for his tattoo because he is editor in chief of *Inked*, a lifestyle magazine dedicated to tattoo culture. When he walked into the shop, he was dreaming of the warmth of the islands, and Ami was on the same wavelength. Mike explained he wanted outlines of the islands with script reading "Hawaii Mike." Ami mentioned his recent trip with Garver to the land of paradise.

*Yeah, we hung out with all the surfers. The women were chasing us around. It was terrible.*

> *"There are two types of people that get tattooed: People that get tattooed for themselves and people that like to show the world their tattoos because they're proud of them."*
> —AMI JAMES

Lucky for Ami, who has big trouble with script, Darren had his back. Darren was glad to help out, but he grumbled about not going to Hawaii. Mike looked over at Garver.

*A little jealousy in the air?*

When Ami was ready for the session, he had two different elements and thus two different stencils. His time with Mike went as smoothly as a session could. Drawing the islands kept him dreaming about Hawaii and put him in a peaceful mood. When the tattoo was finished, Mike was totally pleased.

*Hawaii will always be a definite part of my life. Hopefully I can go back there and retire someday and just hang out— be a beach bum!*

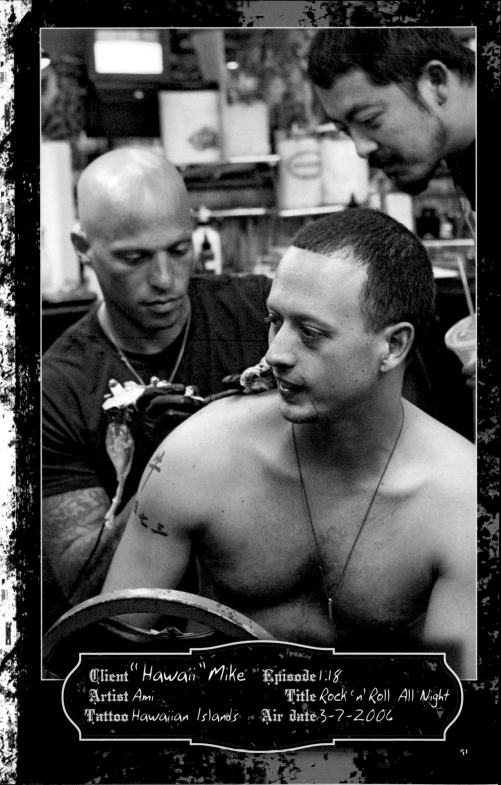

Client "Hawaii" Mike  Episode 1.18
Artist Ami  Title Rock 'n' Roll All Night
Tattoo Hawaiian Islands  Air date 3-7-2006

# Soaring

Jason had a fire in his belly. He'd been riding with his dad on the back of Harleys since he was only three. And now he wanted to state his biker identity with a big back piece featuring an American eagle. He rode to the shop and shared his idea.

*American eagles are the symbol of freedom. I get on my bike and I feel free. And I've wanted an eagle tattoo for the last few years. I just never got around to doing it.*

Jason presented Ami with an artistic challenge because he already had a tattoo in the middle of his upper back. Ami started to work on the design, but it wasn't coming together, so he asked Garver to help him out.

*Chris has drawn 2 billion eagles in his life. It'll be a lot better if he gives me a sketch, and I work from that.*

But collaboration can be tricky. Each artist has a different vision and ego. Garver cracked that Ami was unprepared to do the tat—that he hadn't given himself enough time to work on such a complicated design. The room

was fast becoming too small for the two of them. Ami ambled over to the drawing table to look at Garver's work. Garver was becoming frustrated.

*You don't do a back piece design in an hour before you do the tattoo. Normally I would spend about a week getting the design exactly the way I want it before I'd even schedule the appointment. Maybe Ami thought it was going to be easier to design.*

Just as Garver said they weren't ready yet, Jason came back. For the sake of art, and business, Ami and Garver worked out their differences—just as they knew they would. As for the back piece stencil, it was completed and set in place on Jason's back.

The tattoo took three sittings: one for outlining, another for shading, and a final session for color and a few details. Jason was now ready to show the world the unique work of art displayed on his broad, biker back. He was the ultimate traveling advertisement for *Miami Ink,* not to mention one very satisfied customer!

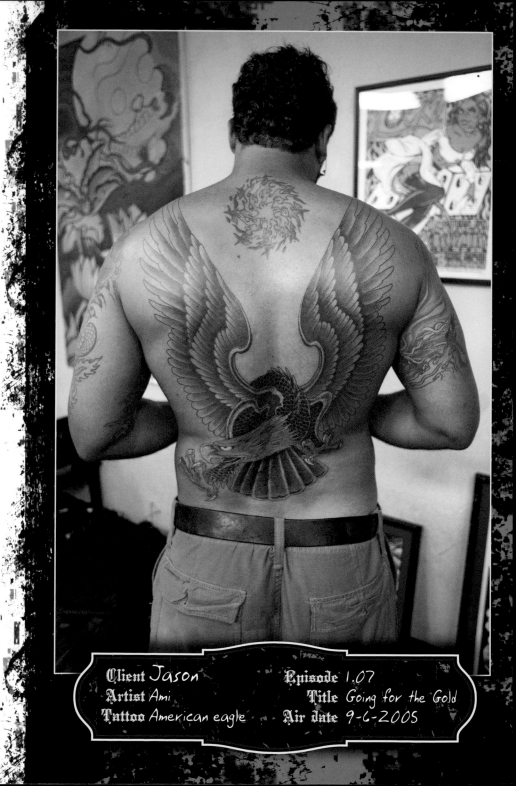

Client *Jason*
Artist *Ami*
Tattoo *American eagle*
Episode *1.07*
Title *Going for the Gold*
Air date *9-6-2005*

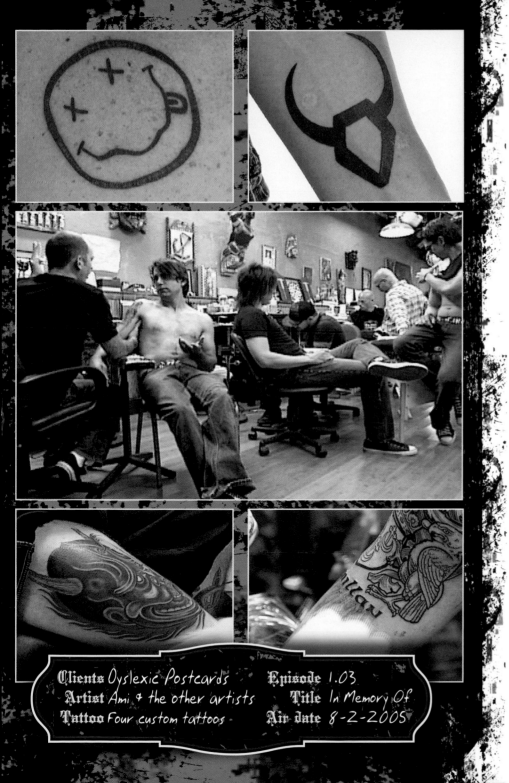

**Clients** Dyslexic Postcards
**Artist** Ami & the other artists
**Tattoo** Four custom tattoos

**Episode** 1.03
**Title** In Memory Of
**Air date** 8-2-2005

# Banded Together

One morning there was chaos in *Miami Ink.* Four guys from Dyslexic Postcards, a local garage band, had gathered around the drawing table. They wanted to get tattooed together to solidify their friendship and make them a better band. Ami tried to help sort out the confusion.

*For many people, getting tattooed in a group is a symbol of unity. From the looks of this consultation, these guys need all the unity they can get. After a lot of back and forth, we finally figured out who was going to get what. These guys were really the most unorganized guys I ever met in my life. But who am I to judge?*

Each band member wanted something different. Josh, the lead singer, wanted the astrological sign Taurus—the bull with horns. Adam, the guitarist, wanted a little Nirvana logo in memory of Kurt Cobain. Joel, the drummer, already had a number of tattoos and wanted to add an Asian demon mask to his collection. And Randall, the bass player, wanted to celebrate his Scottish heritage with a family crest.

When the band came back for a two o'clock group appointment, *Miami Ink* became very intense. Work stretched well into the evening. Darren did Josh's Taurus sign on the inside of his arm. Ami took on the big Japanese demon mask that went on Joel's thigh. Chris Nuñez zeroed in on Adam's Nirvana symbol chest tattoo, and Garver created Randall's intricate family crest. Ami liked the fact that everyone in the shop was working. Later the band gathered around to show off their tattoos. Joel summed up the experience.

*We not only rock the stage, we rock the ink.*

> *"For many people, getting tattooed in a group is a symbol of unity."*

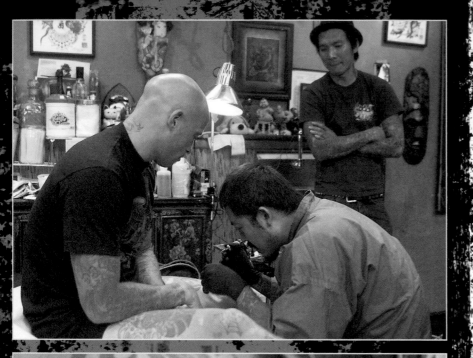

# Gift from a Master

Ami was elated when his friend and teacher Shinji Horizakura flew down from New York to visit the shop. Their friendship began a few years ago in Japan, and Ami doesn't hesitate to state firmly that Shinji has been one of his best teachers.

*Shinji is one of the very best traditional tattoo artists. The style of Japanese tattoo that he does is called tebori, in which the artist tattoos with handheld needles. Shinji's tattoo name is Horizakura, and he was an apprentice in Japan to Horitoshi, one of the world's renowned tattoo masters. The Horitoshi style is highly respected all over the world.*

Shinji moved about the shop in muted green pants and shirt, a great contrast to the bold and funky T-shirts that the other guys usually wear. Yet as Shinji laid out his needles and talked to everyone, it was apparent that he felt at home in this environment. No doubt art shrinks geography and links all artists together. Ami had a lot to tell Shinji about the success of the business, but there was really only one thing on his mind.

*It's great to have Shinji in town and maybe I'll finally be able to be tattooed by him after all these years. I hate getting tattooed, but I want to get tattooed by Shinji.*

Shinji agreed to tattoo Ami in the tebori style, a technique sometimes referred to as "hand poking." The process requires inserting ink into the skin with a needle attached to a stick. When it was time for the session to begin, Ami chose an image of a frog for Shinji to place on his leg. Shinji's sketch was delicately detailed and, as Ami added, "suitable for framing."

*You know when you receive a tattoo from somebody that you like or who means something to you, that tattoo is a gift. I have a lot of respect for Shinji. He means a lot to me and he's helped me a lot with my art.*

Ami lay down on the padded table. He was excited.

*In Japanese tradition the frog represents changes in life and wisdom.*

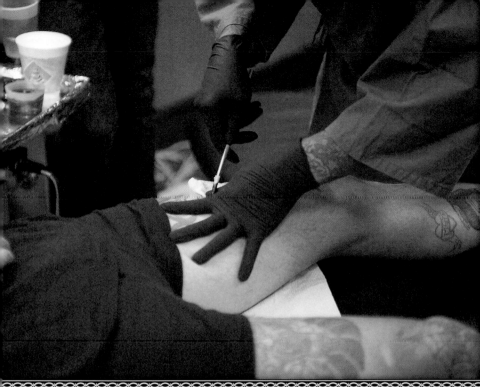

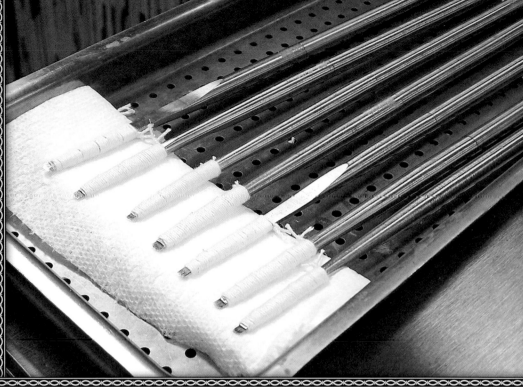

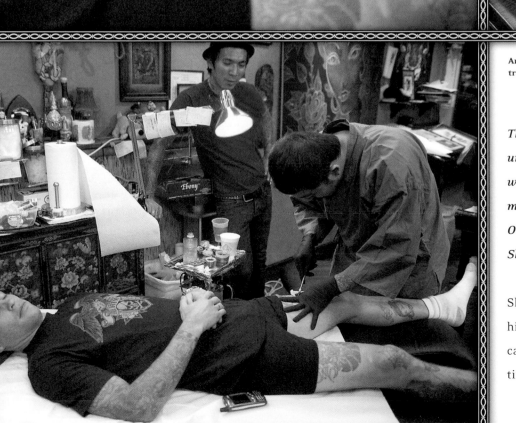

Ami has long considered Shinji Horizakura an outstanding artist and one of his greatest teachers, so receiving a traditional-style, handpoked tattoo from the master was both an education and an honor.

*The style of the Horitoshi family is unique in its beauty of design. The way they use color and shading almost makes the frog look three-dimensional. Okay, you guys. Come close. You'll hear Shinji's needle plucking the skin away.*

Everyone listened and watched as Shinji pierced the skin. Ami closed his eyes and drifted away. He seemed calmer than he had been in a long time. He mused later that receiving a traditional Japanese tattoo might always be the best way for him to relax.

*My frog tattoo is amazing—so cool. It was a great experience, and it will stay with me forever. Every tattoo I get reminds me of a moment. I don't think anyone ever forgets why they got a tattoo—exactly what happened and who did it and the conversation they had with the artist. That's just the way it is.*

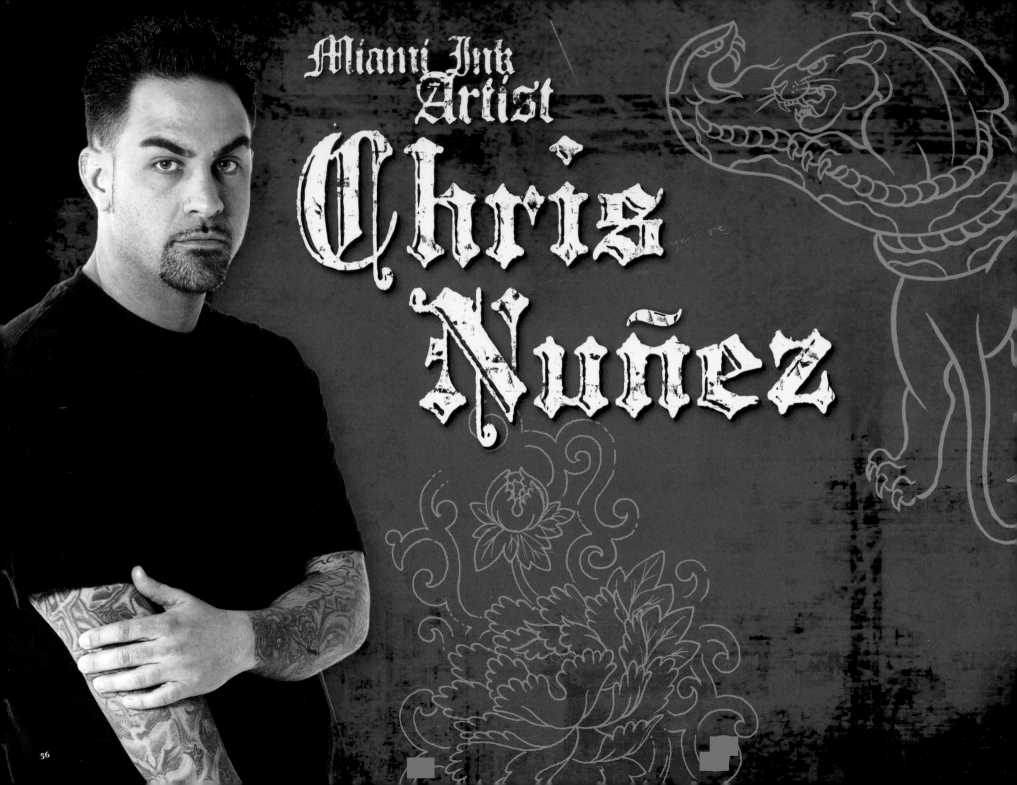

Miami Ink
Artist

# Chris
# Nuñez

# H

E HAS A SLIGHTLY WRY SMILE— SOMETIMES CHARMING, SOMETIMES DEVIOUS, ALWAYS INTRIGUING. HE MOVES WITH STRENGTH AND CONFIDENCE BUT GENERALLY SPEAKS JUST LOUDLY ENOUGH TO BE HEARD. BUT IT'S HIS DARK YET BRIGHT EYES, PUNCTUATED BY THOSE EXPRESSIVE EYEBROWS, THAT GRAB YOUR ATTENTION AND DON'T LET GO.

SURE, HE GETS BILLED AS *MIAMI INK*'S RESIDENT "LADIES' MAN," BUT CHRIS NUÑEZ IS MUCH MORE THAN A LOOKER OR CHARMER.

Chris Nuñez grew up in Miami and traveled the world learning the tattoo arts and making a wealth of professional connections. But in the end, he returned home to South Beach to open his own tattoo shop (with business partner, Ami, of course).

The first hints that Chris would live life as an artist came early—when he began laying on graffiti as a fourth grader and also taking note of others' body art.

*Two kids in my neighborhood built homemade machines and started tattooing people. I was always, like, "Wow." I always thought, "Damn, look how cool that guy looks!" He would be all bikered out, all crazy looking, but I turned on to that particular look. It wasn't that I wanted to look like a biker; I just liked the way the art looked on bikers' bodies.*

An artist's job, even a beginner's, is to make art. By the time Chris was in middle school, he graduated from being the mascot of a teen break-dance group (his first graffiti was on the cardboard he used for spinning) and became part of a graffiti crew that traveled, usually on foot or bicycle, through metro Miami doing their art. All the time, he was drawing—on scraps of paper, in notebooks, and on the backs of school announcements. Gradually his graffiti and sketches turned to tattoo designs.

*I would draw designs for my friends, but I just wouldn't wear them. When I was 16, I finally let them tattoo me, jailhouse style. We stole the ink from art class and wrapped thread around a needle and made a tiny hand-pulled cross on my arm. It was barely visible when it healed. But I was thrilled, "Look, there it is. This is so great!" They wanted to do more on me, but I wouldn't let them. I didn't want to make my parents crazy.*

It would be a few more years— years filled with their share of ups and downs—before tattooing emerged as a real career possibility for Chris.

*I was 18 when my father died. I was shattered. I couldn't focus for more than five minutes on anything—not a woman, not a question, not a drink, nothing. There wasn't anything that*

Whether in the shop or out on the town, Nuñez is known as a fun-loving party guy for good reason. Even some of his personal tattoos—such as big tears inked on his index fingers—have a sense of both attitude and playfulness.

*could keep my attention. At that time I was still drawing and painting but I was also running wild. And then things began to change. I met Lou Sciberras—Tattoos by Lou—by accident. We were both painting on the beach. One day we got to talking. And he said I should come by his shop. I was broke and I listened, and I spent the next year as an apprentice. And that's how this whole thing got started.*

In art school, painting students are usually introduced to all the materials they will ever work with. This includes most things that will hold graphite or paint—canvas, linens, myriad papers of varying thickness and sizes, Bainbridge boards for sketching, drawing, and painting, natural and manufactured fabrics, and a variety of metal and ceramic surfaces. But for Chris Nuñez, as for any tattoo artist,

*"I think we've all kind of maintained our friendships. There's been a little bit of tension, but that's normal with old friends. We're in a semi-stressful situation, and you know, we can all deal with that. We respect each other."*

59

IN A WORD, IT'S ALL ABOUT TECHNIQUE
AND THAT ONLY COMES THROUGH TIME
IN THE CHAIR. IT HAS TO COME TO YOU.
YOU HAVE TO FIGURE OUT BY YOURSELF—
THERE JUST ISN'T ANY WAY TO TELL SOMEBODY
HOW SLOW OR HOW FAST TO MOVE THEIR HAND.

Chris Nunez

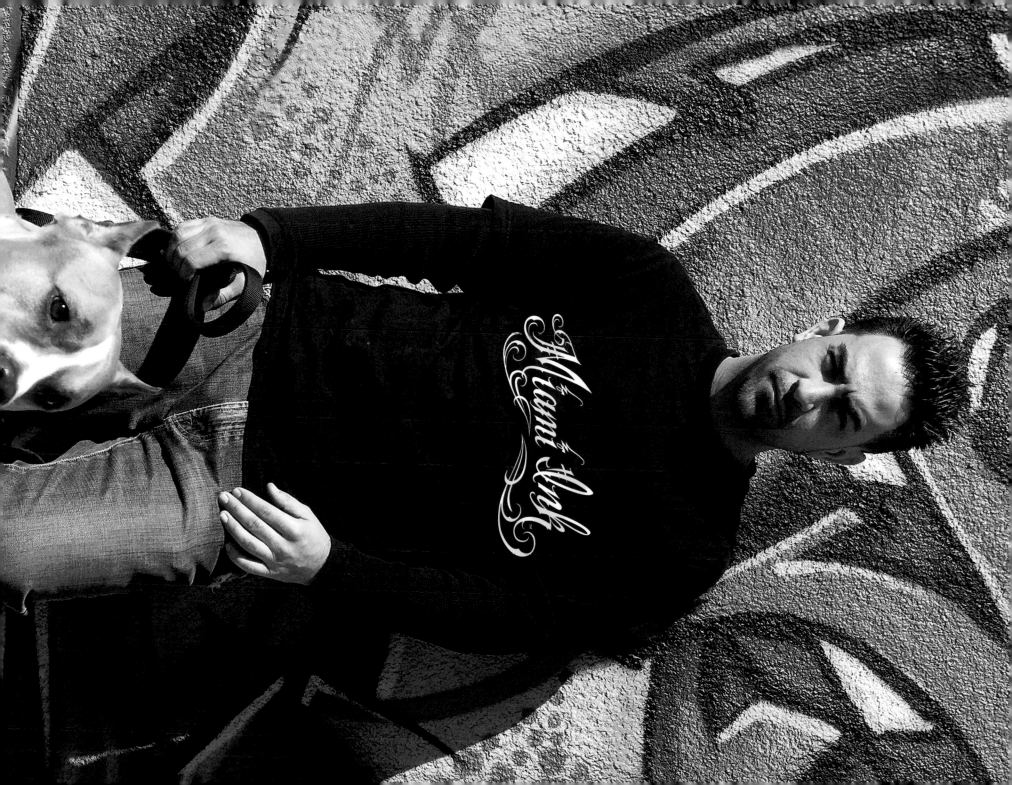

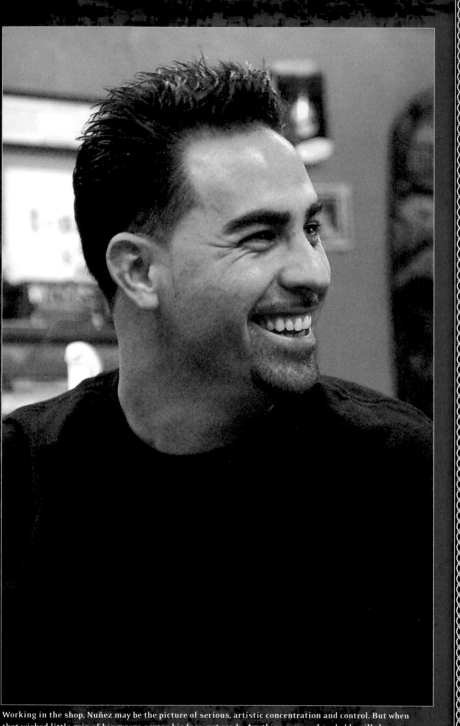

Working in the shop, Nuñez may be the picture of serious, artistic concentration and control. But when that wicked little grin of his creeps across his face, get ready. Anything can—and probably will—happen.

there is no Body 101 course to take as an introduction to the human canvas.

*In a word, it's all about technique and that only comes through time in the chair. It has to come to you. You have to figure out by yourself—there just isn't any way to tell somebody how slow or how fast to move their hand or their motion or whatever. Or how to push just hard enough to accomplish the look you need and yet not overwork it or underwork it.*

By the time he was 20, and with an apprenticeship behind him, Chris was ready to hit the road and put his artistic skills to the test.

*I went to Ohio to work for a friend for a year on and off, and then we started traveling the country—going to tattoo conventions in Philly, New York, working in Michigan in Ann Arbor, driving coast to coast. Always working. At the beginning it helps to*

*"You want to do something that kind of pops, so you try to find a way to make it flow. You have to lay it out just right."*

*be under somebody's wing, someone reputable, who is already on the circuit. You go along with them and you get to meet people. You drink a few beers, make friends, and begin to network. If it is a good convention in a strong town, everybody tattoos all weekend. A lot of clients will come just to be tattooed by a particular artist. Usually when there are a lot of clients, the elite artists can only do so many tattoos a day, and usually people want huge stuff, so then all the overflow—the people fired up to get tattooed—starts branching out, looking at all the other booths. I have been at conventions where I couldn't stop working, where I would work at night in my room, work 18 hours a day.*

Chris began moving into the top ranks of artists quite early in his career. This recognition meant he could find work in about any location

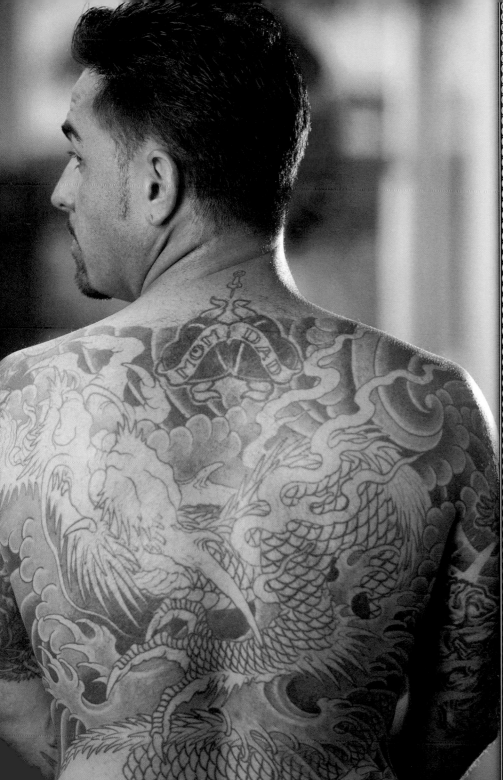
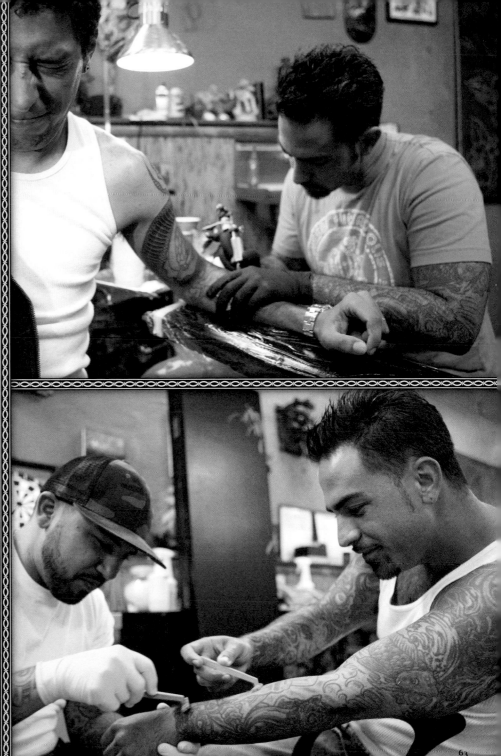

# Chris and his Mom

Chris has been close to his mom all his life. To celebrate their connection, he had her come to the shop and give him a freehand "Mom" tattoo on his leg.

"Chrissy, you sure you want to do this?" Mrs. Nuñez asked as he revealed his plan.

"Absolutely," Chris insisted. "It's all good. Dig away. Hold the machine just like a pen. Just do one line at a time though, okay?"

When Mrs. Nuñez was finished, she looked around the shop and proudly asked, "All right. Anybody else?"

"It's custom," Chris says of the finished design. "There's no tattoo or no thing that could be better than having something from somebody you really love."

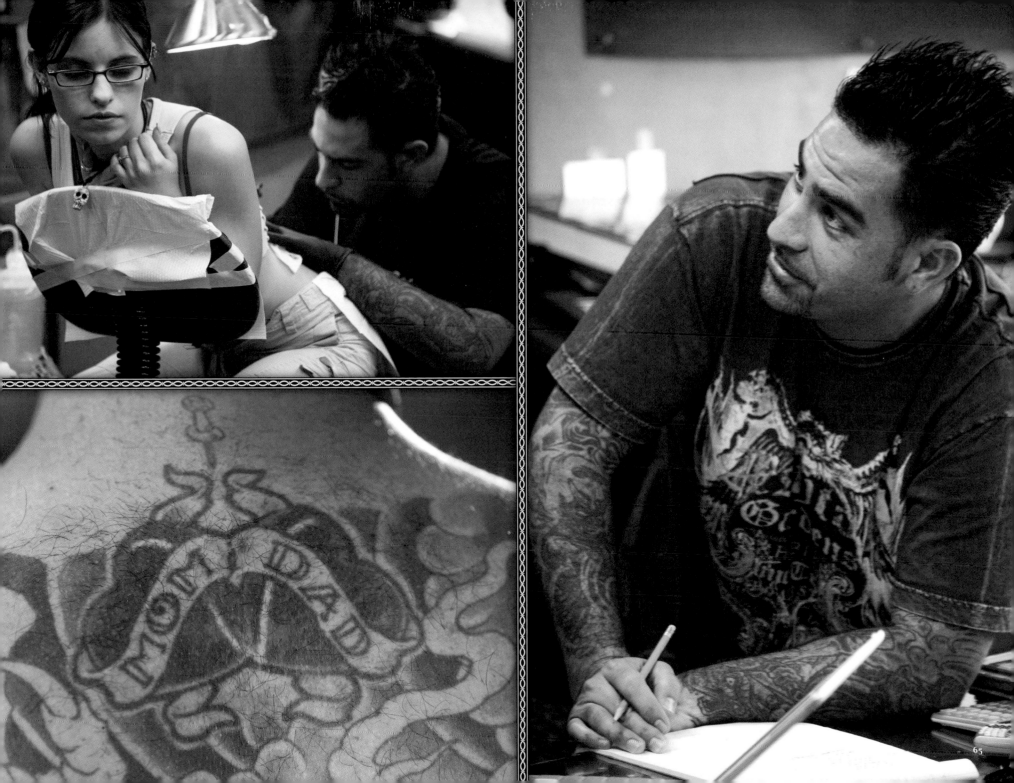

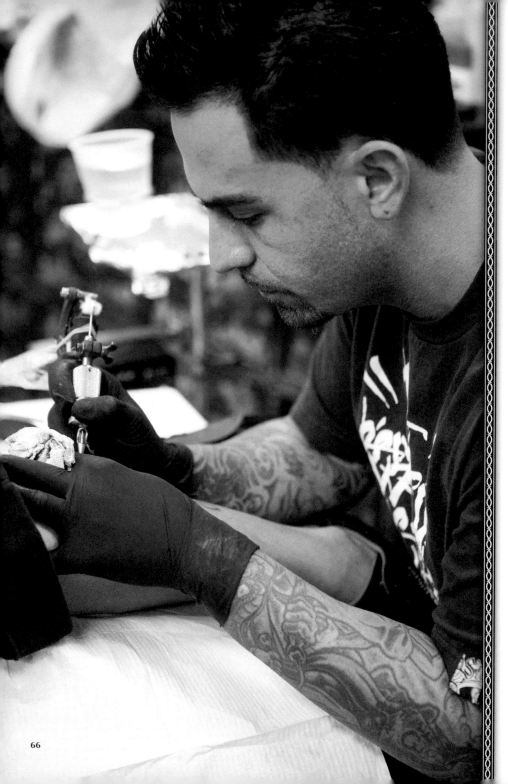

he wanted to be. Over the last decade he's made stops in dozens of major U.S. cities and has spent time throughout Europe and South America. He worked in Hamburg and Stuttgart, then moved on to Milan, Vienna, Salzburg, Graz, and Budapest, learning something useful in each location.

After covering a good chunk of Europe, he went down to Latin America, particularly conventions in Sao Paulo and Rio de Janeiro, to further refine his art.

*There's a big difference between handing your art to a buyer or putting it on the buyer. There's always more to learn. I'll be shown a technique in one place and take it to the next stop—always trying to get better. I've always tried to work day after day around artists who are really good, artists who do certain things better than I do. The idea is to keep improving and keep raising your personal standards. You get one*

*shot and learn over time. I think I've learned something everywhere I've been—things to do and, almost as important, things not to do.*

The history of Chris' growth as a professional artist is one of shared experiences. And today as a partner of *Miami Ink,* he is one of four artists whose work and energy inspire the best from each other. It's this connection, this mutual experience and camaraderie, that makes *Miami Ink* the best job he's ever had.

*Ami and I have been friends for close to 15 years. I've known Darren and respected his work for 10 or 12 years, and when I was starting to work I knew about Garver—he's been great since he started. And since we all first got together, we've been nightclub guys, always out in the fast lane. Usually we are working, but we also choose to go out, have a few drinks, and whoop it up.*

> *"You want to be surrounded with people that you like. I just want to go to work and have it be fun."*

THE ARTWORK OF

*Nunez*

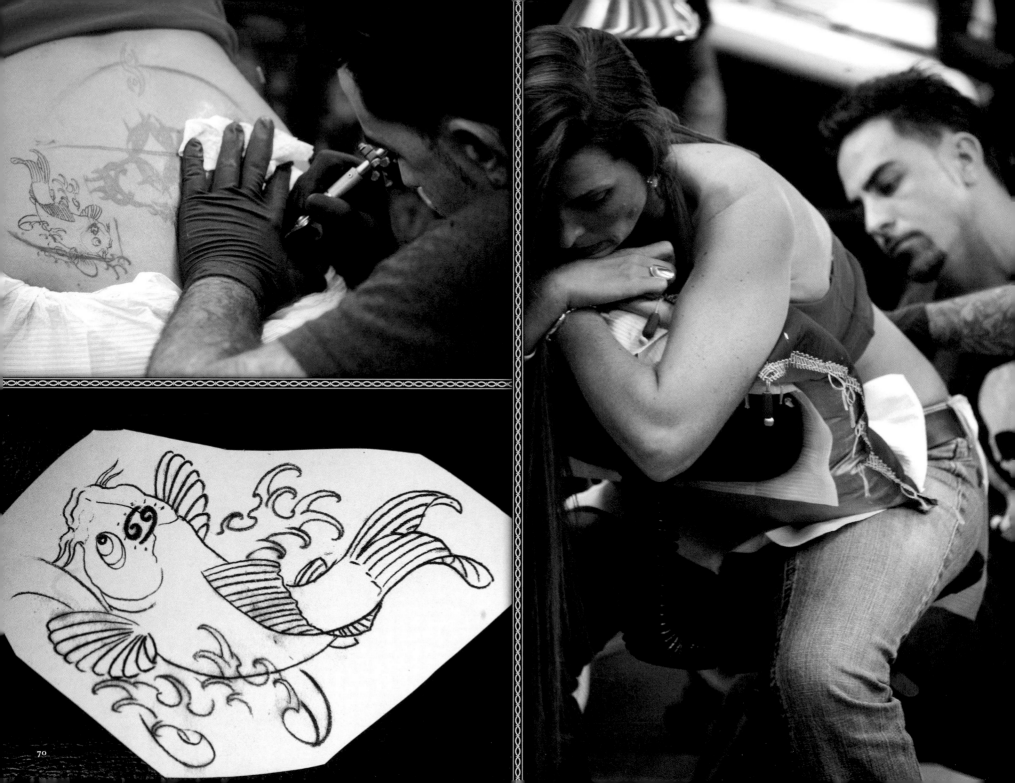

# Father's Day

Chris Nuñez was feeling down, but when Stacy walked into the shop he cheered up—a lot! A model from North Carolina, Stacy had heard about his work. She wanted him to place two koi fish on her lower back to celebrate her father. She also wanted her zodiac symbol, Cancer, and her father's, Leo, placed with the two koi fish.

*I'm a daddy's girl. My dad is a wonderful man. He works very hard. He farms, and I help him as much as I can. And I want to have something to remind me of him. I came a long way for a Chris Nuñez/Miami Ink tattoo. I didn't come to Miami for any other reason.*

When the stencils were ready and they were discussing placement, Chris suggested they move the fish a little lower and to the side. Stacy agreed. Chris was definitely enthralled with everything about Stacy, and as he worked she talked about her life in North Carolina. When she told him that

she also worked as a bail bondsman, Chris shook his head in wonder; that news just didn't fit her. But she felt that it made sense.

*Well, you know, you can't always look the part. You've just got to be the part. I'm a model too. I get people out of jail and I have my picture taken— a nice combination. I actually meet a lot of neat people getting them out of jail. Some people just fall on hard times and they're really good people. And then when I'm not doing that, I drive dump trucks and tractors on the farm. I'm an only child and whenever my dad needs help on the farm, I do it.*

When the tattoos were done she was thrilled—like all Chris' female clients.

*Chris was awesome. It was well worth my trip from North Carolina. When I get back to the farm, I'll send him a picture of me driving the tractor ... in a bikini top.*

> "I want to have something to remind me of him."

Client *Stacy*
Artist *Nuñez*
Tattoo *Koi fish*

Episode *1.17*
Title *While Ami's Away*
Air date *2-28-2006*

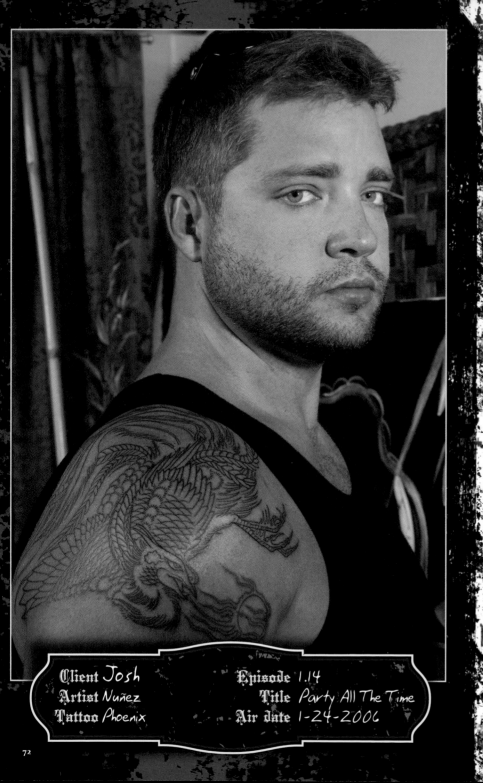

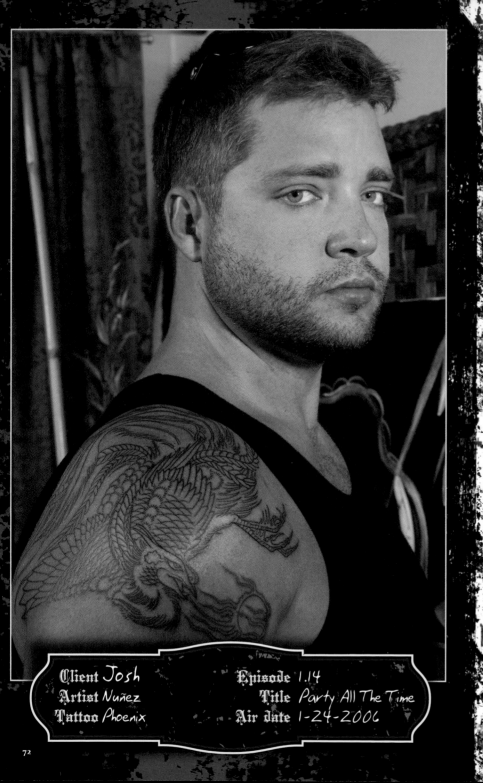

Client *Josh*
Artist *Nuñez*
Tattoo *Phoenix*

Episode *1.14*
Title *Party All The Time*
Air date *1-24-2006*

# From the Ashes

Chris Nuñez was doing paperwork at the front desk when Josh came in to discuss getting a half sleeve design that would cover one arm from shoulder to elbow. Josh explained that he wanted a major Japanese-style tattoo with a dragon, some black water, and some type of Japanese bird. Garver, off in the corner, suggested a phoenix.

*Yes, phoenix and dragons are like peas and carrots, they just go together. In Japanese mythology they share a long history.*

The next day, Josh came back to check out the beginnings of Chris' phoenix drawing. Because the design Josh wanted was so complex, a couple of visits would be necessary to plan and prepare the art for the actual tattoo. Chris traced the basic design on Josh's shoulder and back to map out the approach for the actual tattoo. He and Josh then talked about where to place the phoenix's tail.

*Having the tattoo up on top of the shoulder is a really hard area to work on because, whether you realize it or not, it's full of ridges and collarbones and dips and valleys.*

Chris laid a piece of plain paper over Josh's shoulder to get a clear idea of the amount of space he had to work with. Josh asked Chris more questions about the phoenix—because, after all, Josh would be living with one permanently. Chris explained the significance of this mythological creature.

*The phoenix rises out of the flames. He comes out of the ashes. He's like a reincarnation. The Japanese phoenix symbolizes the beginning of a new era, a symbol of justice and fidelity.*

Josh nodded. The phoenix was certainly the right bird for him because just a few years ago he was living out of his car and spending what little money he had on partying. But Josh had turned his life around. He was no longer sleeping in cars. Today he ran his own contracting business.

*This tattoo will be a constant reminder of where I came from and that I don't want to go back there. The way I was living was basically a slow*

*suicide. This tattoo alone isn't going to keep me from going back there, but it sure as hell is going to help remind me. I don't want to ever forget. I want to stay focused on moving forward because there's so much more.*

The third time Josh returned to *Miami Ink*, Chris had the sketch ready. They had made the decision earlier to omit the dragon and just do the phoenix as a symbol of Josh's commitment to healthy living. The sitting would be long and grueling for both Chris and Josh, but Josh had the harder part to play. Josh was ready and toughed out the session.

*I go through 10 or 12 hours of pain, not excruciating pain, but pain nevertheless, and my whole brain gets focused. The whole time I was thinking about my past and about where I want to be. What I want to be.*

Garver and Yoji hung around as Chris finished the detailed piece. Everyone agreed: The phoenix tattoo rocked. Josh was in awe.

*Chris—you took it to a whole other level. It's a true art form. When I'm dead and gone, you can mummify me. This is something that defines me and I will carry it with me for the rest of my life. Appreciate it, man.*

*"When I tattoo, I have music and just a little background noise and that's it. I focus on what I'm doing, everyone disappears and then tattooing is relaxing. I just go to work and I work."*

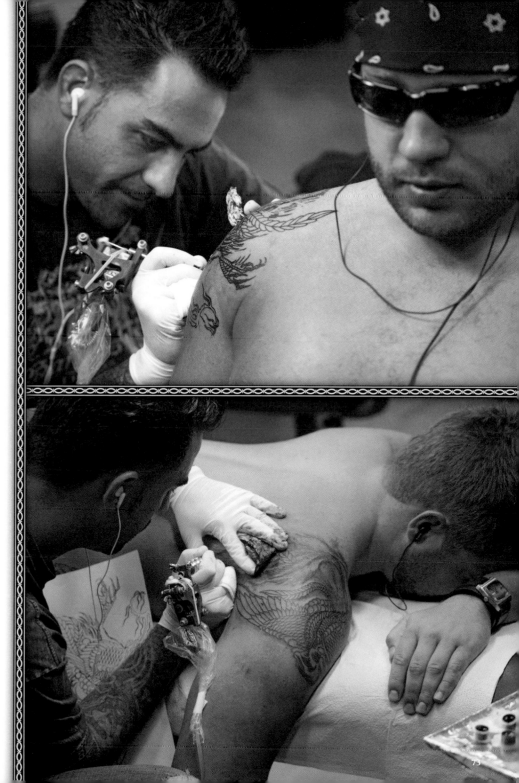

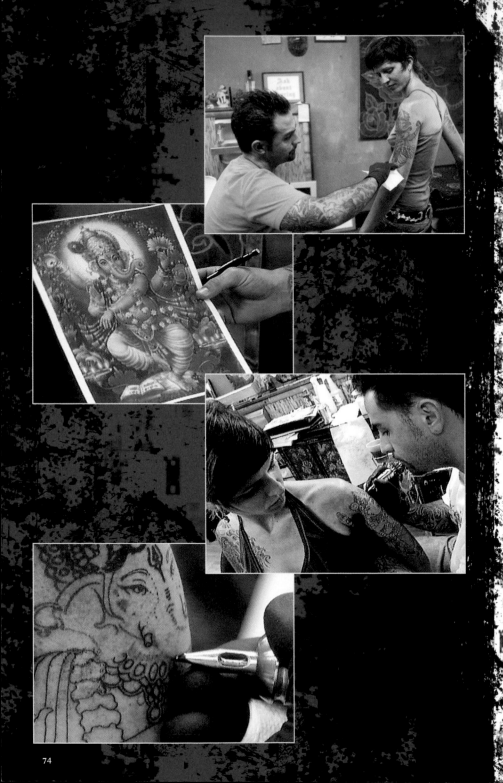

# A Promise

Anna works next door to *Miami Ink* as a bartender. She and Chris Nuñez are tight. A little over a year ago, after the loss of a very close friend, Anna transformed herself, making a new commitment to sobriety and healthy living. And things have been breaking well for her ever since. She talked to Chris about celebrating this new phase of her life with a tattoo, and Chris encouraged her.

*I think if you love somebody or there are powerful memories you want to hold, you can keep them with you forever. It's great to be able to look at a tattoo and be reminded.*

Anna wanted a Ganesh on her upper arm and she brought Chris a picture. Chris is excellent at intricate design and that's what a Ganesh requires. There was no question that the sitting for this particular tattoo was going to take a long time. Anna confessed to Chris that two hours was the longest she had ever stayed still. He asked whether she could do five or six hours, and she said it was a go as long as she could have occasional cigarette breaks. She was determined to have the tattoo as a symbol that she had changed her life. She wiped tears from her eyes as she remembered her friend.

*My friend who passed away had a Ganesh tattoo. It's a Hindu elephant-headed god, the protector of hearth and home, the opener of doors. It helps overcome obstacles and is a protector of women. So it's kind of like a tribute to my friend as well. I realize now what I've put some of the people in my life through. But I'm moving away from having an unfulfilled life. I'm moving toward having a happy life.*

When Anna returned for the actual tattoo, she brought a bottle of water with her, but she needed more than a single bottle to get through this experience. Chris joked with her during the session, playfully telling her to "stop giving [me] any lip." Inking the outline alone took nearly four hours and the style and location of her tattoo required it be completed in one sitting because reapplying and realigning

*"Skin? We're in Miami and we live in one of the toughest places in the world to make people look good. Everybody's in the pool, on the beach, in the sun. Here, it's sun exposure 365, 24/7, and skin is like leather, so it's all about your canvas."*

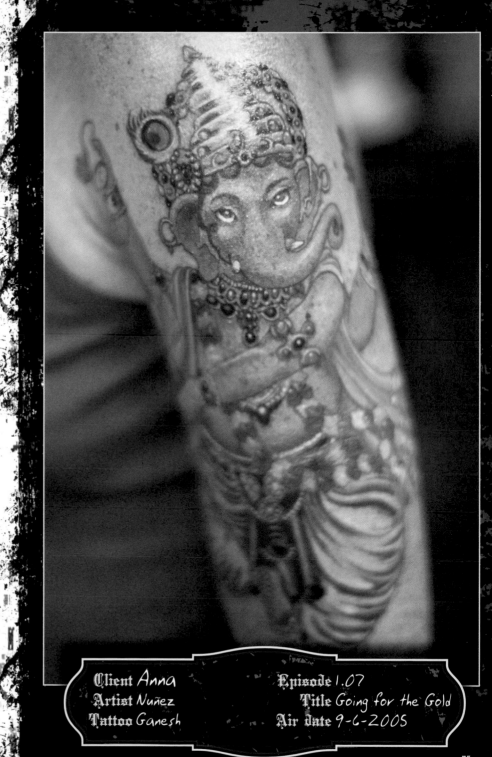

such an intricate stencil for a second session is almost impossible.

After a short break Chris and Anna continued again. The color was applied, and again the process was a challenge to both the client and the artist. Anna had now put in eight hours of sitting and this part was the most painful. She complained, but Chris kept working, telling her that they were almost home. She was still very edgy.

*It feels like someone scratching over the same surface really hard. But sometimes the most beautiful things cause you lots of pain.*

Finally the work was done. The intricate design combined with bright orange, pink, blue, and white details was awe-inspiring. A warm smile spread on Anna's face, seeming to say to Chris that no wait is too long when it means a good change. Chris gave her a hug, told her to "Take care, mama," and promised to drop by the bar soon for a celebratory drink. Anna spoke softly of the finished piece.

*It's beautiful. I knew Chris was going to do his best to get close to the feelings I brought him. It looks really beautiful.*

Client Anna
Artist Nuñez
Tattoo Ganesh

Episode 1.07
Title Going for the Gold
Air date 9-6-2005

75

# Trailing Blossoms

Casey and Jodi, sisters from Canada vacationing in South Beach, decided to get *Miami Ink* tattoos to highlight their trip. As they walked through the door, Ami greeted them. He was actually a little under the weather with an aching back, but he pulled himself together and chatted with the sisters about exactly what they hoped to get. It all sounded a little confusing as Casey described their vision.

*We are not only sisters, but we're best friends too. We've talked about getting lotuses, but we want to have different tattoos. I don't think I want a lotus. But maybe.*

Ami showed them some lotus pictures, stressing that they looked more like water lilies. He also showed them a drawing of cherry blossoms. Casey responded immediately to the cherry blossoms. Just then Chris Nuñez walked into the shop and watched Ami's bewildering conservation with Jodi. She just wasn't certain. She thought that she wanted a lotus, then again maybe a koi would be nice; or a rainbow—no, definitely a koi. And Casey wanted only the blossoms. Ami, forgetting his back pain for a moment and wanting only to get things moving, looked at Chris and asked him to do the cherry blossoms for Casey. He would do the koi for Jodi.

*Chris is very well known for his flowered pieces. He does a great job and I could tell that he was attracted to Casey. For me this will be the third koi I've done this week.*

When the tattooing was under way, Ami traded gentle and not-so-gentle barbs with Jodi. Chris chatted comfortably with Casey, who was quiet and relaxed. He talked her step-by-step through the session, which went very well. At the end Ami and Jodi hugged despite the tension between them—and of course Chris, who always does well with the ladies, got a big hug from Casey. She was a happy vacationer.

*It was beautiful work and I enjoyed Chris. He knows his art. I'll remember this amazing vacation whenever I look at my tattoo or see a cherry blossom.*

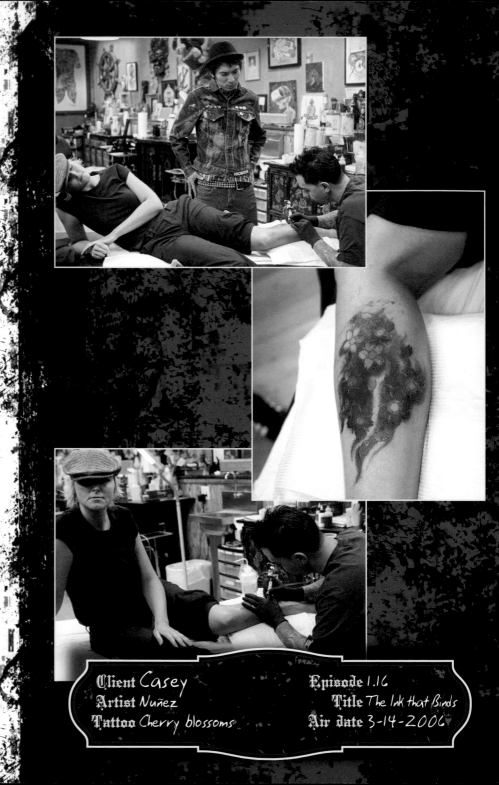

Client *Casey*
Artist *Nuñez*
Tattoo *Cherry blossoms*

Episode *1.16*
Title *The Ink that Binds*
Air date *3-14-2006*

Client *Caroline*
Artist *Nuñez*
Tattoo *Rearview mirror*

Episode *1.15*
Title *Kat's Return, Ami's Ride*
Air date *2-7-2006*

# Lucky Dice

Caroline and her husband felt lucky. She'd gone through three difficult pregnancies, but now they have three beautiful, healthy children. She wanted a tattoo from Chris Nuñez that both celebrated her deep gratitude for her children's existence and somehow kept them near to her always.

Caroline came into the shop wanting a tribal-type tattoo, but Chris wanted her to first talk a bit more to see whether something else might spark his imagination. He asked her to share some of the experiences she has had with her kids. Caroline described driving her car and always looking at them in the backseat through the rearview mirror to be certain that they were safe. This idea instantly sparked Chris' imagination.

*We can put your eyes in the rearview mirror—like you're watching the kids in the backseat. That could be terrific. We could dangle something from the mirror. How about some dice?*

The unusual image inspired Caroline as well.

*My eyes will always be there for them. I want lucky dice hanging from the mirror signifying our girls and our boy—a two on the one die and then a one on the other. I'm always going to be looking out for them regardless of where I am and what they're doing.*

Caroline was thrilled when she saw the unique design Chris worked up for her. When they began the session, she talked about how she enjoyed being a mom. And as the image took shape, she continued talking about her current role in life. When she looked at her finished tattoo in the shop mirror, she broke into a broad smile.

*I just didn't know what to say. It was so much more than what I thought it would be. Chris took something so basic and turned it into this complete work of art. I was so excited that I asked him to come and speak at Career Day at my children's school.*

Chris was pleased too. He hugged her and sent her off with a final pledge:

*I'll see you soon. Career Day! Pencil me in. The future of America!*

# Miami Ink Artist
# Chris Garver

Chris Garver is one of the finest tattoo artists in the world. But at age 34, he still considers himself a student—a home-study graduate student. This isn't false modesty. He knows that he's a leading artist, but he views his art career as a course of study that changes, expanding or at least shifting every day.

Comfortable in his skin, he moves smoothly, seemingly without effort, through a world of images, colors, sounds, and emotions accented with finished works that have earned him a spot at the top of his craft.

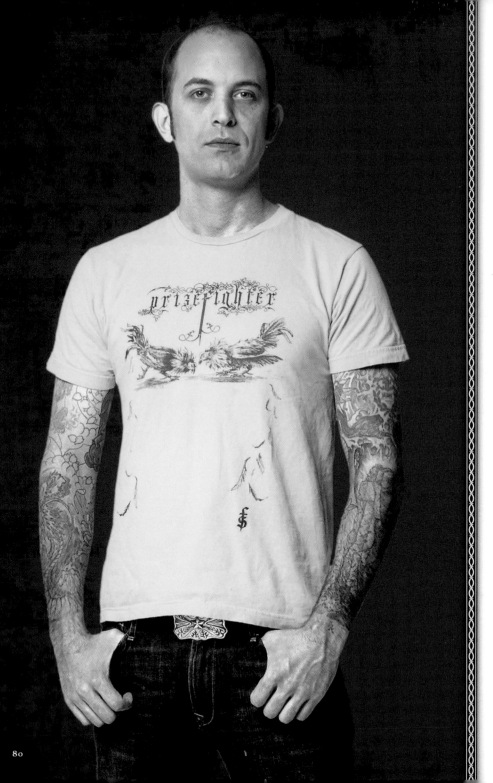

As a cornerstone of *Miami Ink,* he's the artist simply known as Garver—two soft-sounding syllables that wrap around a talent widely recognized as "one of the best." He grew up in Pittsburgh, the youngest of three boys, his mother an artist. He showed early interest in music and drawing. But when he reflects on his beginnings, the strongest coming-of-age memories involve gliding on a skateboard in the early 1980s.

*Life changed the day that I started skateboarding—because for some reason skateboarding introduced me to punk rock and the music. It was an exciting time. I had tons of friends, most of them were older, and they started getting tattooed when I was about 14 or 15. I really wanted one because the guy doing their work was really good. And the guys in all my favorite bands had tattoos and stuff.*

*When I got my first tattoo, I thought that the guy who did it had the life, so I was pretty focused on doing that. All those things that we got into while really young are still so cool now. Most*

people are embarrassed by the things they're into when they are kids, but I still enjoy it all.

Garver graduated from a high school for the arts (academics in the morning; art, drama, dance, and music classes in the afternoon). He did well and earned a scholarship to the Art Institute of Chicago. But he didn't stay long.

*My parents weren't too happy when I quit, but I wasn't ready for it. I wasn't really into what they were teaching. So I stayed in Chicago and started tattooing. I wasn't sure that I really wanted to take tattooing super seriously, but I went through an apprenticeship for about a year.*

While still in high school Garver laid down his first tattoo on a boyhood friend, poking him with ink-dipped needles tied together with thread. It was during his first days at the Art Institute that he tattooed himself for the first time. Using his roommate's equipment, he etched a small dragon on one ankle. But his first professional tattoo as an apprentice left him questioning his decision to become a tattoo artist.

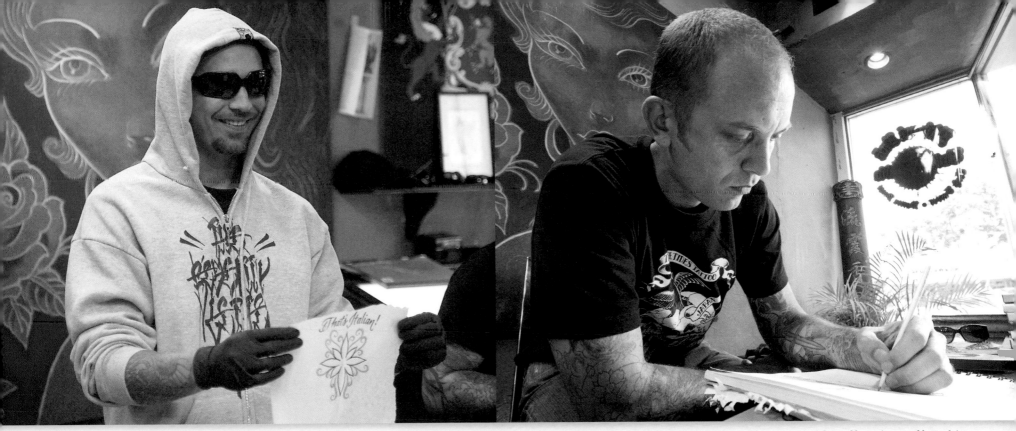

Whether laying on ink, finalizing a design with a client, or sketching at the light table, Garver brings cool, quiet purpose to the shop's hustle. His calm has made him the go-to guy for creative insights and last-minute problem-solving.

*The client wanted a chain link wristband. When I sat down to shave the hair off his wrist with a disposable razor, my boss says, "Nah, this is the big leagues now." He handed me a straight-edge razor. The guy was a 300-pound biker, and I slashed his wrist open on the wrist knuckle. There was blood all over the place, and I almost passed out. I thought he was gonna kill me. I was only 18! But he* didn't care. He was just kinda laughing at me, and I ended up tattooing him. It came out all right, I guess ... I stayed in the business.

New York was Garver's next stop. After a year as an apprentice in Chicago, he enrolled in the School of Visual Arts on Manhattan's East Side. He wanted more information on technique and felt that he might find it in classes.

*"One of the things that helped me become a better artist was trying to always take a fresh approach to what I was doing."*

81

A TATTOO DOESN'T HAVE TO BE LARGE TO BE IMPORTANT. MY GIRLFRIEND WANTED TO TATTOO ME WHEN WE WERE IN BALI. SO I SAID, "HOLD MY HAND, AND WHEREVER YOUR THUMB TOUCHES ME YOU CAN PUT A DOT THERE." IT'S ONE OF MY FAVORITE TATTOOS.

Chris Garver

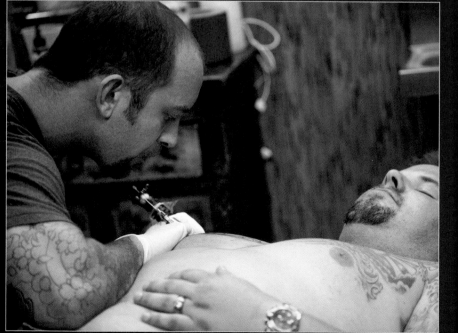

Garver's dedication in the shop is matched by his passion for after-hours relaxation. Like the yin-yangs featured in some of his Asian-influenced work, his life is a balancing act of intensity and reflection.

*I didn't want to talk about art, I wanted to make it. But I didn't get along well with some of the students. I was working my ass off in art classes and most of the students weren't that interested in art. They were there to play. It felt like I was in the wrong place for me. And working as a guest in some of the New York tattoo shops— I was just making way too much money to keep going to school.*

A year later Garver was working in South Beach at Tattoos by Lou with Ami James, Darren Brass, and Chris Nuñez. His work was outstanding and noted almost from the beginning. He spent some time on the convention circuit, and began traveling the world, committed to a career as an artist who does tattoos.

*One of the things that helped me become a better artist was trying to always take a fresh approach to what I was doing—not take it for granted and just try to get by. I still want to make everything special. It doesn't always happen, but that's what I strive for. Even though you do the same imagery over and over and over again, there's something new that you can bring to it every time. I just don't get bored with it. I can try a new thing that I've been thinking of—it just keeps it fresh.*

Being a good tattoo artist takes a lot of skill, care, and work. First you have to be good at drawing, and have a good color sense. You have to understand composition—how an illustration lays on the body, and how it's going to move. You have to consider how a tattoo is going to age. You have to be a good listener, to understand what your client wants. And you have to be a little compassionate because in the process of creating art, you're hurting somebody—you have to try to be gentle when they are hurting. And sometimes you have to be tough, because some customers will try to walk all over you.

> "I still want to make everything special. It doesn't always happen, but that's what I strive for."

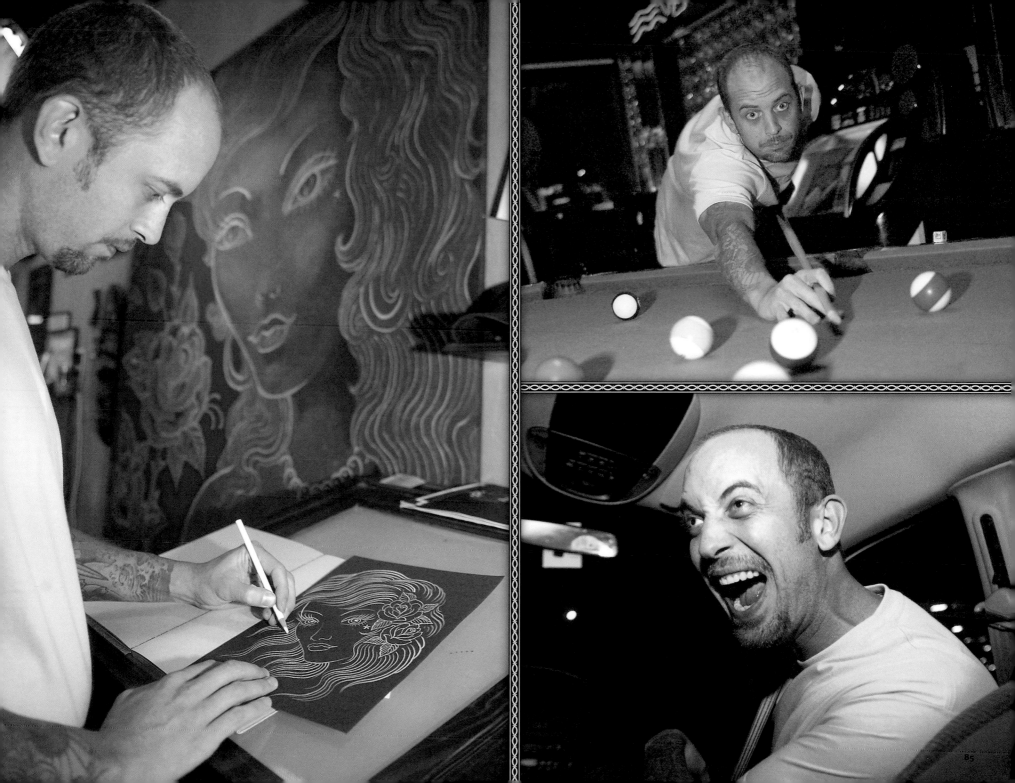

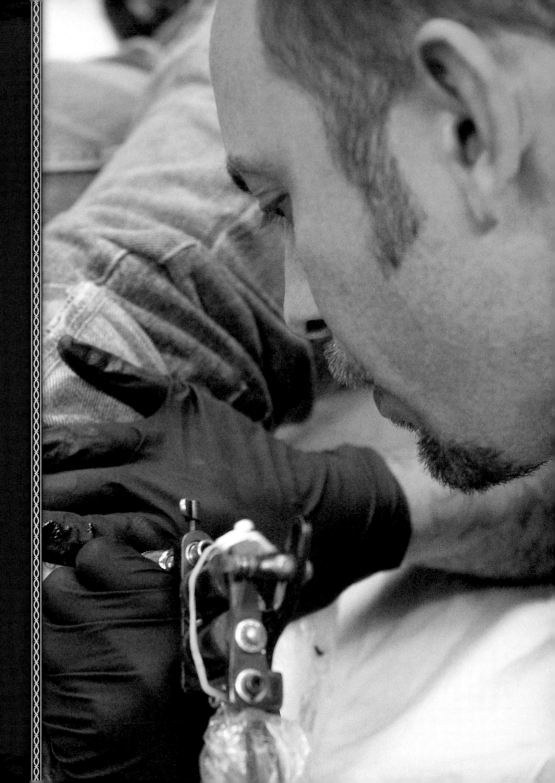

# Garver on Garver

To me art is just about making a picture. That's what I do. The difference is I give people what they ask for, and I do it on their skin. I don't think any medium is more powerful than tattooing—it has real impact. It's on someone's body for the rest of their life. It's not a piece of art that someone can buy and then sell later on when they tire of it.

One of the things that tie my tattoos together are the cherry blossoms. They symbolize that life is beautiful and it is short. A cherry bud blossoms; it blossoms and then it dies, falls off the tree very quickly. It reminds me that I have to make the best of my life.

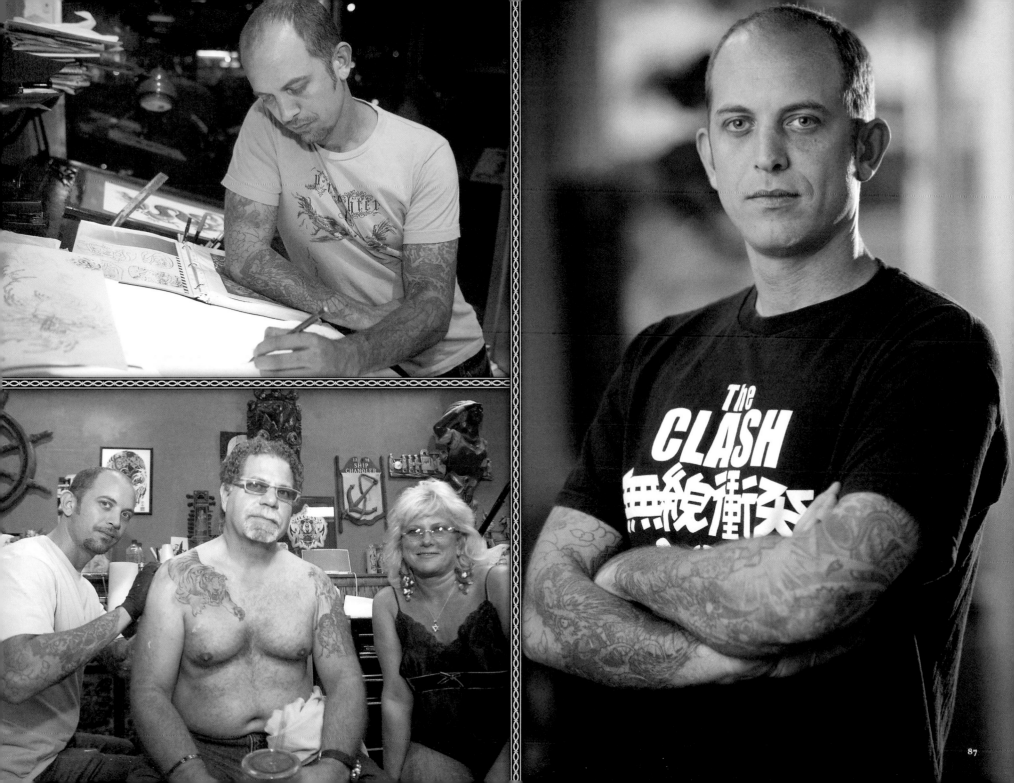

*Art is just about making a picture. That's what I do. The difference is I give people what they ask for, and I do it on their skin. I don't think any medium is more powerful than tattooing—it has real impact. It's on someone's body for the rest of their life. It's not a piece of art that someone can buy and then sell later on when they tire of it.*

*One of the things that motivates me is that my art is something that I can continue to get better at. I feel pretty challenged every day to bring something new to what I'm doing, to push myself, to keep it exciting. I like the fact that my job is very social and is one of my favorite things to do—and that if I keep trying, I'm always going to get better. I can live off of that.*

Since his early days, Garver has been considered an outstanding stylist of Japanese tattoos. It's one of several styles he has mastered. Extensive travel through the Far East, from Japan down to Thailand, gave him insights into traditional approaches and methods that result in the large dramatic images representative of tattoos from the area.

*I tattooed some Japanese artists who were visiting New York in the late '90s. They were well known in Japan and I got invited to visit them there. I jumped at the chance. I had been studying Japanese tattooing, and I decided I'd go to the source of the art. I think that's the best way to learn. I'd hate to see the old techniques die out,*

> "The tattoo he gave me signifies protection, and it's a blessing. In Thailand it's considered a very powerful thing to have."

*but there are still some young people who are continuing the old ways. Tattooing is getting really diverse in Japan. Just a few years ago it was unheard of that there would be a storefront tattoo shop. Now it's pretty common.*

One reward of travel is unplanned moments that occur and become part of the traveler for life. In Thailand, Garver was able to fulfill a dream and receive a tattoo from a monk.

*I went to Thailand with my girlfriend, Carla. One of the things I wanted to do was to be tattooed by a monk—it's a spiritual experience and it was awesome. I got tattooed in a temple. That's very unusual, and it was something that I think in a way really changed my life.*

*The temple was beautiful. We walked up a long stairway into a room open to the sky. There were pillows in all four corners. We sat down on the pillows, monks began chanting, and an old monk tattooed me. The sun was setting in a pink sky, monks were everywhere and it was an incredible experience.*

*The tattoo he gave me signifies protection, and it's a blessing. In Thailand it's considered a very powerful thing to have. I'm not sure that I believe in it as much as they do, but I've been pretty lucky ever since I've gotten it. So maybe there's something there.*

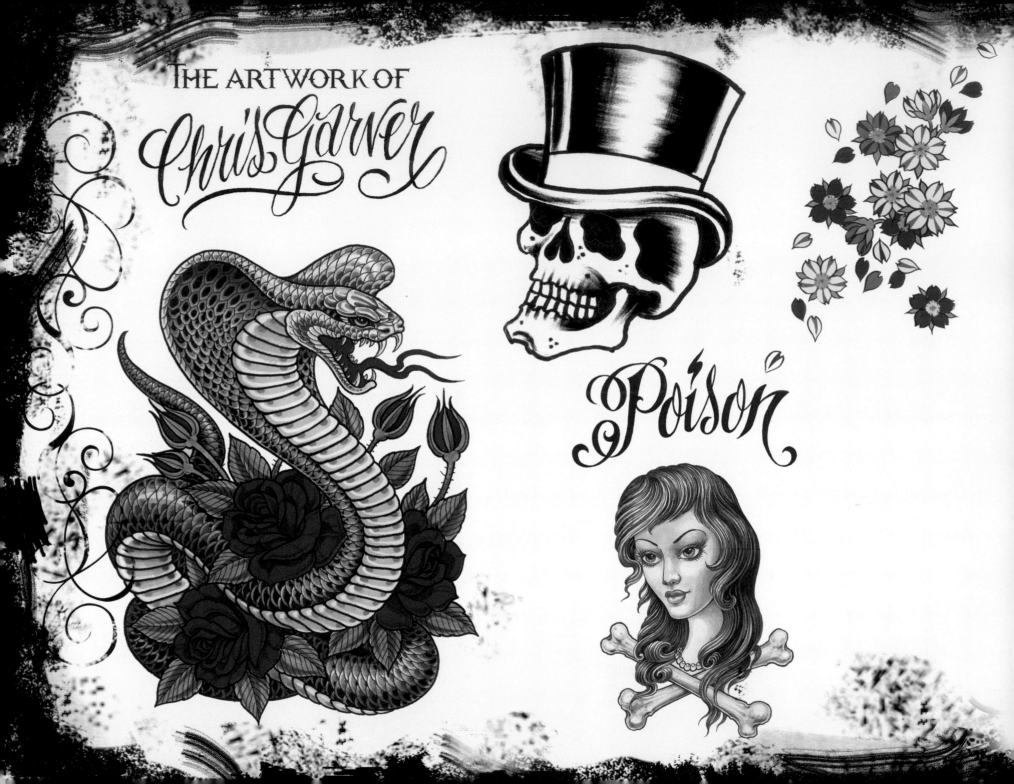

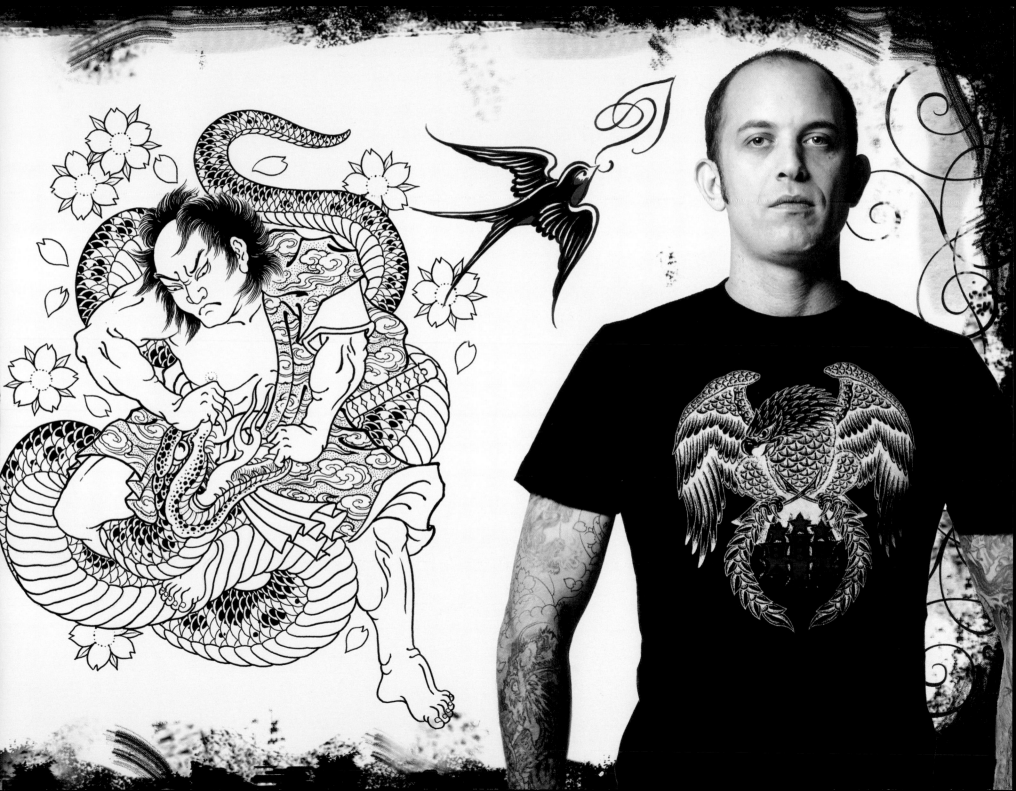

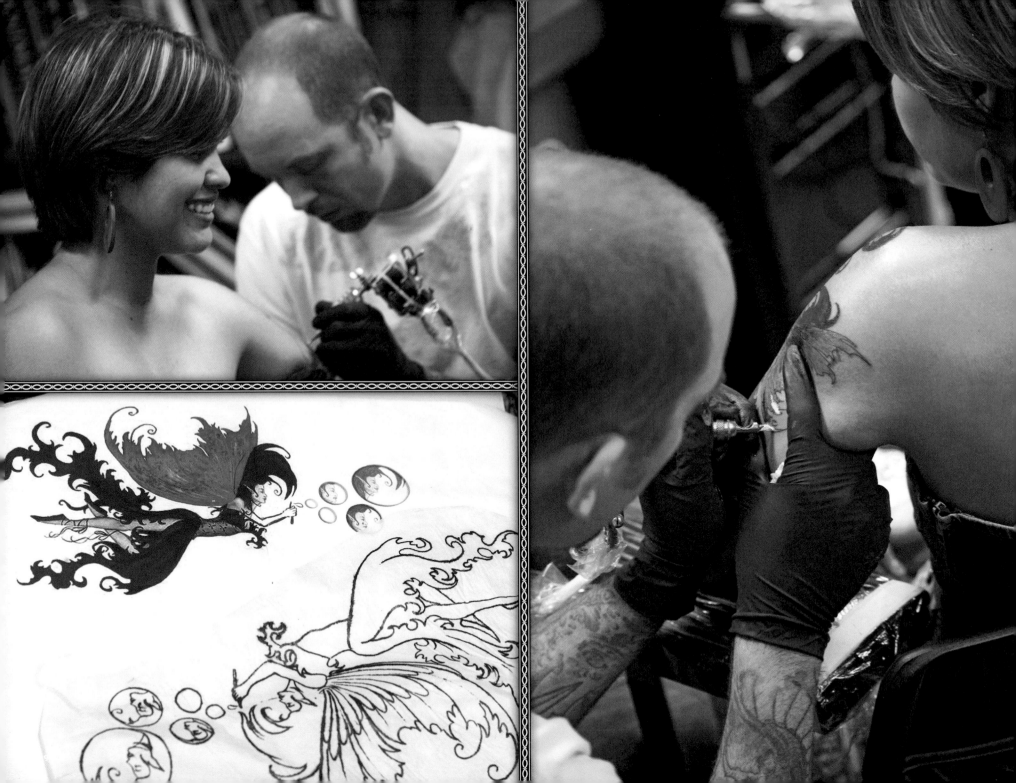

# The Good Fairy

Sue came in with a picture of a fairy that she wanted Garver to tattoo on her arm. He asked for some time to work on a sketch. It was a complex image that would result in a complicated tattoo. It was going to take a while.

*Sometimes you just do what you have to do. And this one better have a really good story with it.*

Sue returned and told her story.

*I've always loved fairies. Basically the fairy is going to represent me, and the faces in the bubbles are the emotions that I've been through during my fight with cancer. I want the first bubble to be a worry face, because that was my first emotion when I heard the word "cancer." I was so worried about my life. The second bubble should hold a crying face. I cried a lot during the whole process. And the third bubble is a smiling face, because that's how I'm feeling now—happy, healthy, and living my life again.*

Sue got to Garver as she talked about being a singer/songwriter. Right after her surgery, she had no voice and couldn't sing.

*I can't imagine my life without singing because it's my passion. I'll get back to singing and writing. I have a lot to say, a lot of emotions inside me. But fighting cancer has definitely made me strong and brave.*

Garver was honest when the session was over and he said goodbye to Sue. *I had a hard time making your tattoo, but when I was done I felt great because you were so happy about it. And you deserve happiness.*

*"... I felt great because you were so happy about it. And you deserve happiness."*

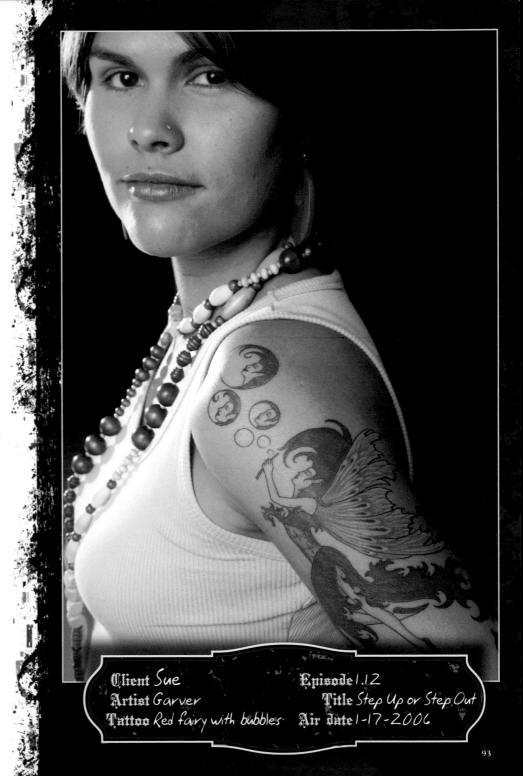

Client *Sue*

Artist *Garver*

Tattoo *Red fairy with bubbles*

Episode *1.12*

Title *Step Up or Step Out*

Air date *1-17-2006*

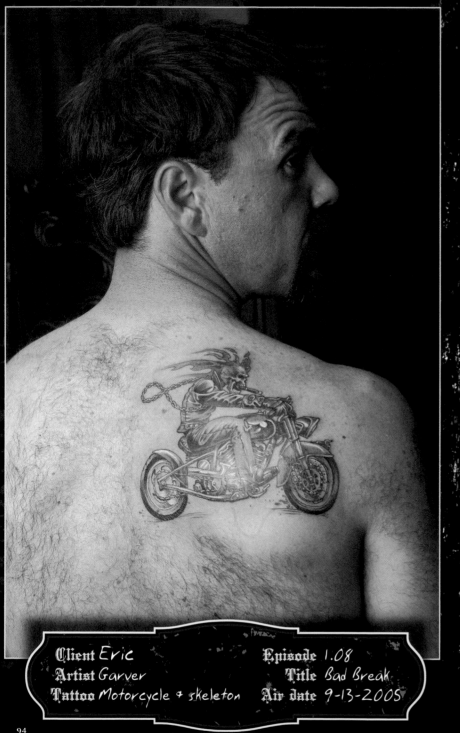

# The Big Birthday

Jen's husband Eric was about to turn 40 and she wanted to give him something very special for his birthday. She called *Miami Ink* from their home in Chicago and made an appointment for her husband to get a tattoo from Garver. Ami liked the idea too—a gift certificate to the shop. Nothing better.

Eric loves motorcycles and after traveling down to South Beach and meeting with Garver, he asked for a cycle tattoo. Garver remembered some pictures he had seen of a skeleton zooming along on a bike. He suggested that they put a cigar in the rider's mouth and get to work. Eric wanted the tattoo on his back, and Garver suggested that they place the piece so the cycle would look like it was riding away. Jen and Eric went back to their hotel to rest, and Garver began to draw.

*There are so many lines in this thing. I've never tattooed a motorcycle before, but I'm sure I can make it work out nice. I think he liked the idea for two reasons. One, he loves motorcycles,* *and the other is the skeleton—it's just the kind of a bad-boy image that goes along with the motorcycle.*

When Eric returned for the session, he was a happy man—it was a great way to celebrate turning 40. Jen sat and watched closely as Garver worked.

*Eric is the kind of guy who doesn't do a lot for himself, so being able to give him something that means so much is just the best thing ever. He's a little crazy and likes to live on the edge. I think one of the wonderful things about this design is that it's kind of a bad-boy tattoo. It's showing a little more of what he's really like.*

When the session was over, Eric studied the bike in the mirror. He beamed. Then he turned to his wife. For a moment he was choked up. The birthday gift was a total success.

*What a gift! Garver did a great job. The shadings and details are incredible. I'm ready to show it off. And I can't believe Jen did all this—did all this just for me. What a great wife! What a great wife!*

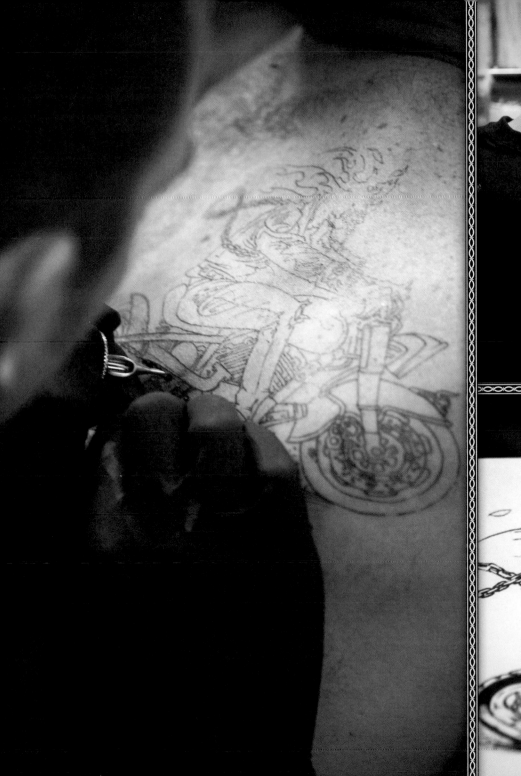
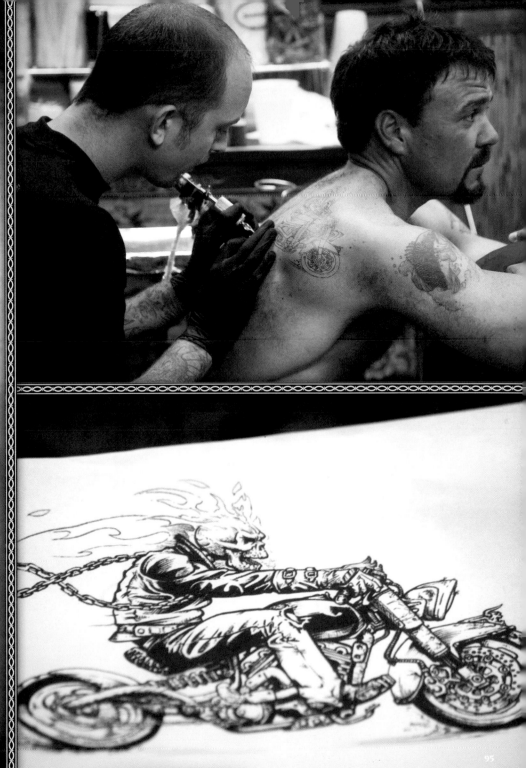

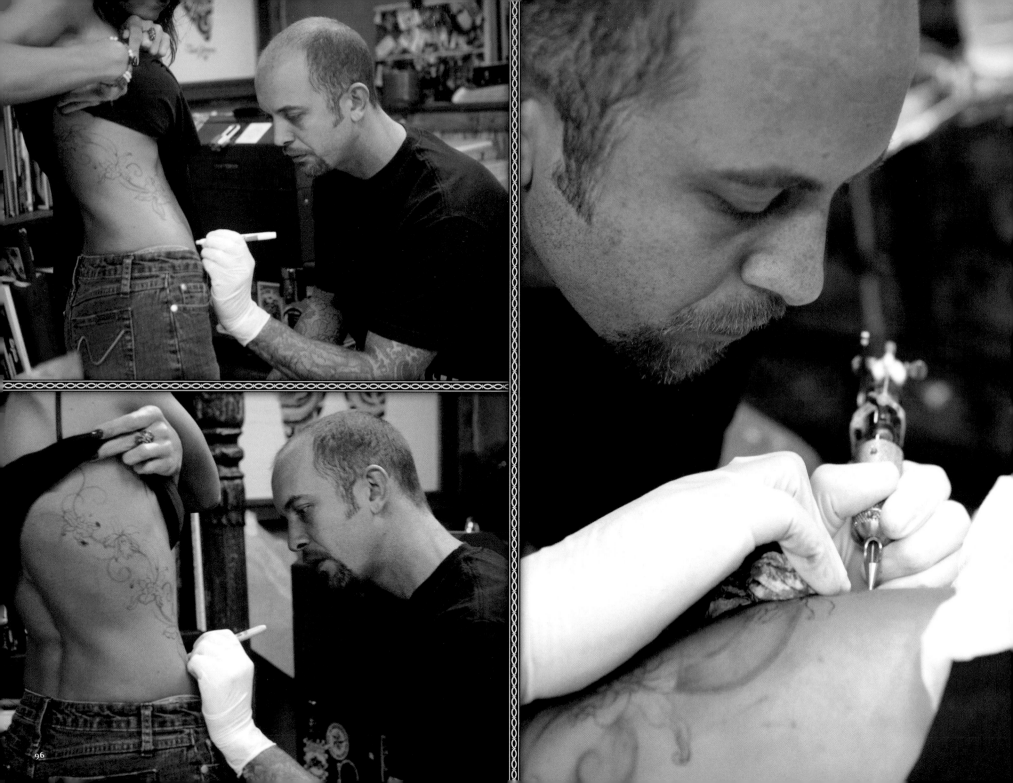

# A Promise

Cindy wanted a Garver tattoo. She came into the shop wanting something feminine on an unusual and difficult spot to work—the shoulder blade and rib cage. Not only is this area one of most sensitive parts of the body to tattoo, but because the body curves, the artist sometimes needs to make adjustments. Cindy chose flowers and a flowing vine. Garver zeroed in on how to do his best work.

*I'll just draw the vine on you and make a stencil of the flowers. I'll freehand the connections. That way I can place it. If I were to stencil the entire thing, the vines might not work with the anatomy as well. I can see where the lines look really good on the body when I draw them on. I'm going to give it a little Art Nouveau look.*

Cindy was impressed with Garver's understanding and the design he developed. She talked with him about the reasons the tattoo was so important to her.

*I battled an eating disorder for the past eight years and it's been a slow healing process. The tattoo symbolizes a promise that I made to myself to respect myself and to accept my body. This will be a permanent reminder of that promise.*

Cindy returned to the shop several days later when the stencil was ready. Initially she seemed pretty calm, but when Garver began the outline she became tense. As Garver kept working, Cindy talked softly about why for years she couldn't appreciate or accept her body. Everything she did revolved around food.

*I got so enthralled about something I could control—what I ate and what I didn't. Your self-perception gets completely distorted when you have an eating disorder.*

Looking in the mirror at the end of the session, Cindy was pleased with herself and with Garver's work.

*It was painful. But I just pictured the end result and how great it was going to be. I feel beautiful, feminine—like the tattoo. I think I'm going to feel this way for a very long time.*

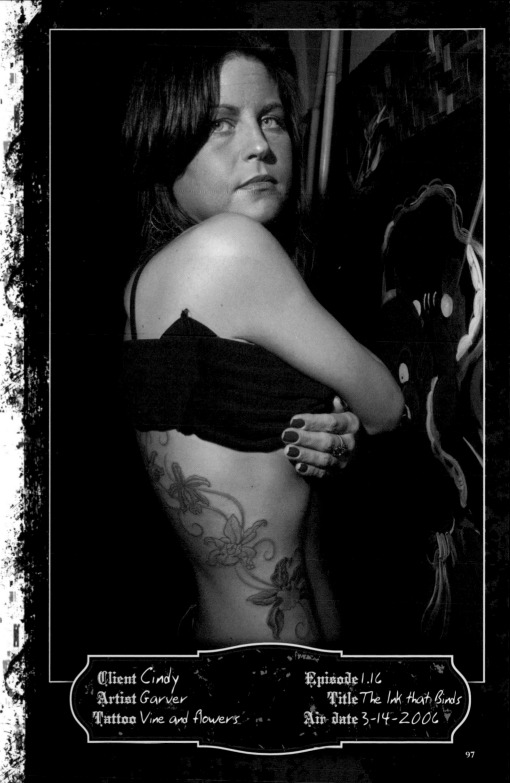

Client Cindy
Artist Garver
Tattoo Vine and flowers
Episode 1.16
Title The Ink that Binds
Air date 3-14-2006

# Calming the Storm

Paul, a young, unassuming South Beach musician with dreadlocks, came into the shop with a tattoo idea that he hoped would help him maintain balance while immersed in the chaos of the music business. His description of what he wanted sounded like he was looking for a guardian angel.

*I want a face, a female face, here on my arm, and have the feathering kind of flowing out. I know that people often get a religious female figure. I don't feel I need to go that route. But I want something angel-like, peaceful, just black-and-gray tones and a little white. In a lot of different art forms women are serene, very peaceful no matter what's going on around them. They might be living with death and chaos, but these women are always in control.*

Garver liked Paul's idea. It triggered his own imagination.

> "He gave me an idea of what he wants. He trusts me and lets me do what I want."

*Paul is pretty much a dream customer. He gave me an idea of what he wants. He trusts me and lets me do what I want. I understand the kind of beauty he was searching for. That was enough for me.*

Throughout the session, Paul was calm, as though the tattoo he wanted was already working its magic. He was impressed by Garver's intense work style during the session.

*When you cut him loose, you can just tell he's locked into his work. He gets this little head tweak—he just stares and you know he's in there and he's doing great work.*

*I've grown up around artists—very visual painting, drawing, all that stuff, and I know Garver's very big. He's a superb artist. I just had faith, complete faith in him. And the face he created has the most peaceful, calming feeling. It's perfect.*

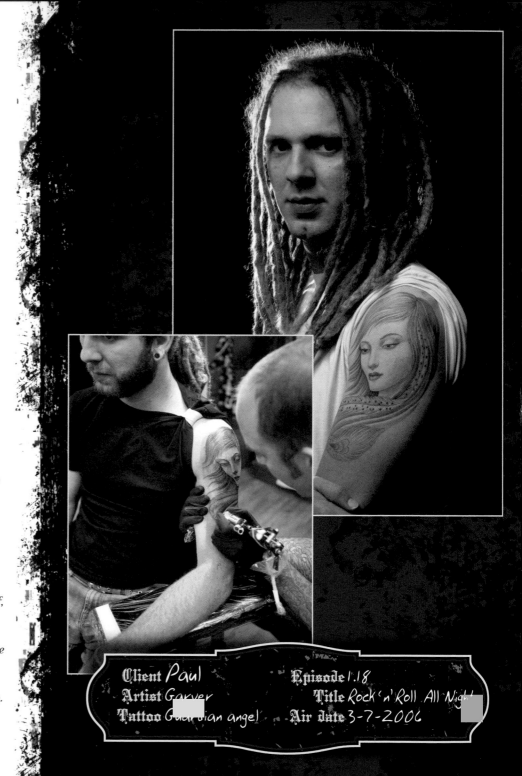

Client *Paul*
Artist *Garver*
Tattoo *Guardian angel*
Episode *1.18*
Title *Rock 'n' Roll All Night*
Air date *3-7-2006*

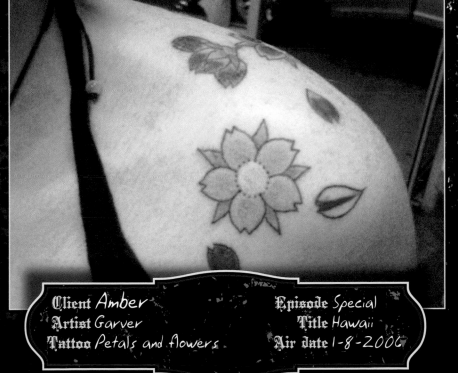

Client *Amber*
Artist *Garver*
Tattoo *Petals and flowers*

Episode *Special*
Title *Hawaii*
Air date *1-8-2006*

# A Blue Flower

It was Amber's birthday. She was turning 20, leaving her teens forever. At the same time she was dealing with the pain of rejection—her boyfriend had let her down and the relationship was over. Amber walked into Hawaiian Tattoo Company and talked to Garver, who was doing a guest spot, about a unique idea for a back piece.

*I want to get some flowers on my back so it looks like the wind is blowing them. I want the flowers to come up on my shoulder. And petals, yes. That would be gorgeous.*

*The last two months have been crazy for me. I never trusted somebody that much and had so much faith in a person—and then it had to be stripped away instantly. It was a big breakdown for me. This tattoo will mark a turning point, a new beginning in my life.*

Garver created two stencils, one for the flowers he planned to scatter across Amber's back and one for some additional petals. To emphasize her birthday number, Garver placed 20 flowers down her back. Then they discussed colors. She knew she wanted one blue flower.

*The blue flower is on my shoulder, closest to me. It will stand out and remind me that even though I am letting go and changing my life, I don't want to change who I am.*

Garver finished the tattoo, and Amber admired the results. He asked her if she knew herself a little better now. Her response was great to hear.

*I need to live life day to day and remember that things about one guy don't matter much in the big scheme of life. This will be a wonderful visual reminder to keep with me.*

> *"I need to live life day to day and remember that things about one guy don't matter much in the big scheme of life."*

Miami Ink
Artist

# Darren Brass

**M**AYBE IT'S BECAUSE HE STANDS A PUGNACIOUS 5 FOOT, 6 INCHES TALL. MAYBE IT'S THE BEARD AND BIG, FAST GRIN. OR MAYBE IT'S THE STEADY, EASY WAY HE CAN REASSURE A NERVOUS FIRST-TIME CLIENT OR A TATTOO VETERAN WHO IS STILL SENSITIVE TO THE PRICK OF NEEDLES. WHATEVER THE REASON, "TEDDY BEAR" DARREN BRASS IS THE KIND OF GUY YOU WANT IN YOUR CORNER. OF COURSE, IN ADDITION TO THE NICETIES OF ENCOURAGEMENT AND SUPPORT, YOU'RE GOING TO GET ONE HELLUVA TATTOO BECAUSE YOU'RE WORKING WITH ONE OF THE FINEST GRAPHIC AND TATTOO ARTISTS AROUND.

An easy, in-and-out business trip—that's what it was supposed to be. But as the tattoo fates would have it, 22-year-old Darren Brass' first trip to South Beach to do a guest spot as a visiting tattoo artist turned out to be much more. Art Deco Week—the popular festival each January that draws crowds of more than 500,000 to Miami—was about to start, and Tattoos By Lou always staffed up when a lot of tourists were expected in town.

*I came down from New York to the Beach to do a four-day gig. One of the main reasons I agreed to come was that I knew that Chris Garver, an artist who I'd admired for years, was working at the shop. As it turned out, Ami was there too. And Chris Nuñez was in and out during those first days. It was great. I made more money than I ever had and worked with the most incredible crew I had ever worked with. Everything just fell into place. At the end of the long weekend, I was offered a permanent position. And, of course, I took it. From there, we just developed a friendship.*

The four-day South Beach guest spot lasted a year and a half. It was an extended stay that changed Darren's life in several ways. For the first time he could truly settle into his art. And he was finally in a position to share a learning experience with several developing artists.

*It was one of the moments in my life where I took that step forward. Miami has always been a great place for me. I never again questioned whether tattooing was the art I wanted to do. Those first few days I thought, "Wow! Here I am. I made it to South Beach. This is absolutely what I want to do." What got me there? The tattooing got me there. And since then tattooing has pretty much gotten me everywhere I wanted to go and pretty much gotten me everything in life I wanted.*

Growing up in Waterbury, an aging blue-collar town in eastern Connecticut, Darren Brass was certain that he was, and would be, an artist. He could draw, so that's what he did. Because walls were easier to find than good drawing paper—and they allowed him to work large—his first major

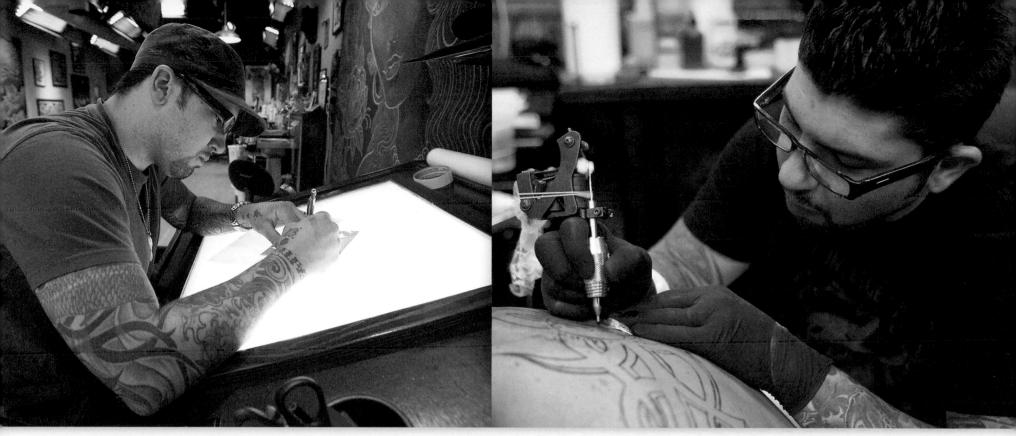

The images and words in many of Darren's best tattoo designs seem to effortlessly blend into a cohesive whole, but those flowing fonts and interlocking images require careful planning and refinement to get just right.

artistic outlet during his early teen years was graffiti. His initiation into the art of tattooing came during the same period—not by getting tattooed but by drawing designs for friends.

The painting of graffiti and the creation of tattoos have a number of things in common. In the late 1980s, when Darren was beginning his art, both forms were generally considered outlaw media. (Although most U.S. states now permit licensed tattooing, graffiti generally continues to be heavily restricted.) Both art forms drew attention. As personal statements they each had—and continue to have—a boldness that challenges the status quo. To excel as a creator in either form, talent must combine with an opportunity to develop that talent. And for the artist, each demands considerable investments of time.

*I did a lot of graffiti. It's an incredible art form and it's hard work. I love the art. I wish I had the time to be out there still doing it. But you don't make money with it. It's pretty tough. We would go out about 11 at night and be out until 6 or 7 in the morning. We would walk the [subway] train lines and go down and down, and if there was a laid up car, then we were going to hit it ... bridges, tunnels, everything.*

*"The least painful place to be tattooed is wherever you want it the most."*

The lettering on my wrist, "faith" and "hope," is there because I don't feel that you can go wrong with those on your side. I have shamrocks on my hand; I'm Irish. I have a red shamrock because I'm Polish too.

Darren Brass

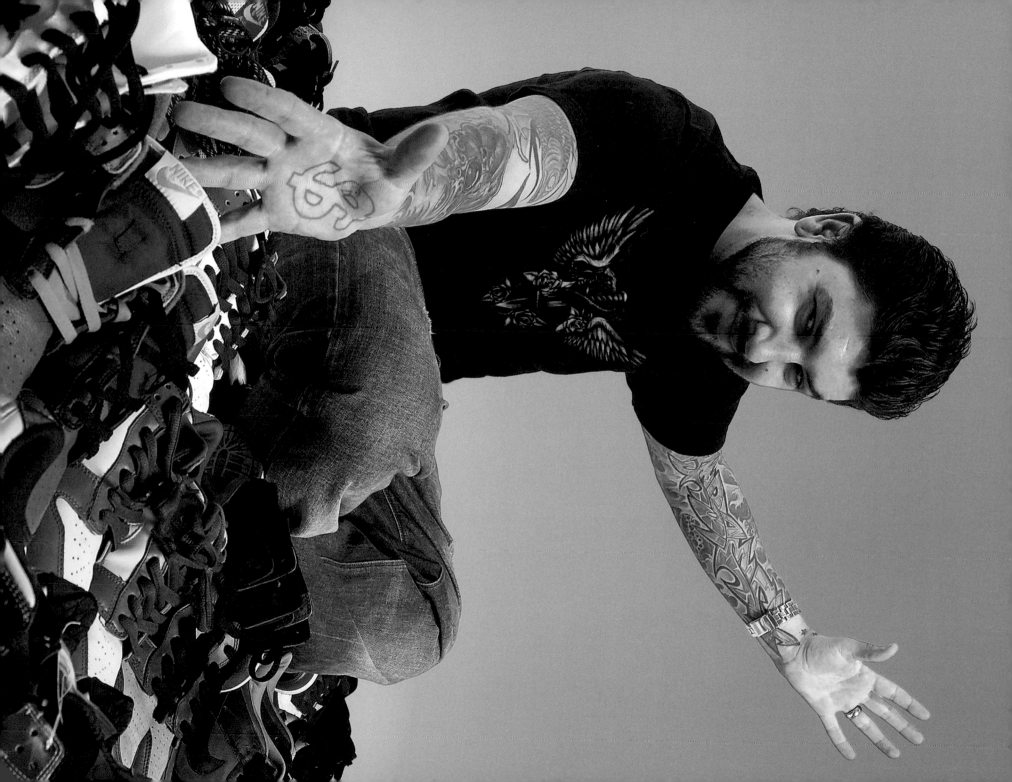

Whether he's prepping equipment for his next client, discussing a segment for the show, or cruising the streets of South Beach, Darren is always diligent and focused, cool and collected.

We would just hike and paint, working fast, for 10 to 12 hours. You would spend about 5 to 10 minutes on a piece and get that big, bold lettering up there. Just get your name up there. That's called "bombing." That is a big part of it. And there were murals. If I felt safe and thought I would have the time, I would just do the big piece.

Following high school and a semester and a half of art school, where he took calligraphy and drawing courses and studied painting with acrylics and oils, Darren was bored with classrooms and decided to get an education in tattooing. He had been tattooed for the first time on his 18th birthday and liked the experience a lot. With help from a friend who had connections, he began an apprenticeship at an underground shop in New York City. It was a major move for an art student from Connecticut.

*"I love Miami Ink; I get to work with some of my best friends, a group of incredible artists."*

When I first told my parents, "Listen, this is what I am going to do, I am going to be a tattoo artist!" they were very wary. They were still getting used to the tattoo (a sun, on my forearm) I'd gotten a year earlier. Their first questions were "Are you going to make money doing that? Is there any future in that?" And you know, at the time, in the early '90s, it wasn't as popular as it is. You didn't see it as much. But, again, over the years I have proven myself to them, and I think now they are really proud of me and really happy I did what I did.

After a year of toil, a sign reading "TATTOOS BY APPRENTICE" was finally hung in the window of the shop where Darren worked. Months of scrubbing floors, sterilizing and sorting equipment and needles, taking care of the artists, and watching others etch lines and lay down color

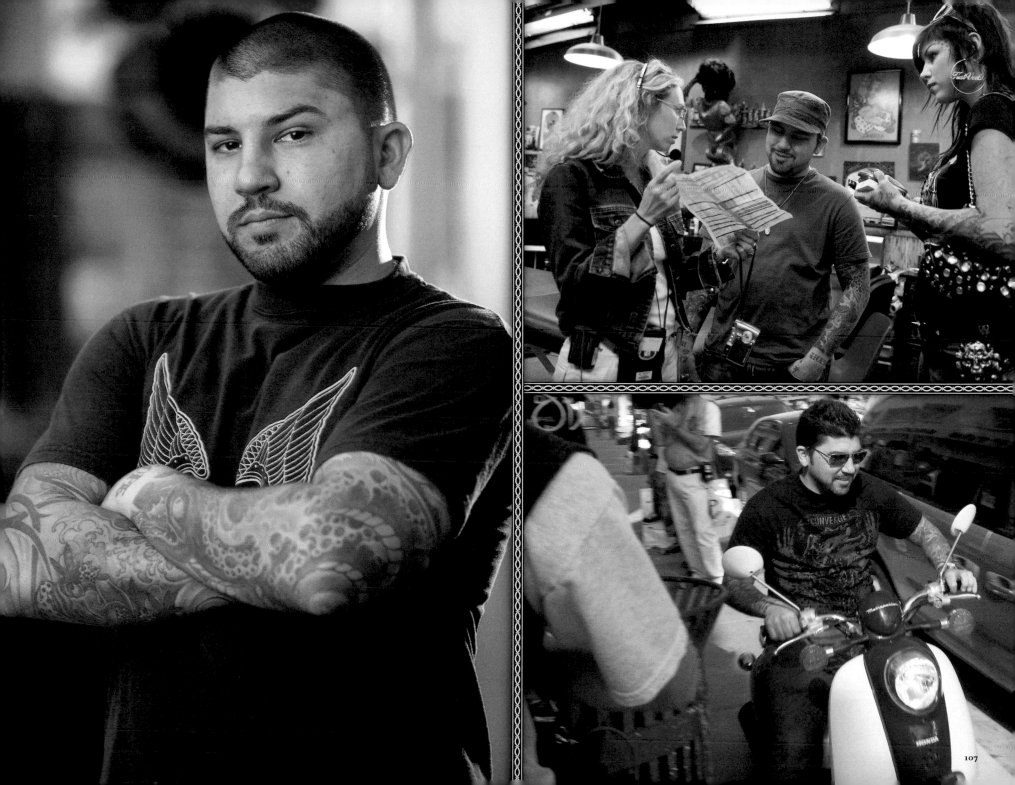

# Darren and his Dad

Darren knew his brother Ryan was visiting *Miami Ink*, but he was surprised to see their father, Richard, also walk into the shop and announce that he wanted to get his first tattoo from his favorite artist—Darren.

For inspiration, Richard brought along a figurine of three penguins that Ryan had given him as a gift. To Richard, the father penguin protecting his two young penguins represented the three of them.

Darren's work on the tattoo was so good, Richard could only beam with pride at his son.

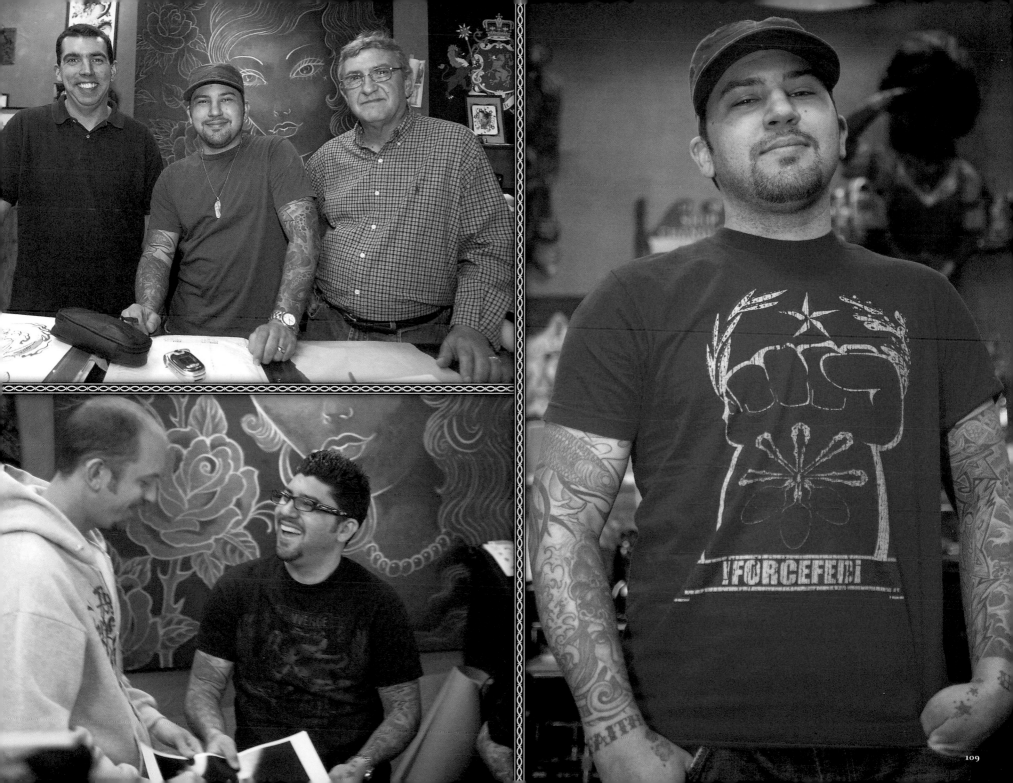

were behind him. During his training he'd given himself a few small tattoos and worked on three close friends, but now it was time to show what he was learning. The sign drew in a few clients, and Darren Brass was on his way.

*After the Lower East Side apprenticeship, I became kind of a journeyman. I would go around and do guest spots at particular shops. If someone from a shop is going out of town for a couple of days, their spot needs to be filled, so you may be invited in. A number of things can play a part: the people you meet, the people you know, and the people you have worked with. So with luck you'll hear, "Oh, listen, why don't you come down here, I will set you up with appointments." You do your guest spot and begin to build up a clientele.*

Although Darren's tattoos explore a wide range of style and designs, his roots as a graffiti artist, experimenting with different types of fonts and scripts, play a strong role in some of his most popular creations.

*Over the years, one of the things I've come to be pretty well known for is my lettering. It stands apart. And I have my own way of laying out different things. Every piece is different, every individual is different, so it is pretty much what works with a particular piece. You try to stick to a certain style, as far as how it is put on the skin or drawn. Each artist has a different flair. That is what sets us apart.*

"*I do a lot of different types of lettering on people and that obviously comes from the graffiti or just a love for lettering.*"

The "old days" in the tattoo business are not so old. It's only in the last 10 years that tattoo art has begun to edge its way toward the mainstream. And in the first few years of this century, Darren has been part of the end of one era and the beginning of another.

*It really is an old art form, but over the years—particularly in the past*

five years—it has really opened up to the public, more so than ever before. There is so much more diversity now in skill levels of the artists and in the range of customers, men and women from bikers to bankers. You know, when I started my apprenticeship, you couldn't open up a weekly magazine and see pictures of stars, famous

people with tattoos. I couldn't go online or to the back of a men's magazine and find tattoo equipment. It's become a much larger world.

A few years ago the Brookings Institute, a major Washington, D.C., thinktank, produced a report that listed the personal qualities needed to gain success in life. First on the

list was physical durability. This characteristic makes sense in business or politics—and definitely in Darren's own experience. Since apprenticing in those recent "old" days, Darren Brass has become widely respected for his imagination and unique skills as an artist along with his ability to work intensely for long periods. Four to six to 10 hours or more doing a single piece. Tattooing requires the ability to concentrate deeply and deliver. And Darren does.

*When you get into a piece, you completely go into a zone—you just get locked into it. The focus is on one thing and that is that piece and every element that goes into it. It doesn't matter what part of the body or where it is or who it is. You kind of put everything else out of your mind or you try to put it aside. With certain people, of course, you develop a connection, a bond, just talking with them; with others you don't—but it doesn't really matter. It's just doing your job. You are trying to give everyone the same thing—a beautiful piece of art.*

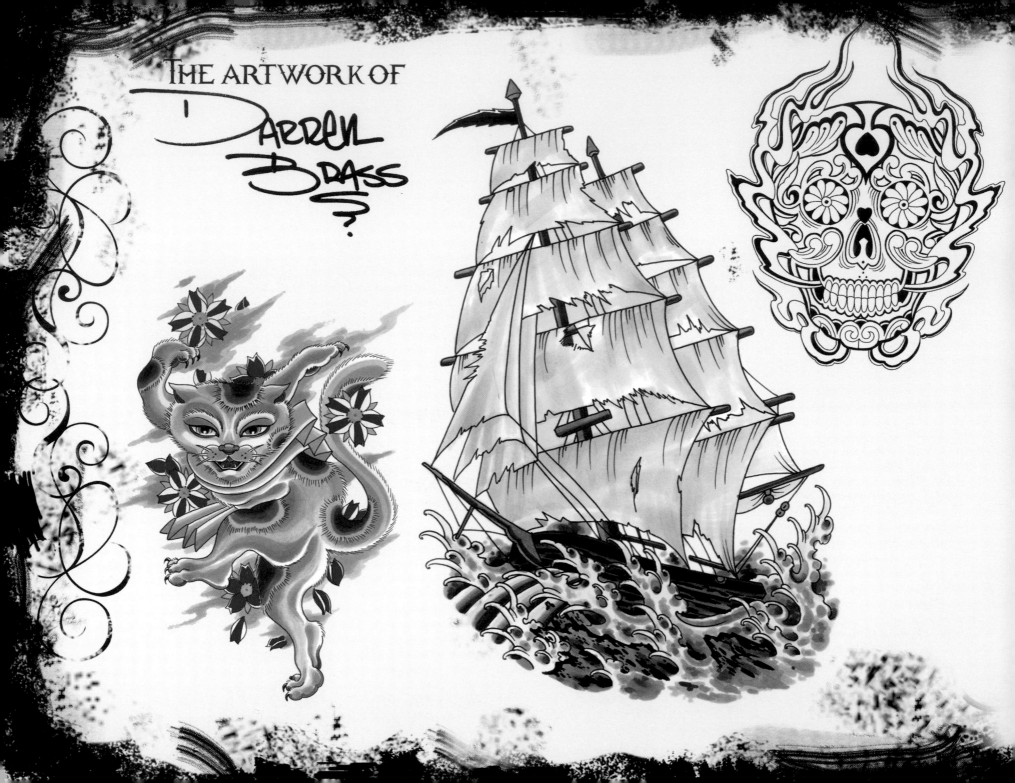

THE ARTWORK OF DARREN BRASS?

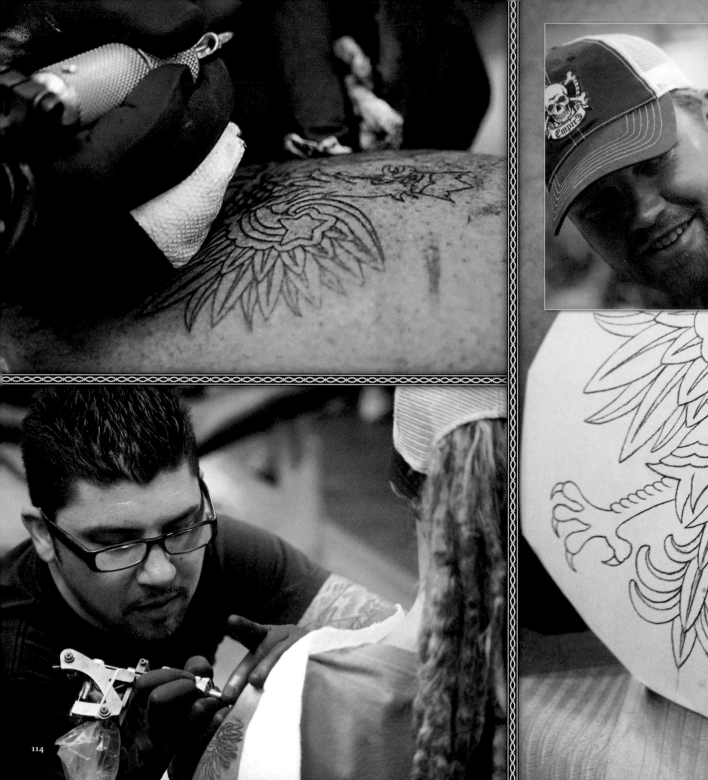

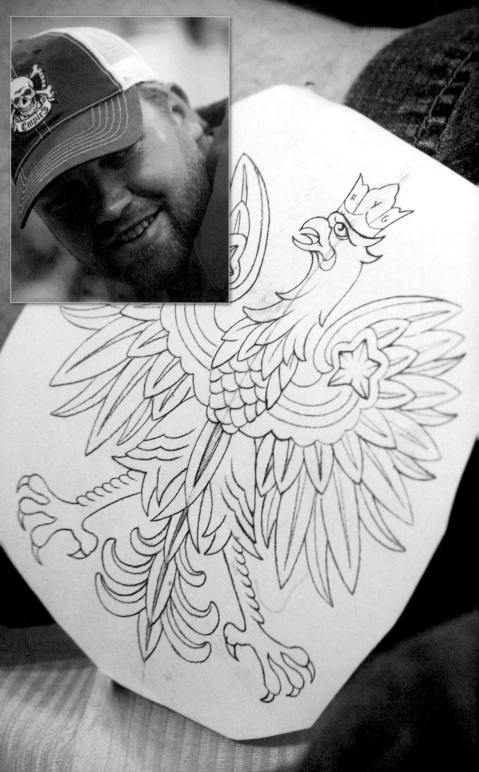

# Polish Power

Two brothers, Michael and Stephen, came into the shop for matching tattoos. Michael, in town visiting his brother, had never experienced ink. But when Stephen suggested that they both get a Polish eagle, it sounded like a good idea. Darren was knocked over by this.

*No one ever asked me to do anything Polish. Someone might make a joke about my doing something Polish—like if my line was crooked or something.*

Darren high-fived Michael, bragging about his own Polish heritage. Nuñez grinned and argued that Darren was really Puerto Rican. But Darren just shook his head and laughed, proud of his Polish-Irish bloodlines. The brothers knew what they wanted.

*The Polish eagle is a powerful image. It's something we connected with growing up with my grandparents in a Polish household. My heritage means a lot to me. We'll put it on and it will be there for life.*

But when the brothers came back for the real thing, Michael wasn't so sure the eagles were a good idea. He was thoughtful, watching Chris Nuñez outline the tattoo on Stephen's calf. Of course, Nuñez had to give him a zinger.

*There's nothing to it. Bee stings, ant bites, cigarette burns, and muriatic acid all at once.*

Darren set up his station to begin tattooing the design outline on Stephen's shoulder. All of a sudden Nuñez and Darren realized they were at the same point—tattooing two brothers with the same design. The race was on and you could almost hear the "Beer Barrel Polka" playing in the background. Darren had to let go.

*Polish power for life, baby!*

Team Darren won the race. When it was over Stephen declared that he felt more Polish than ever before. Michael summed up the experience.

*My brother and I didn't have very much when we were growing up. Family was all we had, and we had a lot of that through our grandparents. And that's the main reason we did this—to honor them.*

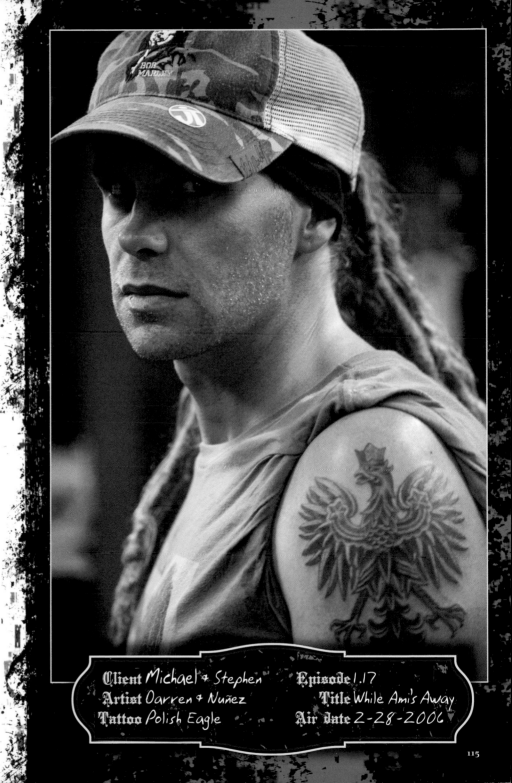

Client *Michael & Stephen*
Artist *Darren & Nuñez*
Tattoo *Polish Eagle*
Episode *1.17*
Title *While Ami's Away*
Air date *2-28-2006*

**Client** Frank
**Artist** Darren
**Tattoo** Bottle, garlic, bullets
**Episode** 1.16
**Title** The Ink that Binds
**Air date** 3-14-2006

# For Uncle Patsy

Darren has a tattoo of his aunt on his leg. He says that no matter what he has done in life—his graffiti, his tattoo art, how he dressed—his aunt always supported him. So he totally understood when Frank asked Darren to create a tattoo in memory of his uncle.

*Uncle Patsy was the greatest uncle there was. He was the only person that could motivate me to do my artwork. He said, "You have more talent in your pinkie than I have in my whole body!"*

For the tattoo, Frank wanted Darren to arrange a bottle of Crown Royal and some garlic cloves. When Darren asked if there was anything else to include, Frank said that he'd like three bullets as well. Then Darren knew. All through the consultation, Frank's voice was soft and dulled. He was obviously struggling to overcome great sorrow.

*After my uncle took his life, I stopped doing my art. I became very depressed, very tired, and I haven't really done any artwork since then. This has been a very difficult time in my life.*

As Darren sat working on the design, he talked about the approach that Frank was taking by incorporating the constant things he would remember about Uncle Patsy, his wonderful cooking, and the things that brought him down—drinking and a gun.

A few hours later, Frank came back and Darren applied the stencil to his leg. Frank recounted that Darren had come highly recommended to him because of his color work and style. Darren realized that he would have to alter the design to get everything to fit because Frank already had a tattoo on the leg.

When Frank came back two weeks later for the second session, Darren began to apply the color. He could tell that his client was doing a lot better.

*Yeah, the tattoo helps a lot—just the memory of my uncle yelling at me to do my artwork helps. I've been painting and sculpting these last two weeks because I feel he's with me now. He'll be in my life forever and help me do my artwork every day.*

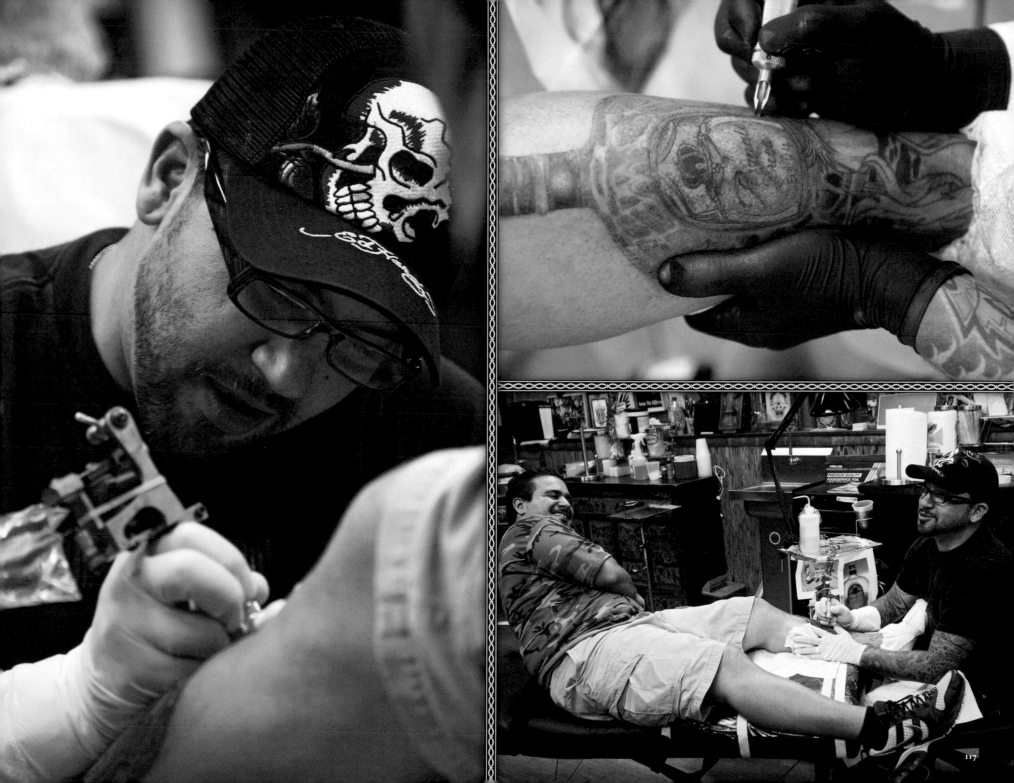

# A Father's Pride

A few months ago, Ivan and his wife had decided to divorce. Ivan was overcome with the pain of knowing he wouldn't be with his three children every day.

*I sat in front of the judge and I became overwhelmed with the thought of not having the same contact with my kids. Every time I drop them off at their mom's house, I start to miss them. Every moment of my life, they're on my mind.*

He came to the shop and talked to Darren. He thought he wanted a back piece, and for sure he wanted a lion with three cubs.

*The significance is that I'm a Leo and, of course, the lion cubs are my kids, my little pride. I'm thinking of a dad lion just chilling, looking over his pride, looking over the savannah, and the kids just playing around.*

Darren had an idea for the tattoo and a strong sense of what Ivan was going through. He agreed to do it.

*I think that getting tattooed helps some people through very rough times,* *and later it reminds them of those times so they never go back. I have my own reminder. It's a tattoo on my foot, which represents an angry man. I don't ever want to be that angry again.*

A few days later the sketch was ready, and Ivan came back to the shop. He thought the design was perfect, but he didn't want it on his back. He asked if the design could be modified for his shoulder. He wanted to be able to see the tattoo. Of course Darren could do it. He reworked the stencil, and they got down to business.

When the session was over, Ivan was thoughtful and very appreciative.

*Darren is awesome. What he gave me was not only what I envisioned, but a lot more. This tattoo will help me because I won't have to pull out my wallet to look at the picture of my kids. From the moment I wake up and brush my teeth and shave in front of the mirror, I can stare at my shoulder and see them. I hope it shows my kids my dedication to them—that I'm here forever for them.*

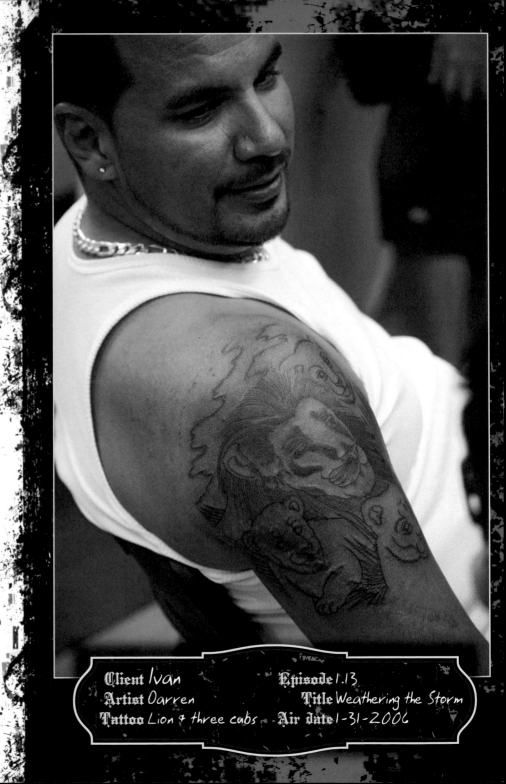

Client Ivan
Artist Darren
Tattoo Lion & three cubs
Episode 1.13
Title Weathering the Storm
Air date 1-31-2006

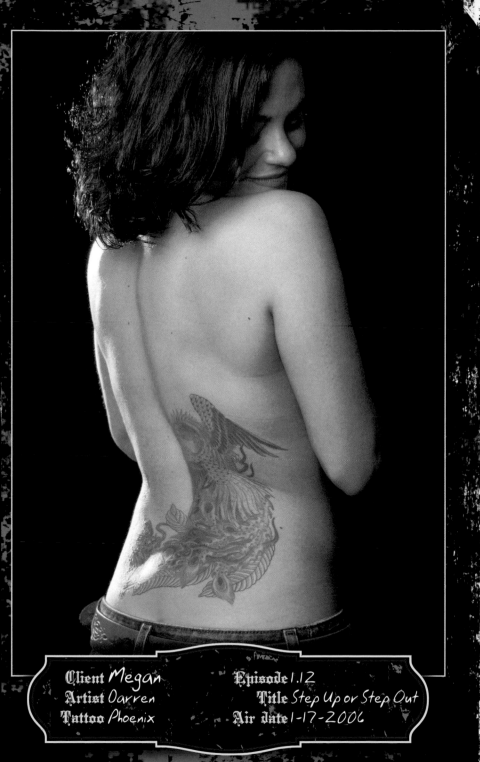

# From the Ashes

Darren and Megan, friends from Connecticut, both worked in South Beach. When word came down that their very close friend, Mark, had died, Megan rushed to *Miami Ink* to be with Darren—or as she calls him, "Gumby." As they shared their emotions with each other, she decided it would be good for both of them to continue on her back tattoo.

*Darren did a dragon on me a while ago, and then a few years later I had the idea for the phoenix to complement it. The phoenix rises up from the ashes and from its strength I'm able to grow each and every day.*

The outline of the phoenix had been completed several months earlier, so Darren concentrated on completing the shading and the color work. Being with Megan and working on the phoenix, a symbol of strength and perseverance, meant a lot to Darren.

*The whole time I was drawing and doing the tattoo, I was thinking about and grieving the loss of one of my best friends. It was really tough. It was hard to get through. But at the same time Megan and the phoenix caused me to look forward.*

Megan knew that Darren's work would help ease his sorrow. And despite the circumstances of the day, or perhaps because of them, his work was impeccable. "You did good," he told her at the end of the session. "You did too," she replied.

*The three of us were close since middle school. It's like losing a brother. He was a young guy and his days are done. We need to use our time well.*

> *"Graffiti helped me a lot with different color theories as well as composition. It also helps because you're on the run; you're on the fly, like tattooing."*

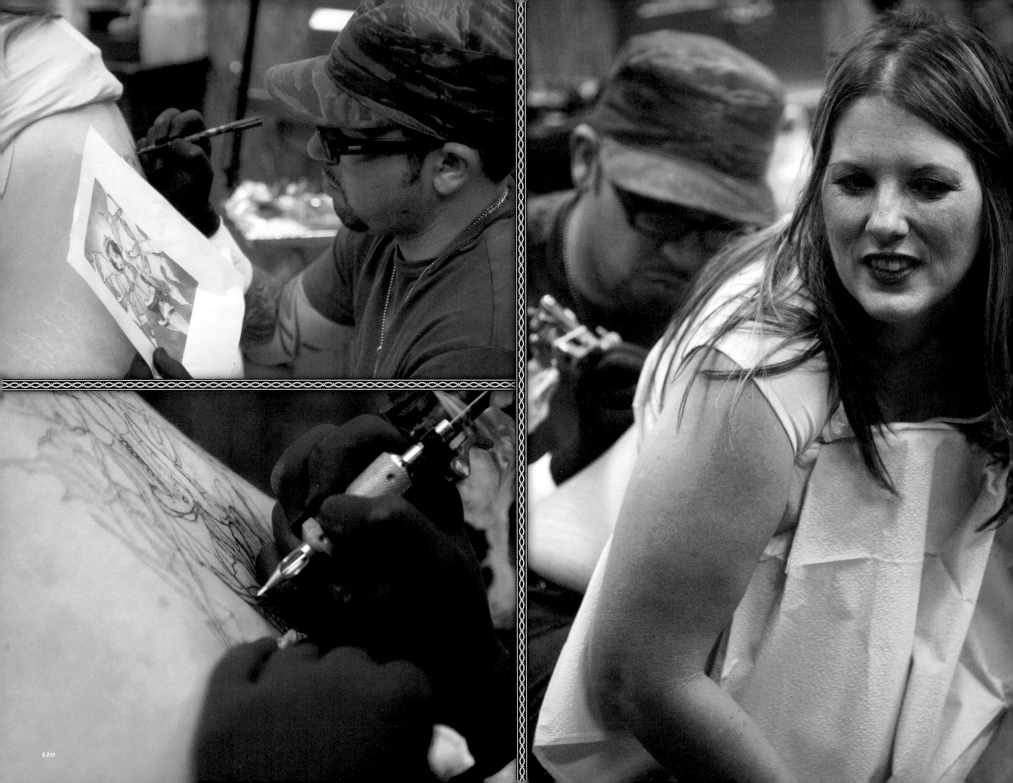

# Spreading Her Wings

Peggy stood at the front desk of *Miami Ink* and talked to Darren about losing her mother two years ago. She showed him a picture of a Japanese animation-inspired fairy that she wanted, but she needed Darren to somehow incorporate the word "believe" into the design.

*The design I want to get represents someone who has been through a life. The word "believe" is going to be there so that when I'm having a bad day, I'll look at the tattoo and it will be like my mother telling me to believe in myself no matter what my situation is.*

While her friend Gina stood beside her, Peggy talked about the loss of her mother, calling the experience the worst thing that could have ever happened in her life.

*My mother was my best friend for my whole life. A day never went by that I didn't speak to her at least once. When they put her in the ground I felt that they put part of my soul in there with her. It's not so much a struggle as just a longing to have her back.*

Darren set up his needles and colors. When the session began, Peggy leaned into the back of a chair while Darren, adding some details freehand, worked on her lower back. Her face reflected many thoughts of her mother and why she was getting the tattoo.

*I've been a nurse for 15 years and I was able to take care of my mother at home. If I couldn't save her life, then I was going to make her death a pleasant passing. It was really hard being her nurse while being her daughter. But my mother brought me into this world and I was going to see her out of it.*

Finally Darren wiped down the tattoo. The fairy creature with the word "believe" soared along Peggy's lower back with spread wings. The mirror reflected the tattoo and Peggy's happiness.

*I'm absolutely loving it. I think my mother would be proud to see how far I've come in my personal growth, and now I know that she's with me, that she's not lost.*

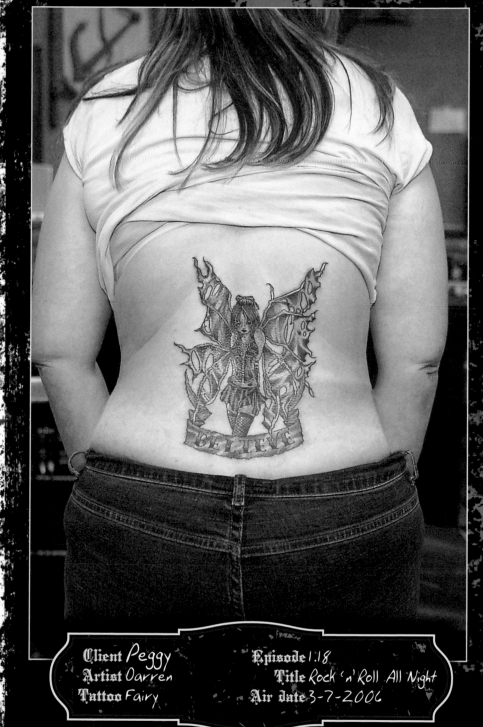

Client *Peggy*
Artist *Darren*
Tattoo *Fairy*

Episode 1.18
Title *Rock 'n' Roll All Night*
Air date *3-7-2006*

121

# Yoji Harada

With his open, warm face and quirky smile, Yoji Harada looks like he just stepped out of a silent film. Maybe it's his wiry body that looks as though a brisk wind could blow him away. (It can't; he's too quick.) Or maybe it's his black Charlie Chaplin bowler hat that has become a personal SOBE trademark, along with his plaid shirts and tattooed body. Whether pushing a broom, running the autoclave, or paying intense attention to an artist's instructions, Yoji is motion and rest, activity and concentration combined.

Growing up in Tokyo, Yoji never imagined that he would one day find himself working in a tattoo shop in Florida with a wife and baby daughter. In his Tokyo days he had a single dream—to make music on the world stage. But this dream required a lot of traveling—from Tokyo to New York City—all in pursuit of his one goal.

When Yoji arrived in New York City, he spent a few weeks looking for, and playing with, various pick up bands. But it didn't take long for him to realize that he needed to earn some money at a day job in order to keep pursuing his musical dreams. The city's restaurants and shops are heavily staffed with talented young people determined to break into the theater, television, dance, and a host of other performing arts. It doesn't take long to learn that while attempting to break in, you're better off having a place to sleep and food to eat. Hence the day jobs.

Yoji found his day job in a Lower East Side tattoo shop working as a "do boy," as they say in the trade. The job description was pretty simple: do anything that is needed. During any given day, a do boy keeps the place clean, runs errands, makes sure the artists are fully supplied, and ensures that the place runs smoothly. For Yoji, working at the tattoo shop was just a job, not an apprenticeship. And at the end of most working days, he was able to make music in usually unpaid gigs with a number of bands.

While working in the shop, he got to know a number of outstanding tattoo artists who came through doing guest spots. He spent some time with Ami James from Miami and Chris Garver from the West Coast. He got to know Shinji Horizakura, a highly respected Japanese artist. While he got along with nearly everybody who came through the shop, he continued to chase his other dream.

In the spring of 2004, when Ami reunited Darren Brass, Chris Nuñez, and Chris Garver as *Miami Ink*, Ami had only one person in mind as the group's apprentice. He got in touch with Yoji and offered to move the whole family—Yoji, his wife Bridgette, and their soon-to-be-born daughter

In addition to a laundry list of daily apprentice duties around the shop, Yoji still finds time to practice tattooing techniques on artificial skin, refine his drawing and tracing skills, and spend quality time with his young daughter.

Sydney—to South Beach. For the first time, Yoji Harada had a Plan B.

*Ami told me that I'd be his apprentice, and that if I was patient and worked at it, the Miami Ink guys would teach me what I needed to know to become a tattoo artist. I made the decision to put my music away for a little while. Ami said that it would be a lot of work, that it would take a while, but that it could pay off.*

*Miami Ink* has been a good gig for Yoji, but he learned early on that his apprentice job isn't a walk in the park. Ami is very demanding—it's just part of who he is. And even without personal pressures, Yoji is likely to be bleary-eyed when, after completing his many daily chores, he finally gets a chance to learn something.

Most accomplished tattoo artists have been through this kind of

apprenticeship, or something similar. Ami spent the early days of his career apprenticing for Shinji Horizakura. And Shinji, earlier in his introduction to the art, underwent rigorous traditional training in Tokyo as an apprentice to the famed Horitoshi family. Apprenticing is a great way for a student to learn and for an artist to pass on his skills. The apprentice watches the craft, the style, and the

*"I think tattoos are beautiful. Like having art on your body, it's amazing, you know? Some people don't agree, but I think tattoo art is the most beautiful art."*

YEAH, WE'RE A TEAM. MY POSITION IS APPRENTICE,
BUT WE'RE A TEAM. EVERYBODY HELPS EACH
OTHER AND ALSO WE ARE LIKE FAMILY. WE'RE
A CLOSE FAMILY. I HAVE TWO DRAWING TEACHERS,
CHRIS GARVER AND CHRIS NUÑEZ. AND I'VE GOT A
TATTOO TEACHER, AMI JAMES. I FEEL PRETTY LUCKY.

Yoji Harada

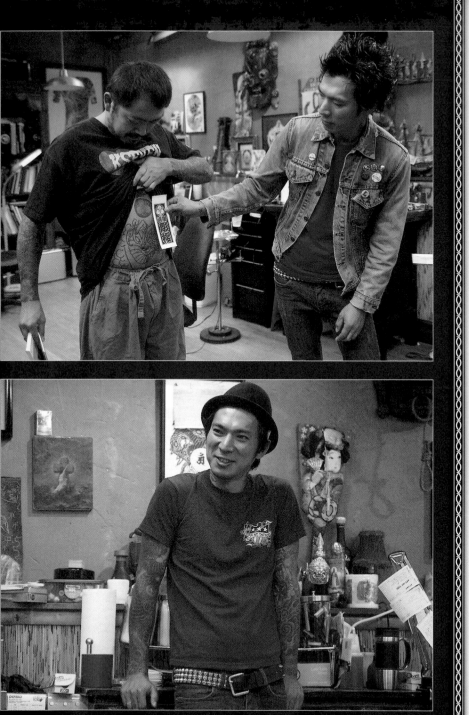

The shop serves as Yoji's classroom for learning technical skills and refining his design sensibilities. The entire *Miami Ink* staff—as well as visiting artists such as Shinji—provide instruction on various topics.

master's approach for hours and hours—perhaps even for years. The learning must be exact. After all, a master is passing on insight and discipline to his apprentice. What the apprentice produces reflects directly on the master. Classic tattooing technique has continued to move down through generations in this manner.

As the master of a new apprentice, Ami stresses that besides shop chores, Yoji must watch and study the technique and artistic style of each of the *Miami Ink* artists.

*Yoji has to be like a sponge, a human sponge, and he has to absorb everything in the shop for better or for worse. Yoji basically needs to be behind me at all times. He needs to learn how to tattoo, how to do line work, and how to do shading. He needs to learn everything even though he's not going to do it for*

*a couple of years. It's important for him to watch simple tattoos and to pay attention to complex and finely detailed pieces. One day he's going to have to execute it.*

When Yoji talks about his present life, he always mentions his responsibility to his wife and child.

> "Every five minutes people keep calling the shop trying to make an appointment, and you know I have to clean the shop. I have to work for these guys. It's really hard."

He knows tattooing success can secure the future of his family. Bridgette supported his decision to become the *Miami Ink* apprentice.

Yoji worked in the New York shop for a long time. He worked with some really great artists and every once in a while he would wonder about getting more into tattooing. But the music came first. Becoming a father made him finally want to learn how to tattoo. He has a family to support now and that is really making him try to be the best he can be.

As Yoji has become more comfortable with shop work, Ami has ramped up the teaching. For the apprentice, the most difficult part is not learning to hold the machine in his hand. The hardest part is learning to watch and to listen.

*When Ami tattoos, he wants me to sit next to him. He's a good teacher. When he is doing a tattoo, he says to me, "Yoji, when you put in a shading, you have to do this a certain way." He taught me how to draw roses, how to shade, and how to do color.*

Yoji navigates through daily challenges and pressures, but there's more to it. In fact there are plenty of laughs and more than a little craziness when the four artists work together. Yoji recalls a particularly memorable moment with a smile.

*Garver offered to tattoo my daughter's name on my upper back. He drew different styles of letters at least six times. "Yoji, do you like this? Do you like this?" I'm like, OK, let's do it. I like this one, let's do it. Six times. Then he went to work. S-Y-D-N-E-Y. When I looked at the finished tattoo in the mirror I realized that*

*I had misspelled it. I misspelled my daughter's name! It should have been S-I-D-N-E-Y. Bridgette was stunned. And then Nuñez spoke up. He said there's no way to fix that—except one. "You'll have to change the birth certificate." And that's what we did!*

As Ami promised early on, Yoji is being tutored by all the artists. An apprentice has to be able to draw, create images, copy some designs, and make others come alive right out of the air. Each of the *Miami Ink* artists has played a part in Yoji's education.

*I've been working with Chris Nuñez for weeks—pretty much every day. He's really supportive. Like Ami, he's been teaching me how to draw, how to control and match lines. Ami told me that I'm getting better. It makes me happy, and I just have to work harder on it.*

*And Garver—he plays guitar. He's not too bad, but we made a deal. I give him music lessons and he pays me with drawing lessons. It's been great. It turns out that my first dream—music—is helping to pay for my second dream—becoming a tattoo artist.*

# First Steps

When Yoji wanted to do his first tattoo, he got up the courage to ask Ami if he could work on a customer. Ami said no, the apprentice wasn't ready to tattoo customers. But he could tattoo his friends and practice on himself. Yoji left his shop chores and practiced drawing. He decided to tattoo a butterfly on his leg. Ami's pushy encouragement blistered the air, but Yoji had his sight on the big picture.

*I'm still an apprentice, so I don't make any money. I'm worried about that, but I'll do anything for my daughter. I change my daughter's life if I start learning tattoo. If I become a tattooer, I'll make a lot of money.*

Tattooing himself would be good practice, but it wasn't easy to do the piece in the middle of the *Miami Ink* shop. Darren (who pointed out that Yoji had the needle on upside down) rolled his chair closer to inspect Yoji's technique, and Chris Garver came up on the other side. Ami warned them both not to stress Yoji out. Then he calmly said to Yoji:

*This is a really simple tattoo. Before you start, I want you to breathe deeply. And relax. Just think that you're just tracing a piece of paper.*

Yoji's hands shook. He chewed on his lip and kept trying to position himself correctly. He rehearsed the tattoo's first line three times in the air before setting the needle to his skin. When he completed the line, Garver commented that it was shaky. Ami blew up.

*What is wrong with you people? Stop. I swear to God, I'm going to kick you both out of the shop. I'm not joking. It's important that you give him support. Because that makes him breathe easier and it makes him not shake as bad.*

After Yoji took a few more breaths and practice passes, he began laying down his second line. Ami was pleased.

*There. That was the best line he did so far.*

When the tattoo was completed, Yoji looked down at the butterfly on his leg. His voice was low.

*It wasn't that easy. But I did it.*

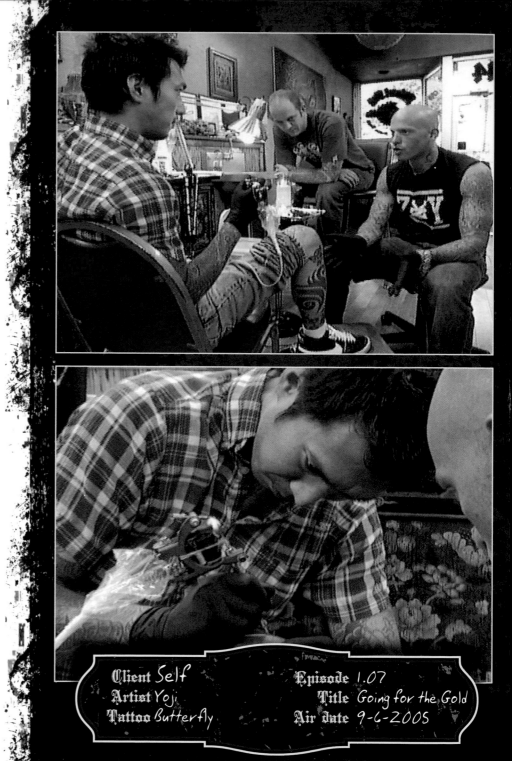

Client *Self*  Episode *1.07*
Artist *Yoji*  Title *Going for the Gold*
Tattoo *Butterfly*  Air Date *9-6-2005*

Client *Annette*     Episode 1.10
Artist *Yoji (with Ami)*     Title *Finding Balance*
Tattoo *Kanji character*     Air Date *1-10-2006*

# Yoji's First Dollar

Sometimes an artist receives a gift in a client. Annette was that gift to Yoji.

*I came in for a consultation with Yoji because I want to get one of two kanji characters. The first one is hito, that means human being, and it has two strokes in the character and if you take one stroke away the other one falls and vice versa, and it kind of symbolizes the fact that human beings need one another. And the other one is haha and it means mother. When I was 21, I found out I was adopted. So this character is a reminder that there is this woman out there, whom I may go look for one day.*

Annette would be Yoji's first real client, not a friend who was trying to help him out. She was pleased that *Miami Ink* even had an apprentice and she was adamant about her reasons for wanting Yoji.

*It's important for me to have someone do these characters who understands the importance of strokes in Japanese calligraphy. Japanese people can look at what you wrote and see if you did the wrong stroke order just by the final result.*

Annette was comfortable having Yoji do her tattoo. She wanted to show independence in her thinking and choices.

*I'm leaning toward getting hito right now; it's two strokes and I believe Yoji can do it. He's worked under Ami and he's really listened and watched and learned and I would be proud to be one of his first customers. I have a tendency to be extremely independent so having this character on my body would be a really good reminder that I do need people.*

But Yoji was nervous and in the end, after a sleepless night, the decision was made that Ami would outline the hito and Yoji would fill it in. Annette agreed to the plan. She called it a family affair.

*When Yoji was filling in the outline, I could feel when he was doing too much or too little. But I was totally comfortable because I trust Ami. So I'm really glad that it all worked out and that Yoji could do my tattoo.*

131

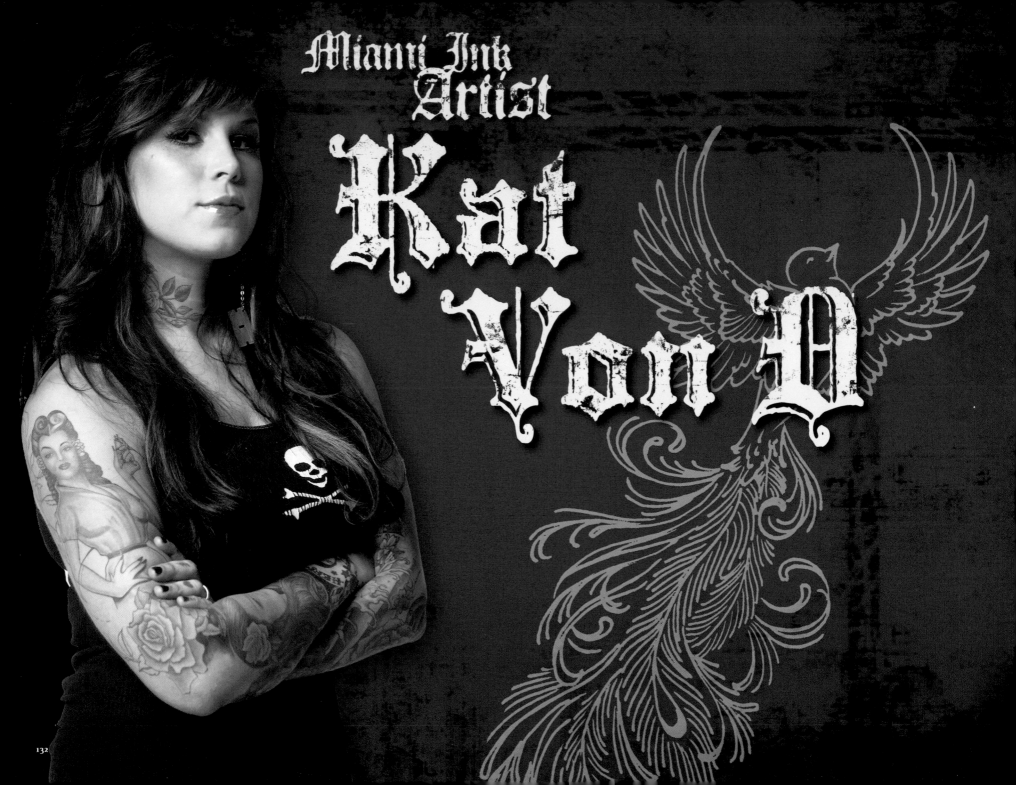

Miami Ink
Artist
# Kat Von D

**K**AT VON D DOESN'T SLIP INTO A ROOM.
SHE MAKES AN ENTRANCE AND AN ALMOST ELECTRICAL CHARGE
RIPPLES THROUGH EVERYONE IN VIEW. CASE IN POINT: AFTER DARREN
BROKE HIS ARM, AMI CALLED KAT TO HELP FILL IN AT *MIAMI INK.*
SHE FLEW STRAIGHT TO MIAMI, CUTTING SHORT A GUEST SPOT IN FINLAND.
AND WHEN SHE WALKED INTO THE SHOP, THERE WAS A MOMENT,
ALBEIT BRIEF, WHEN THE ROOM SEEMED SUSPENDED. KAT WAS HERE.
HER DISTINCT PERSONAL AND ARTISTIC STYLE—REMARKABLY
IDENTIFIABLE FOR SOMEONE SO YOUNG—WAS ABOUT TO BE
UNLEASHED ON SOUTH BEACH.

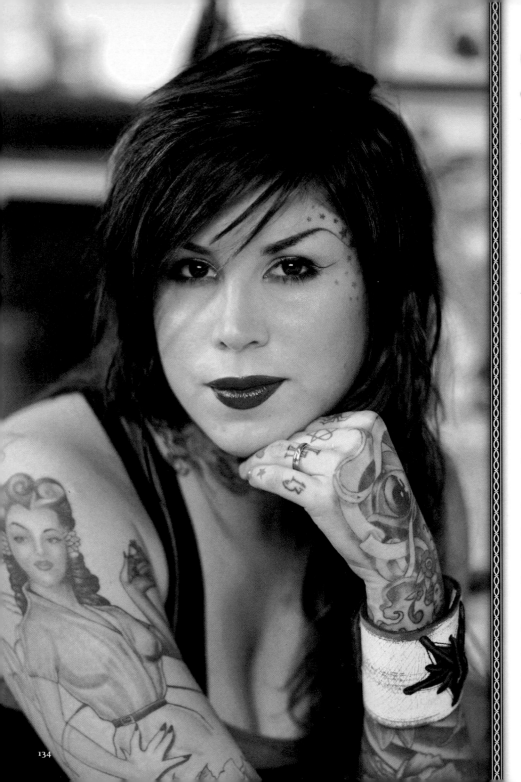

Although Kat (born Katherine Von Drachenberg) was drawn to tattoos in her teen years, her first artistic passion, as is the case with so many artists, was a deep childhood interest in music, both as a performer and a fan.

*I've been playing the piano since I was six or seven. My grandmother was a pianist in Germany in the '20s, and she taught my brother, my sister, and me to play when we were kids. So I am classically trained. I don't—I can't—rock out. You know, I can't, like, write music. I read music. I think I play well, but I do Beethoven, Chopin, and stuff like that. No Jerry Lee Lewis ... I wish I could, but ...*

Kat's tattoo art has the line and texture of black-and-white master drawings. Her portraits—strongly shadowed, clearly lined, and richly textured—have become her signature efforts. The inspirational sources that drew her to realism, however, were not carefully hung pieces in local museums. Instead she was inspired by the tattoos worn in her San Bernardino neighborhood.

*I have always liked realism. When I started tattooing I naturally just gravitated toward that style and to portraits. The neighborhood was super ghetto. And in the ghetto there were a lot of cholos in L.A. and in Southern California in general. They are like gangsters, and the cholo tattoo look is very fine-lined, prison style. You see them wearing portraits of all the dead friends, dead family members, and many people have their baby's mommas' names in Old English script. I was influenced by the look of the people around me and I took that same style and added my own feeling to it.*

The kids Kat hung out with shared her love for punk rock and tattoos. They also knew that she had artistic ability. Kat produced her first tattoo at the age of 14.

*There was this kid that used to tattoo out of his house, and one day he just said, "Hey, Kat, you draw, you should tattoo me." I did. Then I began tattooing friends and I knew that this is what I wanted to do. I just gravitated toward it. I dropped out of school a year later and although, as*

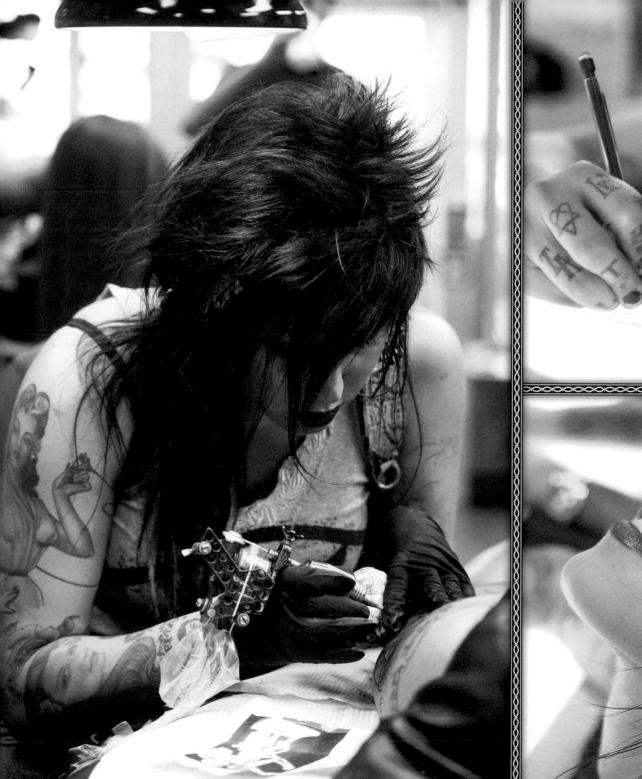

MUSIC IS A HUGE PART OF MY LIFE. IT INFLUENCES MY DRESS, MY WORK—EVERYTHING. I LIKE EVERYTHING FROM THE NEW YORK DOLLS TO SLAYER, BUT I AM OBSESSED WITH BEETHOVEN. I LOVE THAT HE WAS A HOPELESS ROMANTIC, THAT HE LEFT EVERYTHING HE OWNED TO THE MYSTERIOUS IMMORTAL BELOVED.

Kat Von D

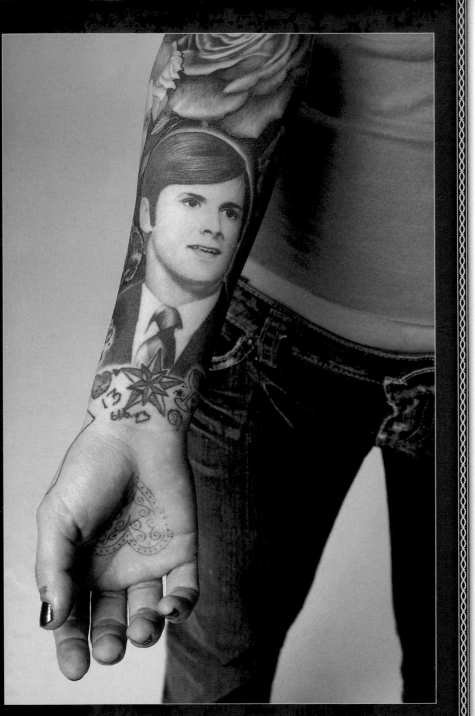

Like a personal, black-and-white photo gallery, Kat's body is covered with a collection of shaded portraits, including on Kat's favorite tattoos—an inked image of her father as a young man on her forearm.

*young as I was, it might have been a crazy decision, I knew what I wanted to do—it wasn't just something I was doing just for fun. I wanted to turn it into a career. I've worked really hard since then to get to where I am. It's a career now.*

The process of breaking into the business was very much up to Kat. With very few women in the tattoo arts, she had no usual routes or role models to follow. She didn't do a traditional apprenticeship like Ami, Nuñez, Garver, or Darren. Self-driven rather than self-taught, she was on her own from the beginning, but she always paid attention.

*At first I didn't really know what I was doing. When I was a kid I would look at tattoo magazines and see these people—the big names, you know—and I would see their stuff and be knocked over. "Wow! How do I do that? How do you do this?" I pretty much self-experimented and started growing and learning. And when I was 16, I started working at a tattoo shop in San Bernardino with other artists. I learned from everybody.*

*I'm still learning. When I got into my first tattoo shop, I signed my life away to tattoo. I just knew this was it. I am not doing anything else ever again.*

After a year in her first shop, Kat moved to Los Angeles. Her husband, Oliver Peck, owns and runs a tattoo shop in Dallas, but L.A. is home, the starting and ending point of the many trips they book. Their travel schedules are heavy. Whether they're working together in Texas or California or at *Miami Ink* or doing guest spots or attending conventions in distant destinations such as Brazil or Finland, someone is always on the road.

Oliver's work—bold, bright, colorful, and traditional—is nearly the polar opposite of Kat's fine-line black-and-gray art. The two artists, however, feed off of the diversity; it works for them. It also arguably helps to keep the duo at the forefront of the tattoo arts. In the few years since Kat entered the business, more people are getting more tattoos, and the diversity of clients continues to expand.

*I tattoo everybody from lawyers to the girl at Washington Mutual that*

cashes your checks. I have tattooed people that just barely turned 18 and somebody who was 81 years old, every type from the person who said she would never get a tattoo to the person who is obsessed with collecting tattoos from all over the world. I have tattooed every kind of religion, every kind of race, I even tattooed my mother this last year—you know, someone who I never thought would get tattooed.

Kat received her first tattoo when she was 15. This amateur ink job, a small letter J done in Old English script, was executed with a homemade machine on the inside of her ankle. Her first tattoo from a professional was a black-and-gray Vargas pinup done by Pete Castro when she moved to L.A. And over the years she has collected, among other images, black-and-white portraits of her mother (left shoulder), father (right forearm), and sister (left arm), as well as clusters of photo-realistic roses and several small memory marks on her hands.

*The initials [on my hands] are for people and thoughts very dear to me. PECK—that's my husband's last name,*

*TLA is true love always, and LVB is for Ludwig Van Beethoven. LTP means loyal or love the profession to me, and I have LA on my ring finger, the artery that goes straight to my heart*

Kat's brash West Coast wardrobe and styling may seem at times almost counter to her controlled power and visual directness. But the truest testament to her focused talent is the heart that's visible in her art, the studied touch she invests in her craft, and the pride she takes in her work and the work of her colleagues.

*Chris Garver, Ami, Nuñez, Darren, and I have been working all of our lives, you know, doing tattoos. We love the trade. And we love being in the front ranks. Right now I am really young and I have a lot to learn. I still have a long way to go and I need to get as much from my coworkers as I can. You know, that is how I learned—being around other tattooers and seeing other tattoos being done. I don't want to get stuck. It's not yet time to be working by myself—I could see my style staying the same, freezing, and I want it to evolve.*

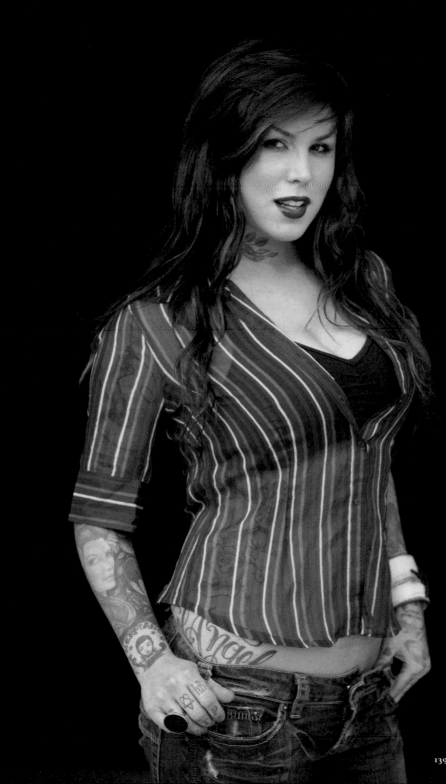

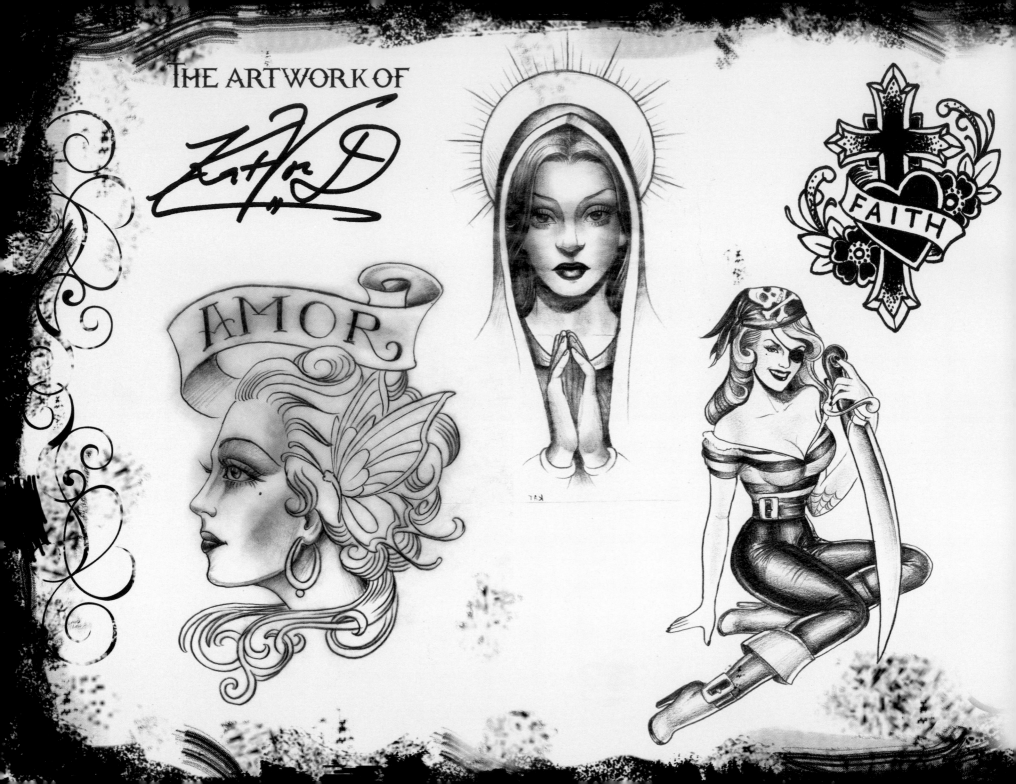

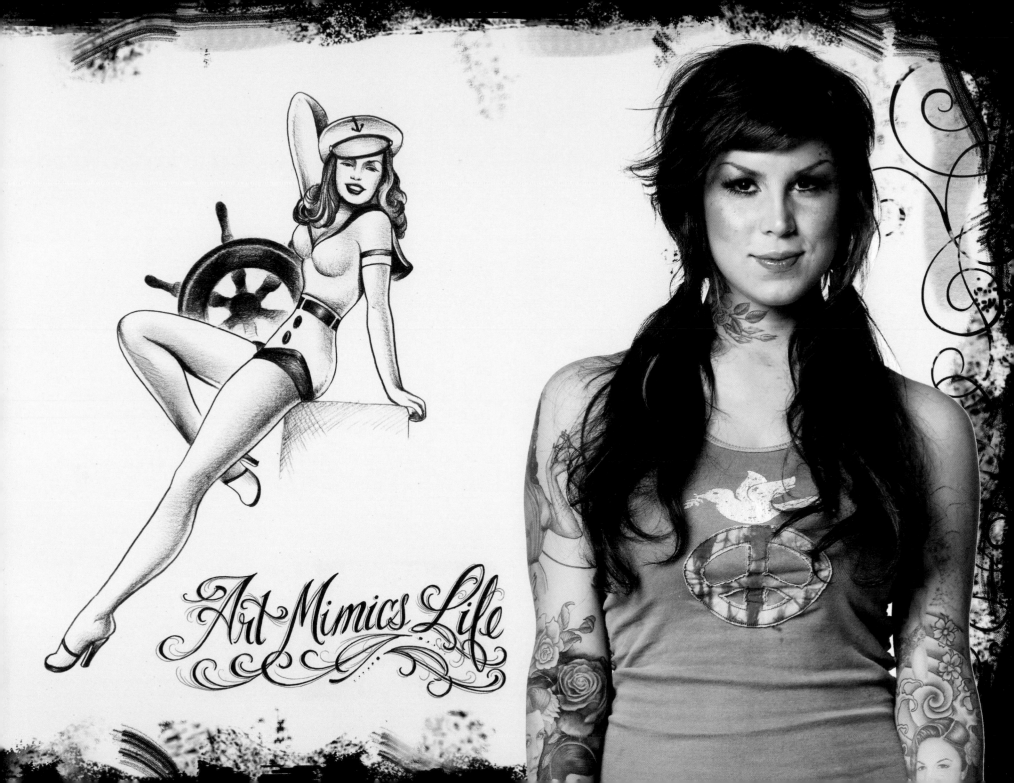

Client John
Artist Kat
Tattoo Image of daughter
Episode 1.17
Title While Ami's Away
Air date 2-28-2006

# Forever Safe

Tattoo artists sometimes learn unexpected, even painful, stuff. Like Kat did the afternoon that John came into *Miami Ink* to have a portrait of his daughter drawn on his chest. He brought along photographs of Elise, his sweet, 2-year-old child who has Tay-Sachs disease.

*It's a terminal illness and I don't know how much longer I have with her. So I want something to always remember her by. She's blind, doesn't sit up. It's absolutely every parent's nightmare. Parents aren't supposed to outlive their kid.*

John had chosen the perfect tattoo artist for what he wanted because Kat is renowned for her black-and-white portraits. As Kat began working on the portrait tattoo, she asked John to tell her about Tay-Sachs disease.

*The easiest way to describe it is to think about every physical and emotional function from blinking your eyes to swallowing, and then assign each of these functions its own light switch. In effect the disease starts going through and turning off the light switches. When I hold her on my shoulder, I can feel how she relaxes. That's the only time I can really feel any emotion from her.*

Kat kept working, but she was very aware of the emotion that John was fighting to control in his voice.

*I don't know why we were the parents to have her. Maybe we are meant to start educating people about this disease and let everyone know that this is totally preventable. All it takes is a simple blood test before a couple gets pregnant. You can be treated, and Tay-Sachs can be avoided.*

The portrait finished, John checked out his new tattoo in the mirror.

*You captured my daughter's innocence. It's phenomenal. This tattoo will give me a little more peace. Now I have her near my heart. She'll be safe.*

After John left, Kat was reflective.

*Because I do a lot of portraits, my work definitely pulls me pretty deeply into people's lives. I definitely feel honored to have done John's tattoo.*

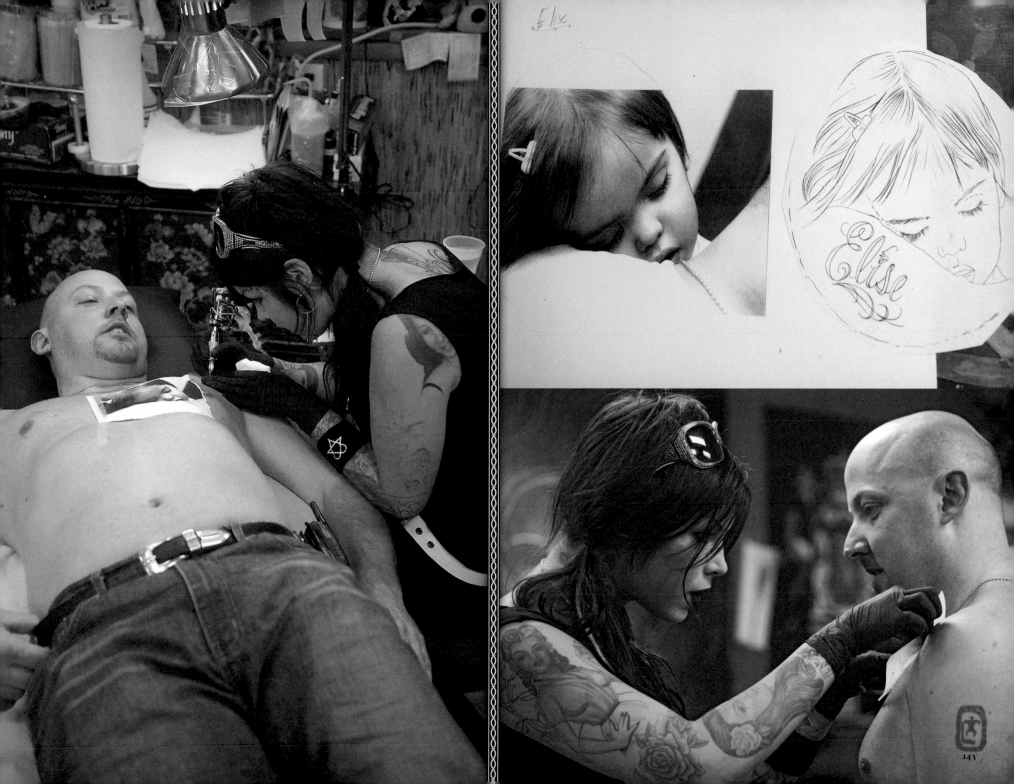

# Tattoo Tag Team

A former Marine, Jerry had convinced Garver to do two "sleeves" of pinup girls as a homage to the culture of the 1950s. Garver did the outline and the shading for the art on Jerry's right arm and asked him to come back later for the color. When Jerry came back for his color, he asked Kat if she would do the art on his other sleeve. Kat and Garver both liked this idea of creating a tag-team tattoo.

*It's pretty intimidating tattooing somebody when Chris Garver is tattooing him at the same time, even though there's never been any competition between us. It'll be cool, though, because we're friends.*

While Kat sat down and worked on her own sketch and stencil, Jerry had a moment of buyer's remorse, but he talked himself back into the gig. Kat's husband, Oliver, who is not a big fan of pain, couldn't believe that Jerry would commit to this.

*"It's not every day that one can walk into a tattoo parlor and be tattooed by two masters ..."*

*When you're having a tattoo, you wait for those times when they pull the needle away and you get a break. He's not going to get any breaks.*

But Jerry was firm because his faith in both Kat and Garver as artists was total. His only job was to stay very still. So when Kat shouted, "Let's go!" the work began fast and furious, but Kat kept complaining that Garver was making Jerry move.

*Every time you touch, you move him, every time you wipe, you move that arm, which is connected to his back, which is connected to this arm. All those things make a big difference when I'm trying to do a face the size of a dime.*

No matter; Jerry's project was a huge success. He was delighted.

*It's not every day that one can walk into a tattoo parlor and be tattooed by two masters—and that's the only way to put it. And you be awesome, Kat!*

**Client** Jerry
**Artist** Kat and Garver
**Tattoo** Pinup girls
**Episode** 1.15
**Title** Kat's Return, Ami's Ride
**Air date** 2-7-2006

**Clients** Melody
**Artist** Kat
**Tattoo** Mermaid

**Episode** 1.18
**Title** Rock 'n' Roll All Night
**Air date** 3-7-2006

# Lady of the Sea

Melody wanted a pinup of a mermaid as a tribute to her father who had been in the Navy. When Melody was a kid, her dad told her stories, and one of his favorite yarns was about mermaids who would come to the ship and sing to the sailors so they wouldn't be lonely. Melody's father died when she was 21, and now she understood and realized the depth of her loss.

*I was the youngest of five girls and I always hung out with my dad. I was his buddy. The older I get I realize how young he was and how much I missed because he wasn't there for me. I see other dads with their daughters and I think that's great. I wish I had that.*

Kat was more than eager to get going on the project.

*I've done a lot of mermaids in my time and pinups in general. Not everyone can do them. I definitely think that it's a specialty. Male portraits tend to be a lot harder for me because they don't have as many defining features as women do. If you overaccentuate their lips, they look like* they have lipstick on, and you can't overdo their eyelashes. It's definitely nicer to do women tattoos.

When Kat completed the drawing, she explained her modifications.

*I put a little kelp or seaweed-type plant on it without cluttering it too much. As far as size goes, I don't want to go too small, then her face would be the size of a dime. I still want to get all the detail.*

Melody flipped her blonde hair and smiled. She was ready. Kat worked in the gray-and-black tones for which she is so well known. At the end she added white highlights to give the design more dimension. Garver watched the mermaid, a side-lying, exotic creature, take shape on Melody's lower back.

*Kat, you're a bad ass. Did I ever tell you that?*

Melody looked in the mirror for a long time, awed by the results.

*I think it came out just perfect—the style, the pinup look, and the '40s feel to it. I love it and I'm sure my dad would love it. Thanks, Kat.*

# Series Index

Miami Ink

# Ami James at a Glance

**Name:** Ami James

**AKA:** The Tough Guy, The Boss

**Age:** 33

**Born in:** Israel

**Resides in:** Miami

**Early influence:** His father, a painter.
"He would grab a brush and give me some acrylic paints.
I used to sit next to him and paint."

**First tattoo:** A dragon, at age 15

**Number of tattoos on his body:** 40

**Other passions:** cars, painting, freestyle fighting

# Chris Nuñez at a Glance

**Name:** Chris Nuñez

**AKA:** The Ladies' Man

**Age:** 32

**Hometown:** Miami

**First tattoo:** His parents' names, at age 16

**On work:** "When I tattoo, I have music and just a little background noise and that's it. I focus on what I'm doing, everyone disappears and then tattooing is relaxing. I just go to work and I work."

**Other passions:** Women, being the life of the party

# Chris Garver at a Glance

**Name:** Chris Garver

**AKA:** The Intellectual

**Age:** 34

**Hometown:** Pittsburgh, PA

**Resides in:** Hollywood, CA

**First tattoo:** Accidental pencil stab to a finger at age 6.

**Favorite tattoo:** Script tattooed by a monk in Thailand that means "to protect."

**On travel:** "I think traveling is one of the greatest things you can do for yourself because life is short. See as much of the world as you can and, you know, it's gonna make you a better artist."

**On being a tattoo artist:** "If you don't like people, you're not going to enjoy being a tattoo artist at all. I think artists are usually alone, kind of tucked away. They work by themselves in a studio and they paint. They don't really have anybody to respond to. But I do."

**Other passions:** Playing bass guitar, enjoying live music, traveling the world

# Darren Brass at a Glance

**Name:** Darren Brass

**AKA:** The Teddy Bear

**Age:** 33

**Hometown:** Waterbury, Connecticut

**Heritage:** Half Polish ("Polish Power, baby!") and half Irish. He has shamrocks tattooed on his hand; one is red to represent his Polish heritage.

**Personal:** Married to Carolina

**First tattoo:** Received as a gift on his 18th birthday

**On his wrist tattoo:** "Faith" and "Hope" in script. "I don't feel that you can go wrong with those on your side."

**On his pre-tattoo art days:** "Graffiti helped me a lot with different color theories as well as composition.
It also helps because you're on the run; you're on the fly, like tattooing."

**Other passions:** His dog, partying like a rock star

Miami Ink

# Yoji at a Glance

**Name:** Yojiro "Yoji" Harada

**AKA:** The Apprentice

**Age:** 32

**Hometown:** Tokyo, Japan (he lived there until age 24)

**Resides in:** Miami

**Personal:** Married to Bridgette; daughter Sydney

**Other passions:** Singing in punk rock bands, motorcycles

Miami Ink ™

© 2006 DCI

# Kat Von D at a Glance

**Name:** Kat Von D

**AKA:** The Queen of Portraits

**Age:** 23

**First tattoo:** A script letter "J"

**Born in:** Mexico

**Currently resides in:** Hollywood, CA and Dallas

**Personal:** Married to tattoo artist Oliver Peck

**Feline friends:** Two sphinx cats, Hollywood and Lebowski (or Holly and Leebo).

**Other passions:** Classical and heavy metal music, movies, skateboarding, 1970s platform shoes.

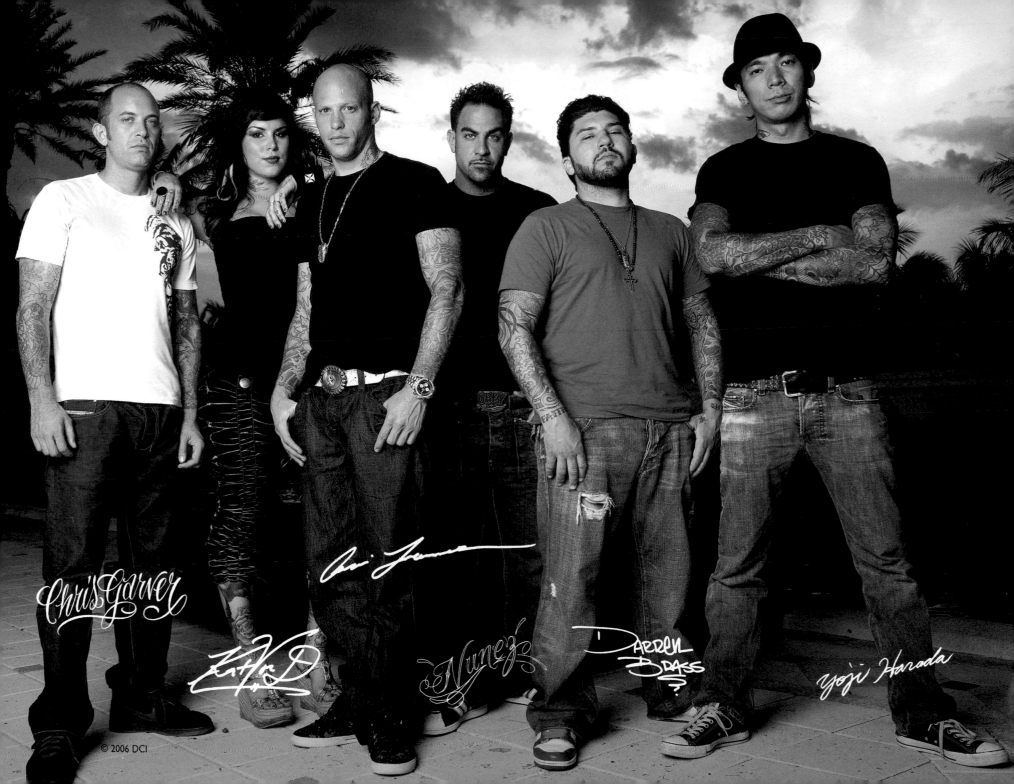

Chris Garver

Kat Von D

Nunez

Darren Brass

Yoji Harada

© 2006 DCI

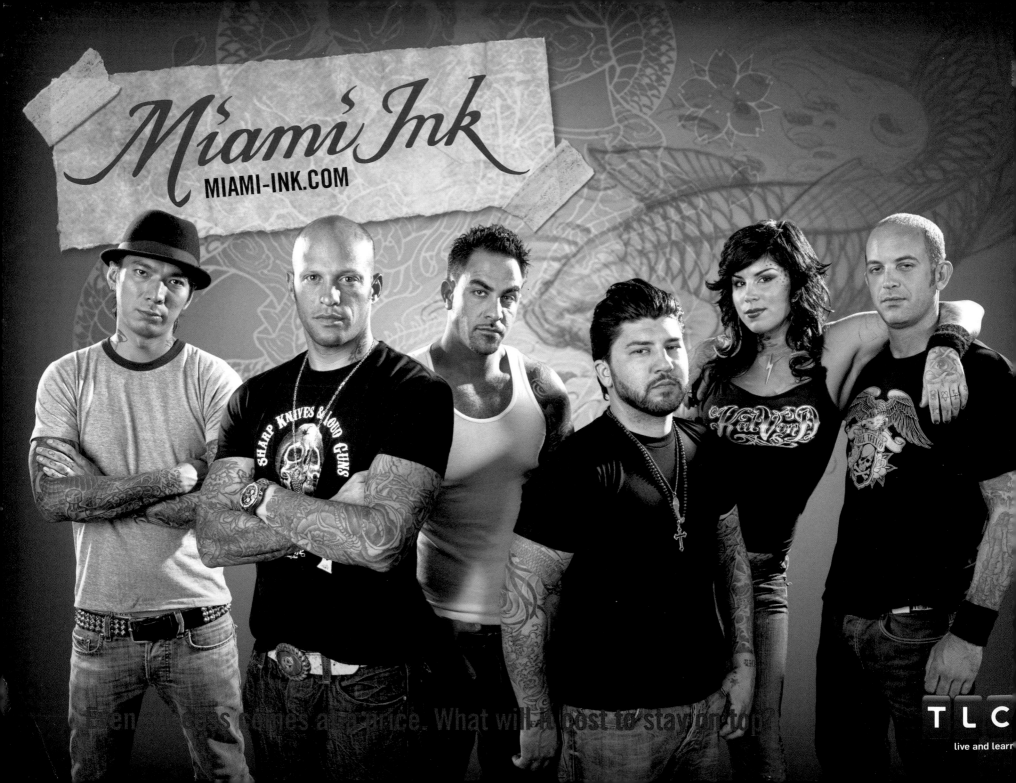